D1417856

PLAYING WITH FORM

ALEXANDER ALLAND, Jr.

PLAYING WITH FORM

CHILDREN DRAW IN SIX CULTURES

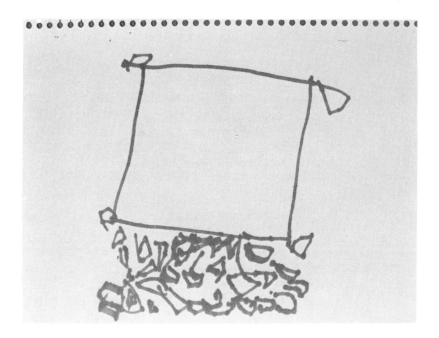

NEW YORK • COLUMBIA UNIVERSITY PRESS • 1983

Fried, 27.00 | 24.30 | 6 | 24/83

Library of Congress Cataloging in Publication Data

Alland, Alexander, 1931–
Playing with form.

Bibliography: p.
Includes index.
1. Drawing ability in children—Cross cultural studies.
I. Title.
BF723.D7A44 1983 155.4'13 82-25269
ISBN 0-231-05608-7
ISBN 0-231-05609-5 (pbk.)

Columbia University Press
New York *and* Guildford, Surrey

*Clothbound editions of Columbia University Press books are Smyth-sewn and printed
on permanent and durable acid-free paper.*

This book is dedicated to
children everywhere

CONTENTS

PREFACE

THE DATA of this study are, I believe, unique. This book is the first published cross-cultural analysis of children's drawing in which the data from several cultures were collected under controlled conditions and in which children were filmed in the process of making pictures. I have, for these reasons, presented a good deal of primary material in the descriptive segments dealing with each of the six cultures studied.

The ethnographic summaries presented at the beginning of each data chapter are meant to guide nonanthropologists concerning some salient aspects of the cultures in question as they might affect the way children draw. They are not meant to inform an anthropological audience. A cross-cultural study of this type cannot be ethnographic, but I hope that the data presented will stimulate others to study the development of drawing skills in greater depth and in the context of specific non-Western cultures. I hope to do some of this work myself in further research in Bali.

Cross-cultural field studies are very difficult to accomplish. In each of the countries chosen I was concerned about obtaining permission to work, the assistance of interpreters, and access to a sample of children who would be willing to draw for me. I faced the additional worry that my film would be damaged in development, or that it would be lost in transit. The experience of rapid field work in a series of culturally different settings is draining. As soon as my wife Sonia and I had become comfortable in one setting we had to move on and reestablish ourselves in another. These burdens and worries were reduced considerably by the help and cooperation offered by a large number of individuals in the several research set-

tings. I am particularly indebted to the following individuals and organizations:

In the United States

The John Simon Guggenheim Foundation and The National Science Foundation (Grant Number BNS 7611171) both of which financed the research project and The National Science Foundation (Grant Number BNS 8018071) which allowed me to finish the analysis of the data and prepare this monograph. I also wish to thank Mrs. Jacqueline Holland for her help in obtaining a major part of the U.S. sample.

In Bali

Professor I Gusti Ngurah Bagus of the Fakultas Sastra, Universitas Sastra, Sangglah, Bali, Indonesia; Ida Bagus Astawa, who was our host in Batuan, and his son, Ida Bagus Mertha Astawa who served as my interpreter.

In Taiwan

Professor Mei-Chun Tang of the Taiwan National University; and Shiao-Ling Lee who served as assistant, interpreter, and in whose home we worked.

In Ponape

Solik Anastasio Dolsalua in whose house I lived and who found subjects for me, and Bill Selvidge who served as my interpreter and who found subjects in Saladek.

In Japan

Professor Minoru Sumio of Tokyo Gakugei University, Yumiko Hisamoto-Sakaguchi who interpreted in the Shimotakaido Kindergarten, Head Mistress Mrs. Kanazawa of the Shimotakaido Kinder-

garten, Head Mistress Yuriko Kono of the Kawamura Daini Kinder-
garten, and Mrs. Minoru Sumio who interpreted at the Kawamura
Daini Kindergarten. Thanks are also due to Dr. Sam Coleman who
helped me establish contacts in Japan and who smoothed the way
for us to live in Tokyo.

In France

Mayor Jean Lasalle of Soubès, and Miss Cecile Velas of the école
maternale of Soubès.

Joe Bosco made the pictures for this monograph. The text was
read and edited by my good friends and colleagues, Joel Wallman
and Scott Atran, whose critical comments were both welcome and
useful. They are, of course, not responsible for any of the shortcom-
ings in this book. I am most in debt to the children who drew for
me and to Sonia who assisted in the research and writing up of this
project.

Production costs have limited to 100 the number of pictures re-
produced in this book. I would, of course, have liked to present the
entire sample and to have included several color plates.

PLAYING WITH FORM

INTRODUCTION

THIS STUDY is an empirical investigation of how children in different cultures draw and use a limited set of colors. Its purpose is twofold: to see how current generalizations about the development of drawing skills in children hold up under cross-cultural examination, and to understand how children in different cultures put pictures together as a step-by-step process. The latter involves the derivation of rules for the generation of pictures. In order to fulfill these tasks it was necessary to film a series of children of different ages and in different cultures in the process of making pictures. It was also necessary to find at least some cultures in which children up to the age of six had no school experience, and, when possible, no experience with art. The places finally chosen, Bali, Ponape, Taiwan (China), Japan, France, and the United States, provided a set of cultures with diverse approaches to art as well as differential access to it in everyday life. The data challenge the stages approach to children's art, except, in part, for the development of human figure drawing. In addition they call into question the idea that representation is an automatic goal in the development of drawing skills.

I believe that art qua art is disciplined and goal-directed play with form. The goals themselves involve aesthetic canons that are restricted, at least in part, by cultural conventions. I do not accept the notion that the drawing and painting young children will do on their own is goal directed, at least not in the same way as it is for artists. Rather, although children's drawings may conform unconsciously in many ways to cultural conventions, what children do basically is play with form and let the process itself take them where it will. This is, of course, an ideal situation for self-direction and discovery that can lead to the eventual mastery of form.

Although what I have just said conforms to a Piagetian notion of development involving orderly stages of discovery, my theoretical position concerning aesthetics is that of a nativist. I recognize the tremendous place culture and learning occupy in the use and appreciation of art styles, but I am guided in my thinking by the idea that certain aesthetic principles (what might best be called "good form") are universal and coded in the human brain. It is not at all illogical to assume that the discoveries made while playing with form are limited by a finite set of formal properties that trigger aesthetic satisfaction. Nor is it necessary that a single output be the result of such rules. All that is necessary is that the outputs, whatever they might be, meet the parametric requirements set by the aesthetic rules.

The data of this study cannot be used to *prove* a nativist position. In fact, on the *surface,* they appear to contradict it. In the three cultures where I had access to unschooled children in a range of ages, the results show a high degree of formal similarity *within* each culture, but also a strong lack of similarity *among* them. The patterns characteristic of each culture appear in the work of very young children as soon as the scribbling stage is over.

For reasons alluded to above I am reluctant to abandon the nativist position on the basis of these results. The leading nativist in the field of linguistics, Noam Chomsky, has suggested that language development moves toward a precoded target, but admits with no discomfort that particular languages, with all the differences they display, are learned. The only thing that is precoded is a set of limited underlying rules that determine the shape (the outer boundaries) of all languages. My data do not allow me to judge whether or not universal aesthetic principles underlie the observed diversity, but they do not really contradict the idea either. In fact they can be interpreted to partially support it, provided the interpretation is guided by nativist theory.

If indeed there is an aesthetic "target" toward which the development of drawing skills move it may not be reached until adolescence or later, and only with a good deal of practice. It is well known that even precoded skills may require practice for their emergence to occur at the proper time in development. Howard Gardner (1973) notes that while musical genius appears early in a significant num-

ber of cases, fully developed skills in the visual arts almost never emerge until well into adolescence. Known exceptions to this are limited to the astonishing precociousness found among some very young autistic children (cf. Selfe 1977).

The restriction that precoded aesthetic rules emerge only with experience is supported by the cross-cultural studies of aesthetic judgment published by Irvin Child and his associates. (Child 1965; Child and Siroto 1965; Ford, Prothro, and Child 1966; Iwao and Child 1966). These all suggest that patterns of similarity in aesthetic judgment are found only among individuals engaged in the arts (either as artists or critics). That the emergence of a phenotype for the production and/or appreciation of "good form" would depend upon both genetic coding and experience should be no surprise, since this is true of all physical and behavioral traits having a genetic basis. No organism is the product of its genes alone. Let me hasten to add that a nativistic theory of aesthetic form does not imply a genetic basis for individual differences. All normal humans are born with the capacity to speak language and it is certainly possible that all normal humans are born with the latent capacity to produce and/or appreciate "good form." Normal humans brought up in the usual social environment are bound to acquire language skills. The same is not true for art even if the *capacity* for artistic behavior is present. Social life often contains important aesthetic events and many humans participate in such events, but there is no overall aesthetic imperative that can compare with the linguistic imperative in human culture.

While I hope that the readers of this book will find the data on cultural differences, as well as arguments against representation as the automatic target of developmental skills in drawing, important in their own right, I shall also argue in the concluding chapter that significant cultural differences in the formal properties of drawing can be generated from a limited number of very simple rules. This suggests that stylistic differences of considerable magnitude can be due to small variations and can develop rapidly. Further research will be necessary before we can be sure that this is a valid idea and, if it is, what the limitations of these variations are or, indeed, if the variations have limits. It is only when these questions are answered that we will be able to test the nativist proposition that such varia-

tion conforms to a universal aesthetic infrastructure. I believe that my interpretation of the data presented in this study shows that these questions are, at least, worth asking. A nativistic theory of aesthetics wll also require cross-cultural data on older children's drawing skills and on the socialization of artists as they develop into practioners. It is my hope that this book will stimulate further comparative behavioral studies in the various areas of aesthetic development.

The communication function that so often appears in art suggests a parallel between artistic and linguistic development in children. All normal infants babble, and most normal children begin to talk around the age of 18 months. In our own culture children who are given the opportunity will also produce drawings at this age. Beginning with what I shall call *kinetic scribbles* (the result of motor activity and apparent satisfaction from making visible marks), a kind of babble with visual forms, they will go on to produce abstract patterns and, if properly stimulated, to draw realistic subjects by using various schemata. The first representations are usually of people. Later, humans are put into a pictorial context including such things familiar to children as houses or trees. Finally, children will produce coherent, realistic compositions in which each element is part of a single picture.

It is tempting to see the development of language and the development of artistic skills as the unfolding of parallel processes leading to different communicative mechanisms. It is also tempting to assume that emerging artistic skills provide a window onto the way children see the world, or, at least, how they symbolize it. Unfortunately, we do not yet really know very much about the development of *spontaneous* picture making in children. Most studies of children's art have drawn their sample populations from various school settings where a considerable amount of formal or informal art training had already occurred. We also have very little comparative data collected under controlled conditions from different cultures. Those studies that do exist base their conclusions, for the

most part, on collections from which it is difficult to answer the following set of questions: How were the children stimulated to draw? Did they make a single picture or several, and, if the later, which picture(s) is (are) included in the sample? Were they given a specific subject or were their drawings spontaneous? How much drawing experience did they have before the sample was collected? Did they see the work of other children in the sample? In addition, many collections contain pictures made on different-sized paper and with different drawing materials. Yet paint, pencils, felt-tipped pens, finger paints, crayons, etc. can lead to very different and particular stylistic results. (Among the cross-cultural studies of children's drawing, or studies of children's drawing in non-western cultures are the following: Adler 1967; Anastasi and Foley 1936, 1938; Appia 1939 and, of course, the works of Rhoda Kellogg cited in the bibliography.)

All human behavior has its roots in our species' specific evolution. What is unique about us is our general adaptability. Through the mechanisms of language and culture, humans adapt to a wide range of natural and social conditions. While human beings have a genetic capacity to learn language (any language) and culture (any culture), the specifics of any particular language and culture are not programmed in our genes. Thus, aside from certain biological requirements to sustain life and to procreate, if the species is to continue, human behavior, in the context of a specific culture, cannot be predicted from a narrow set of biological principles. This said, it must be noted that there are some theoreticians of language (Noam Chomsky is the best known) who believe that the capacity to speak language implies more than just a readiness to use any purely learned grammar to generate meaningful sentences. Chomsky and his followers believe that all languages (including all possible future human languages) are restricted by a single set of rules that control the generation of meaningful sentences. This common structure is called the universal grammar, or UG. This UG underlies and restricts all *particular* grammars. It is believed by Chomsky to be coded in the brains of all normal humans. For Chomsky, when an individual learns a language, he or she is guided toward a preexisting genetically programmed target that includes all the principles of the

UG. What is really *learned* in this process are only the specific rules of the particular language in question. Chomsky supports his argument about the genetic nature of the UG by showing that trial and error learning cannot account for the ways in which children come to grasp certain general grammatical rules.

Chomsky (1975) uses the following example of simple declarative sentences and their corresponding questions:

(a) "The man is tall." "Is the man tall?"
 "The book is on the table." "Is the book on the table?"

Listening to these sentences, one might derive hypotheses to explain the process by which sentences are formed and transformed. A trial and error learning hypothesis would assume that the child processes the sentence from left to right in sequence "until he reaches the first occurrence of the word 'is' . . . he then preposes this occurrence of 'is,' producing the corresponding question."

The hypothesis works for the sentences in question, but it can be proved false by considering some other, related sentences. Chomsky uses the following examples:

(b) "The man who is tall is in the room." "Is the man who is tall in the room?"
(c) "The man who is tall is in the room?" "Is the man who tall is in the room?"

While children who are learning to speak do make mistakes, Chomsky notes that they never make the kind of mistake seen in sentence (c). This leads him to the following hypothesis: "The child analyzes the declarative sentence into abstract phrases; he then locates the first occurrence of 'is,' (etc.) that follows the first noun phrase; he then preposes this occurrence of 'is,' forming the corresponding question" (Chomsky 1975:31–32).

Hypothesis 1 (drawn from a trial-and-error model) suggests that the speaker is using a "structure-independent rule" that involves an analysis into words in sequential order. Hypothesis 2 (Chomsky's own) suggests that a "structure-dependent rule" is followed.

In the latter case the speaker analyzes the sentence into words *and* phrases. The latter are ordered subparts of the sentence.

Chomsky believes that structure-dependent rules must be programmed in the brain because children are not trained by adults to use them in language learning. Thus he says, "The principle of structure-dependence is not learned but forms part of the conditions for language learning." Structure-dependent rules are one aspect of the UG, which Chomsky defines as "the system of principles, conditions, and rules that are elements or properties of all human languages not merely by accident but by necessity." Necessity here means biological precoding. Chomsky goes on to state that there is no structure similar to UG in the communication systems of nonhuman animals. Thus language, as opposed to other forms of communication (and there are many of the latter), is exclusive to the human species.

Chomsky also notes, and this will be important in the discussion to follow, that the communication aspect of understanding and speaking a language is an aspect of behavior that has less theoretical interest than the UG itself. That is to say, both speaking and understanding are outputs of a code that resides in the brain. It is the code that is theoretically interesting. Of course, we can get at the code only through its outputs, but we must remember that these outputs are imperfect representations of the code itself.

A note of caution must be added to this discussion. Not all linguists and psychologists agree with Chomsky that the UG exists, and even some who do accept its reality do not believe that it is genetically programmed. I raise this issue because, in the United States at least, anthropology has grown up within an empiricist tradition. This tradition assumes that humans are born as *tabulae rasae*. All they need do to understand the world is experience it. The common perceptions that individuals have are due to the common reality we experience rather than to an intrinsic set of specific mechanisms that organize experience internally. Although all empiricists must admit that there are some basic biological mechanisms that allow us to see, smell, feel, and even think about the world, these are seen as general and unformed until they are given structure *through* experience. Empiricists see language as the product of gen-

eral learning in a species which can learn and store a great deal of information and which is social in nature. They look for precursors of linguistic abilities in nonhuman species with the assumption that the capacity to speak results from a cumulative process of increasing intelligence. Chomsky, on the other hand, believes that the linguistic capacity is a highly specific one and that it is unrelated to other aspects of intelligence. For Chomsky the human brain, and only the human brain, contains a language organ, and this is why humans are the only animals to have language.

I accept the fact that behavioral differences among populations of different cultures must be due to learning and are caused by historical factors rather than genetics, but I also believe that a common precoded substratum provides structures that organize perception and thought. Cultural differences occur because diversity of experience provides differential content for these structures and because certain elements of these structures contain flexible elements that can undergo transformations that are nonetheless systematic and predictable. Art, like language, is specific to humans. It occurs in no other species. This suggests immediately that aesthetic behavior is biological in origin. This in turn raises the possibility that precoded principles of aesthetics exist as well. This is why I am drawn to Chomsky's position.

I wish to distance myself from "sociobiology," however. Sociobiology claims direct genetic control over highly specific behaviors. A rationalist or nativist approach to a biological substratum for linguistic or artistic behavior is not sociobiological because it treats the development and operation of an open-creative system. There is a vast difference between a hypothetical, genetically based stereotypic response to some environmental cue (one that triggers aggression, for example) and the formation of a sentence in that infinite realm of well-formed sentences. As Chomsky points out, many of the rules of grammar are *recursive*. This means that a limited and finite set of rules gives rise to an open system. The art of any real artist is determined by cultural and historical factors, just as any sentence spoken by a real person is the result of the psychological and historical particularities which characterize the speaker.

If my approach to art were not influenced by Chomsky's theories about language I would use this study simply to emphasize the striking differences revealed by the data from my sample. I believe, however, that hypotheses about formal aesthetic universals should be entertained. To do this we must go beyond surface differences to find common roots. This said it will be important to distinguish between art and language as two different recursive systems and to discuss the evolutionary roots that gave rise to artistic behavior. This discussion will also serve to support the argument that art is not necessarily symbolic in content; that its goal is not necessarily to represent.

While a number of authors have claimed that children's drawing is by its very nature, art, and therefore symbolic (cf. Arnheim 1954), there is no evidence that, left to themselves, children will use visual forms to symbolize. When a child begins to draw with a felt-tipped pen (or any other tool) he or she is certainly engaged in a motor activity that has a visual output. In addition, once the kinetic aspect of such marking gives way, at least partially, to concern with emerging forms, the child can be said to have moved from a scribbling stage to one in which play with form is the dominant motivation. Whether or not children will on their own go further and begin to use formal elements to represent and/or to symbolize is, at the very least, a subject for conjecture. Studies of children's art for the most part have dealt with very young children in, or barely beyond, the kinetic scribbling stage, or with children who have already learned from adults and other children that the purpose of art is to represent and/or symbolize. In working with form, children may certainly discover on their own what particular forms are emotionally satisfying, but there is no reason to assume that left to their own devices, children will, as a matter of course, go beyond this discovery. In fact, the satisfaction they derive from formal play may act to block a transition to symbolic activity in art. Humans *need* language for communication, but they do not need art for it.

In this study I had access to some children who had never drawn before in cultures with strong traditions of visual art and in one culture without such a tradition, at least in its contemporary state.

In the latter situation I found that most children drew formally or-
ganized pictures, but that most of these pictures are nonrepresen-
tational and have no overt symbolic meaning.

Although there is a difference between the formal (rule-deter-
mined) creativity of language as a recursive system on the one hand,
and free creativity, as in the use of metaphor, on the other, in cul-
tures where art becomes symbolic it does so with relative ease. The
extension of formal play into the visual symbolic realm comes when
children are taught that forms can be linked to content. This is not
a difficult process because linguistic skills already include the ca-
pacity to use metaphors. These skills can be shifted easily from a
language mode to a visual mode.

In an earlier work (Alland 1977) I attempted to make a clear dis-
tinction between art and language, admitting at the same time that
both were members of a family of communication systems and as
such contained common features derived from a shared biological
and evolutionary trajectory.

I have said that art (as behavior) is the result of the evolutionary
process. This does not mean, however, that I consider art per se to
be adaptive in the evolutionary sense, even though it may have
functional value in certain contexts. Not all behavior that is geneti-
cally determined need be the result of natural selection. Instead it
may emerge from the random proliferation of selectively neutral traits
or from selection favoring unrelated traits that together give rise to
some new complex. The latter is true, for example, of the speech
apparatus in humans. In *The Artistic Animal* I argued that art results
from the interaction of at least four behavioral systems, each of which
was selected independently. These are *exploration* and *play*, which
foster the manipulation and understanding of the environment; *re-
sponse to form*, which increases awareness of the environment; *fine-
grain perception* and *perceptual memory*, which increase the capacity
to deal with environmental variation and to exploit resources; and
what I call *transformation-representation* (ways of expressing ideas
and images in formal ways that make new connections between
them, as in metaphors). This capacity is one of the most important
elements of language, but lies at the base of adult art as well. The
ability to manipulate symbols in both language and art lies at the

base of free creativity in which previously untapped relationships among unconnected elements are used to add interest and density to spoken and visual messages. New metaphors and combinations of visual symbols provide part of the richness that we associate with all successful works of art. Ezra Pound once said that literature is language charged with meaning and that great literature is language charged with meaning to the utmost. Any genetic element implicated in the generation of art will affect only its formal, rather than its meaning, aspect since the latter depends upon free creativity, limited only by individual experience and historically defined culture. It is the capacity for transformation-representation that is inherited by all normal humans rather than any specific set of transformation-representations.

Art in all cultures where it occurs consists of formal and symbolic expression overtly governed by sets of conventional rules. Its formal aspect may also be governed by a set of covert, genetically based rules, but for the present this notion remains hypothetical. Cross-cultural studies that have attempted to get at universally valid aesthetic principles are ambiguous because, at best, they tend to demonstrate only statistical agreement on aesthetic judgment (see Child and others cited in the bibliography). None of these studies attempts to extract the reasons *why* people agree that one picture is "better" than another. Still, it is logical to assume that sensitivity to, or arousal by, certain patterns in nature and art would be aspects of aesthetic perception and that this perception would have a universal basis. In *The Artistic Animal* I suggested that pleasurable responses to art were due to the presence of a specific aesthetic emotion in humans. I now wish to withdraw this notion. I agree with Nelson Goodman (1976) that art is capable of arousing pleasure, but that this pleasure is the same emotion that can be generated in nonaesthetic circumstances. But art as it is defined in our culture is more complex than this; it is also symbolic. It may signify by representing objects or people, and art qua art is almost always linked to linguistic or quasi-linguistic systems as well as to unconscious symbolic systems (Freud's primary processes). In traditional contexts art is coupled to mythic and ritual texts. To do art is not a purely "artistic" act and artists generally know exactly what they

are doing when they engage in artistic activity. It must be noted, however, that even though an artist may know exactly what he or she is doing, viewers of art *need* not know anything about an artist's intentions. The richness of meaning in art also derives from the private symbolism of the spectator. Although the degree of variation in personal interpretations probably differs from one culture to another it must exist to some extent in all cultures. This open aspect of meaning adds power to the purely formal side of art.

The current and past literature on children's drawing consists largely of developmental studies relating the way formal elements change with increasing age and the ways children use visual forms to symbolically represent the world around them. One of the best known authors on children's drawing is Rhoda Kellogg (1959, 1969). She has dealt primarily with the development of formal elements and their arrangements in designs, and suggests that a rather tight sequence of events occurs as the child moves from scribbles to representation, with each stage in the process giving rise to the next. She is also known for her insistence that the *mandala*, a circular form that incorporates a cross or rectangle, is a basic element in children's drawing at a certain stage. Kellogg says that the scribbles of young children begin to evolve towards definite forms at as early an age as two-and-one-half. Circles are the first true forms to emerge, to be followed by rectangles, and later by triangles. These discoveries are mastered by the child through covering the page with one particular form until he or she finally comes to put one within the other. She calls these more complex units *Combines*. When a few such combines are grouped in the same place on the page she uses the term *Aggregate*. Kellogg has counted the logically possible number of combines based on what she believes are the basic forms of children's art (circles, rectangles, crosses, and triangles) and arrives at sixty-four possibilities. She believes, however, that mandalas are the most common, because of their aesthetic properties. For Kellogg, order and balance are essential elements in the development of children's art. She states that the chosen forms are intrinsically attractive and that a "primary visual order" exists in every mind.

Lark-Horovitz, Lewis, and Luca (1973) suggest that there are three main stages in the development of artistic behavior in children. They call these stages, "scribble," "schematic," and "true-to-appearance." Scribbles are the remains of the motion that produced them and are, therefore, the result of primarily kinesthetic activity. They occur between one-and-one-half and four years of age. During the schematic stage children begin to represent. Schemas are outlined shapes with a degree of resemblance to actual objects, but they are highly general and may stand for a whole class, such as *any* human. This stage is said to begin at about three or four years. In its early phases of development, the schema includes only parts of objects; not until a later stage does it also indicate relationships.

The true-to-appearance stage is characterized by an attempt at realism in which "objects and groups of objects are observed from a single point of vantage. Situation, position, or movement of living things is shown; bending of limbs, reasonably correct proportion among parts, and more 'correct' color and light appear" (Lark-Horovitz et al. 1973:13).

Howard Gardner (1980) says the following of developmental sequences in children's picture making:

> According to the emerging consensus, a child begins making marks during the second year of life, at first enjoying the motor sensations of banging marker on paper, but soon coming to prize instead the contrasts between the dark scribbled lines and the white surface. The contribing of certain geometric forms—circles, crosses, rectangles, triangles—coupled with an increasing proclivity to combine these marks into more intricate patterns is a fundamental development of the third and fourth years of life . . . and indeed a pivotal moment occurs some time during the third, fourth, or fifth year of life: the child for the first time produces a recognizable depiction of *some thing* in the world—in most cases the ubiquitous "tadpole man" who stands for everyman. (Gardner 1980:10)

Agreeing with the stage approach to children's drawing, Gardner notes that the preschool child develops a set of fixed patterns (schemas) for various objects. When these have been assimilated (the term *is* borrowed from Piaget) the child goes on to draw organized pictures in which objects are related to each other in a natural way. These develop so that by the end of the preschool period

"drawings are characteristically colorful, balanced, rhythmic, and expressive, . . . one has the strong feeling that such drawings constitute an important and perhaps a primary vehicle of expression for the young child" (Gardner 1980:10).

Like Kellogg, Gardner suggests that some of the early forms produced by children may reflect innately satisfying patterns, but sees most of artistic development as a cognitive process in which experiment and learning play the major roles. In respect to this idea he divides children into two types in relation to the kind of art work they produce. Some children, he says, analyze their work in terms of the physical attributes of objects. These he calls *patterners*. Other children are interested in events and the way in which they take place through time. Such children are referred to as *dramatists*. "Romancing"—making up descriptions for what appear to be abstract or ill-formed figures and making up stories to go with pictures—is seen by Gardner as a central element in the work of *dramatists*. Attention to story and pattern are, however, both parts of the discovery process that leads to well-formed pictures.

Kellogg, Lark-Horovitz et al., and Gardner all stress the particular stages through which children must go as they move automatically towards representation. Goodnow (1977), in a different and I believe, more reasonable approach to the development of drawing in children, suggests that whatever children actually do in terms of representational or nonrepresentational drawing, they all tend to follow a set of general formal rules. These provide a basis for both experimentation and the solidification of patterns that emerge through learning and experimentation. Although Goodnow does not use the Piagetian terms *accommodation* and *assimilation,* her rules are congruent with the notion that children learn to accommodate to new information (or in this case new forms) and then to assimilate it into their particular schema. Her rules (which, unlike the previous sets, are not sequential) include the following principles of drawing:

1. Children are thrifty in their use of units. They will tend to experiment with a basic vocabulary.
2. Change is conservative.

3. Parts are related to one another according to specific principles.
4. Parts are related in a sequence. Children begin and end their pictures in regular patterns.
5. Children's graphic work represents their thinking and ours.

By rule 5 she means that the features of thrift, organization, and conservatism all involve problem solving and occur in the same manner in both children and adults. Goodnow also notes that young children tend to operate with two general principles: to each its own boundary and to each its own space. Thus, in drawing humans, parts of the body are separated from each other (head from trunk, from limbs, etc.). She asserts that a shift from separate units to embracing lines must be a major intellectual as well as artistic step for the child to make. A human figure drawn with a continuous flowing boundary is evidence that the child has grasped the relationships that exist among parts. The latter discussion, depends, of course, on the notion that children will attempt to represent in some of their drawings. Goodnows subjects, like the subjects of the studies discussed above, represented both because they had learned to in school and because they were asked to represent as part of the study.

Arnheim (1954) believes that children do not attempt at first to draw replicas of things or objects in the world. Instead they construct "equivalents" of the original that share basic features with it. He notes, for example, that the basic feature of the human figure is the vertical axis and that this verticality is used early by children to distinguish humans from animals. Arnheim is little interested in the problem of skill in drawing, as an aspect of such symbolic representations, because he believes that children do not intend to draw realistically.

The following sequence from my field notes tends to contradict this notion. Although it is anecdotal in that it concerns only a single Taiwanese child, it should be taken as a caution when dealing with assumed motivations behind what a child does.

A 2-year-7-month-old Chinese child picks up a red pen, looks over his shoulder at a tiger scroll hanging on the wall of the drawing room and says, "I'm going to draw that tiger." He makes a few

marks on the paper and realizes that he cannot copy the animal realistically. Still wanting to draw he takes another piece of paper and draws energetic red loops and circles on it. When he is finished he tells us that it is a spaceship. This description is probably the result of the child "romancing" about his picture. The child, who realizes that adult pictures have a representational meaning, looks at his drawing and connects the scribbled marks to some objects in the natural world. This event would have been totally banal in terms of what we already know of children's art, if all the child had done was "romance" about his finished picture, but he also had told us what he was going to do in his very first attempt at drawing. (Although he must have seen drawings, and may have observed others drawing, this child had never drawn before.) He was convinced that he could copy the tiger scroll. His inability to do so was visibly frustrating and he actually asked his mother to help him. Furthermore, when he saw that he could not draw the tiger he was not content to romance about the marks he had made and call his scribble a tiger. In contrast, his second picture could reasonably represent a spaceship since it consisted of round scribbles and, therefore, shared certain formal elements with spaceships. Perhaps after he finished this drawing, the shape on the paper reminded him of something he had seen on television, or a toy he had played with. In any case he was able to assimilate a known shape to his drawing and to give the latter a name. His unwillingness in the first instance to romance about the unsuccessful tiger contradicts the notion that children are always satisfied to symbolize things according to abstract or simplified schemata. Even when they are satisfied, such satisfaction may be a compromise between what a child can do technically and what he or she actually wants to do. It is not certain that children do not realize their own representational limitations. But I have a stronger point to make in this book. I shall argue that representation is not the necessary consequence of picture making for children and that at least some, if not all, schemas are learned. If there is a genetic element in aesthetics it is formal and has nothing to do with content.

METHODS AND DEFINITIONS

ASIA AND the Pacific were chosen for this research because a substantial variety of non-Western cultural traditions could be visited and studied on the same plane ticket. The trajectory was, therefore, strategic. The places in which research actually took place sorted themselves out as I received information on access to children, the availability of assistants who spoke both the native language and English, and promises of cooperation from governmental authorities and local social scientists. I was particularly eager to work in Japan and Taiwan because of the rich artistic traditions of Japanese and Chinese cultures as well as important contrastive differences between them in early childhood education. Bali was attractive for its reputation as a culture in which practically everyone contributes to one or more of the popular arts. In addition, I knew that in Bali I would have access to unschooled children of a range of ages and that I could compare my sample to samples of children's art collected in the 1930s by Margaret Mead and Jane Belo. Ponape was a happy accident. Although I had originally planned to work in Papua–New Guinea, permission to do so came only after my travel plans had become solidified. Ponape had already been chosen as a substitute and I had established contacts there through Glenn Petersen, an anthropologist who had worked on Ponape.

The absence of contemporary indigenous art in Ponape (the result of multinational colonialism since the end of the nineteenth century) plus access to both preschool and schoolchildren worked to my advantage. Since I had easy access to French children in a village where my wife and I have owned a summer house since 1967,

pretesting for this study was done in France and a small French sample was included. Finally, American children were used for comparative reasons, particularly because so much has already been published on children's art in our own culture even though little of this material is based on filmed material.

Fortunately, the six cultures in this study provide a series of interesting contrasts and the data show a diversity that reflects cultural differences. Japanese and French children have early access to art in their nursery schools and kindergartens. Japanese children are exposed to a wide variety of art materials and have both instructional and free periods for art work. French children, at least in the nursery school studied, have little specific art training. Their exposure to art is limited to periods of free drawing and painting. The American children sampled also have access to art materials (to different extents in three different schools), but art work, as in France, and in contrast to Japan, tends to be secondary to games and various types of kinetic play. Balinese children are surrounded with a variety of artistic realms, including dance, music, wood and stone carving, weaving, and painting. Yet preschool- and school-age children in Bali have little or no personal experience with the making of pictures. I was thus able to test children in a range of ages who had not drawn or painted before. The same was true in Ponape, but there work in the visual arts was a completely alien pursuit. In Taiwan I had access to children of different ages who had no school experience and was able to compare them to a local sample of young school children in which the ages overlapped somewhat with the nonschool sample.

While a serious attempt was made to standardize the sample size in each culture, the age range of the children tested, the materials used, and the conditions under which the pictures were produced and filmed, this was not possible in all cases and some unfortunate variations did creep in. In one case, the French, (in France I used up a part of my potential sample during pre-testing) there is an important difference in sample size. In addition, the age range and the number of children in each age category is not the same in every culture. While the materials used and the instructions about producing pictures were uniform in each case, the conditions under

which the work was done varied from culture to culture. These differences will be discussed in detail below.

All children in the study were asked to produce a single picture of their own choice. In some cases, after the first picture was produced, the child was asked to make another. A few times children spontaneously asked to start over and were allowed to do so in each case. When this happened their first attempt was kept and noted as data, but the picture that satisfied them was chosen for analysis. Second requested pictures are used in the study for special purposes, and are not counted in the sample. They do reveal a consistency of style in the work of each child.

All pictures but one (see child C 23 below) were made on a 9-by-11-inch page that was part of a spiral notebook. Each page was presented blank to the child and no child (except those noted in the chapters to follow) saw any of the previously drawn pictures. Children were told that they could orient the page in either the horizontal or vertical position and in each case an assistant turned the book both ways to show the difference. Six felt-tipped pens with one-eighth-inch tips were placed to the side of the notebook. The colors provided were red, blue, yellow, green, brown, and black. These were arranged in random order for each child and all children were told that they were free to use any or all of the colors during the course of their drawing. Felt-tipped pens were chosen because they are easy for children to use, do not become mixed as paint might, and because pictures drawn with them film well.

If a child seemed hesitant or unable to conceptualize the use of the pens, one of them was opened and an assistant drew a short straight line on a piece of scratch paper. Except in France and the United States, an assistant fluent in the local language gave the instructions, interpreted any remarks a child made about the pictures while they were being drawn, and asked each child what the picture and its segments meant after the drawing was over. In France or the United States either I or my wife gave the instructions, noted the comments, and asked the questions.

In Japan, work was done in two public kindergartens in middle-class neighborhoods. Although such public kindgaretens exist in Japan, there are not many of them and not all parents send their

children. In one Japanese kindergarten a teacher acted as my assistant; in the other the principal of the school, herself a professor of education, assisted in the work. In Taiwan, work was done in the home of a graduate student in anthropology who asked children of her neighborhood to participate. In Bali I worked in local households of the village of Batuan (studied by Margaret Mead in 1938). There I had the aid of an English-speaking villager. In Ponape, work was done in the villages of Awak and Saladek. My assistant there was a Peace Corps volunteer who was fluent in Ponapean. In Awak, children were filmed on the veranda of a village house and in Saladek on the verandas of each child's own house. In addition, schoolchildren were filmed at both the Awak and Saladek schools. In France, work was done in the courtyard of the school while all but the participating child was indoors. In the United States, work was done in three locations: a Head Start nursery school, a middle-class nursery school, and a kindergarten located in an elementary school in a mixed middle- and working-class district. All three settings were in the same county (a suburb of New York City) and within six miles of each other.

In Japan, France, Ponape, and the United States, most children worked willingly. Those who seemed shy or did not wish to participate were excused after a few minutes of gentle encouragement. Both Balinese and Taiwanese children turned out to be very shy. My assistants in both cases suggested that a small reward be offered for drawing. In Bali this was a piece of candy and a balloon. In Taiwan it was a piece of candy. Only one child (in Bali) appeared to draw specifically for the reward. Other children, once they began, appeared to become wrapped up in their work.

Each child and the drawing were filmed during the picture-making process. Super-eight Ektachrome G160 film was used in either a Kodak SL or a Bolex Macrozoom camera. The Bolex was favored except under low-light conditions. In order to conserve film the camera was turned off when a child was not actually making marks on the paper. The beginning segment of each picture was filmed completely. After the first few minutes, however, the camera was turned off when the child was engaged in filling an already defined

space. Except in Ponape, where I kept a time log, my wife kept track of the time spent in the making of each picture.

After the drawing session was over, each child was asked if he or she had anything to say about the picture. Separate elements were pointed to and the child was asked what significance each had. Identified objects were noted on the back of the page, where their images showed through.

As noted above, it was impossible to get a completely matched sample by age and sex in each culture. In Bali and Ponape very young children are quite shy and reluctant to draw for strangers. This was true, if somewhat less so, in Taiwan also. In France, Japan, and the United States we had access only to children in some kind of school context. Since French children begin nursery school very young, we had access to children as young as 2. On the other hand, in Japan and the United States we were limited to children over three years of age. When work began we did not realize that Japanese children begin kindergarten in March, attend school for three months, and then begin again in the fall. Since our work in Japan was done in January, the youngest and most inexperienced children in our sample had already had seven months of school. In the United States, where work was done in the early fall, the sample included some children who had had very little school and very little, if any, drawing experience.

The Analysis

Both the finished pictures and the films, which reveal the picture-making process, were analyzed. Analytic categories chosen grew out of previously published material on children's art (particularly the extensive work of Rhoda Kellogg 1969, and Kellogg and O'Dell 1967) and the series of operations and configurations observed in the study sample. The finished pictures were examined and coded for the following characteristics: color(s) chosen, placement of marks on page, degree of white space left, density of mark(s), type of mark(s) (the twenty basic Scribbles of Kellogg, her Diagrams, Combines, and

Aggregates), the presence of filling in of an enclosed space, the presence of building-up of an area not defined by enclosing lines, subject(s), human figure(s), the presence or absence of overlapping, the relative size of each mark, discrete versus connected marks, and the use of circles in the construction of pictures.

The films were analyzed for the development of drawing sequences, particularly where the child moved on the page, the direction of lines and other marks, and the process of covering over previous marks when it occurred.

Advantages and Disadvantages of this Research Design

In studies of this type, what one gains in control and comparative power one often loses in detail. The fact that a single team (plus different assistants) collected all the data under fairly comparable circumstances and with the same materials imparts rigor. On the other hand, the comparative nature of this study forced me to work through interpreters in four of the six cultures chosen. These four are also exotic to me even though I have read much of the anthropological and psychological material available on them. In addition, the methods used in this study precluded my becoming familiar with the subjects as individuals and we did no psychological testing. Since I have, in most cases, only one picture per child, and because I was unable to follow the chronological development of the children in their art work, this study is developmental *only* in the sense that it samples the art work of children in six cultures from a range of ages. Since I asked each child to produce a free drawing, providing no subject matter, the study does indicate the kinds of choices made by the sampled children, and, by extension, what kinds of choices are made by children in each of these cultures, but the size of the samples provide little reliable comparable data on how specific types of design are drawn at different ages in the six cultures. As it turns out, by chance I do have some significant data to show that picture making is often not conceived of as representational by children in non-Western cultures who have had no school experience with art. In addition I have some good comparable data

on the drawing of the human figure and, in the Bali sample at least, human-figure drawing provides an index of skill (using norms drawn from Western children) against which one can make rough judgments about overall drawing ability in what appear on the surface to be highly complex designs.

Since most previous studies of children's art took place in a school context, most deal with children who have had at least some exposure to art. In this study some of the children of varying ages from Bali, Taiwan, and Ponape had had no schooling and indeed, in some cases, had no dawing experience prior to working for me. This provides an opportunity to analyze the art of children of different ages who have not learned to draw as a visual and/or motor activity. The Taiwanese data allow me to compare nonschool and school children of the same age.

The film data turn out to be most interesting when they concern those pictures drawn by children with no school experience, particularly when the material is nonrepresentational. The film data on school children tend to reveal rather stereotypic and predictable patterns, most of which can be deduced from the finished pictures.

Definitions

In the analysis to follow a series of descriptive terms are used. Where possible, common usage is employed and an attempt has been made to avoid neologisms except when deemed absolutely necessary.

Aggregate: A grouping of units. Kellogg uses this term to define a grouping of *Combines.* I do not use the latter term (defined by Kellogg as the combination of two diagrams—a circle divided by a cross, for example) because I find it too restricting. The term *Diagram* is also rejected here because it tends to be ambiguous in some contexts and restricting in others.

Build: The drawing of a solid shape without previously constructing an outline.

Composition: A coherent picture in which separate units are thematically related to one another.

Element: A coherent part of a figure, composed of a mark or a set of marks. A circle, even as a single mark, may, as a head, be an element of a body; a line, as a leg, may be an element of body. An eye is an element of the head.

Fence: A line or lines separating one part of a figure from another. A line between the head and neck or between the neck and the body in a drawn human figure is a fence.

Figure: Any obviously realistic form such as a human, animal, plant, house, etc.

Fill: The filling in of a previously outlined shape.

Kinetic scribble: Drawing in which motor activity appears to dominate (as shown by films) over the production of visual patterns. This term does not imply that visual patterns play no role in scribbling. As Rhoda Kellogg points out, children appear to enjoy the visual result of scribbling activity.

Line: Any straight or singly curved line.

Thread: Any line that changes direction more than once.

Unit: A shape composed of two or more marks, or closed shapes such as squares, triangles, and circles made with single marks.

The following terms are used when describing different ways of drawing the human figure. These terms, somewhat modified to fit my data, are drawn from the literature on children's art.

Mandala figure: Person (and sometimes an animal) represented as a head or face, with or without limbs, in which the limbs, if present, project as nonparallel lines from the head itself.

Tadpole figure: Person (and sometimes an animal) represented by a head with legs that project downward from the head as two parallel lines. If arms are represented also these are drawn projecting from the head.

Open-trunk figure: Person represented by a head and attached limbs that project downward from the head as two parallel lines *and* with arms projecting from the legs.

Closed-trunk figure: Person (and sometimes an animal) with a fence between the trunk and the legs.

Well-formed figure: Person or animal in which the head, body, and limbs are drawn as one continuous shape with no fences between parts. When clothing is depicted fences are used only as realistic

separations among dressed body parts. Thus the neck and head should be continuous, but a fence might separate the neck from a dressed upper trunk.

In referring to ages in the text the first number is the year and the second number the month. Thus 6.5 equals 6 years, 5 months of age; 6– means that a child is 6 years old, but that the number of months beyond 6 was not given by parents or other informants. Children's ages in Japan, Taiwan, France, and the United States are accurate. I cannot be sure that ages provided in Ponape and Bali are exact, but they are probably close to correct.

BALI

BALINESE culture is well known for its high degree of artistic productivity. The Balinese cultural and natural environments abound in visual stimulation. The compact island of Bali has high volcanic mountains, clear crater lakes, rushing streams and irrigation canals, dense forests, lush rice paddys, long stretches of sandy and black lava beaches, and finally, the sea. The Balinese love color and show this love in the flowers they grow, wear, and combine into sacrificial offerings, as well as in their weaving and the imported batik cloth from which their clothing is made. The imperatives of the Balinese form of Hinduism demand an artistic display of high order. Temples are decorated with intricate carvings in stone and wood. Balinese stone, of volcanic origin, is soft and the island's climate is warm and damp. As a result both wood and stone monuments need to be replaced frequently and temples (of which there are an estimated 20,000) are in a constant state of renewal. The ceremonial life of these temples depends upon performers of high caliber who attract the gods from the sacred mountain of Gunung Agung on the east coast of the island with dance dramas, operas, and masked plays, as well as shadow-puppet performances. Balinese religious observances in the temples take the form of entertainment because the gods will not leave their Olympic heights without the enticement of a good show. Every 210 days (a year in one of the many complex Balinese calendars), a temple's birthday is celebrated by local villagers. Silent for the rest of this "year," the temple bursts into life during the few days of the celebration. While these performances are meant as entertainment for the gods they also entertain the Balinese. Among the most avid spectators are children who particularly enjoy the comical aspects of these specta-

cles, which always include clowns of great verbal and physical dexterity.

In addition to these temple birthdays other ceremonies punctuate the Balinese year. These range from rites tied to the calendar to the intervention of shamans and gods during such critical periods as earthquakes, volcanic eruptions, deaths, and sickness. Ceremonies also occur at such happy times as weddings and the annual new-year's march to the sea, when temple effigies are cleansed in the waves and everyone picnics on the beach.

Since at least as early as the 1930s Bali has drawn a large (and still growing) tourist trade. Tourists are attracted by the sea, the soft tropical climate, relatively empty beaches, and low prices. Many are also attracted by the dance and music of the island, and many local performing companies have been formed specifically for the entertainment of tourists. Visitors to the island also buy local art and handicrafts. A brisk trade has developed in antique and contemporary Balinese art. Many Balinese now make their living, or part of their living, producing baskets, weavings, carvings, jewelry, and paintings of variable quality. The villages of Batuan, Klungkung, Ubud, and Mas are particularly known for their sculpture and painting (the latter of which originally stimulated by a small group of European artists who lived on the island in the 1920s and 1930s).

It is in this environment that Balinese children grow up. They are literally surrounded by art and artists. Although they do not themselves participate in the production of plastic art at young ages, and have no access to paint until they are in their early teens (if and when they are apprenticed to an adult artist), most Balinese boys learn to play musical instruments and to dance almost as soon as they learn to walk, and most girls learn to dance just as early as the boys.

The methods used to teach dancing and instrument playing to Balinese children are significant. They do not learn a technique of dancing or a means of playing an instrument. Rather they are taught to dance a particular dance or to play a particular piece on a particular instrument. Adult dance performers are known as experts for particular dances rather than as masters of Balinese dance technique. Adult painters also specialize. Some paint only religious

themes, some treat secular themes, producing what are known as Bali life paintings, and still others paint stylized figures based on traditional decorations found on roof beams in Klungkung. Finally, there is a category of tourist art that, while recognizably Balinese, fits into that vast category of low quality work known as "airport art."

The initial stage of dance and instrument training is completely passive. The child is manipulated like a puppet by the adult teacher. When a child has absorbed the kinesthetic elements peculiar to a particular dance or score he or she then begins to practice in the presence of the teacher. In the case of dance the student performs behind the teacher, imitating his or her movemets. New dances, and, in the case of music, new tunes, are added to an individual's repertoire in this way.

When older Balinese children begin to carve or paint, they work in a manner similar to apprentices in Renaissance Europe. They will mix paints or take care of the master artist's tools. Later they will color certain parts of a picture already outlined by the master artist. As their skills develop they will be left to compose and to complete their own works. If an artist becomes well known it will be for work in a particular style which is determined by region and subject. Ubud is known for colorful painting. Klungkung artists, for the most part, reproduce antique themes. The better quality artists in Batuan paint delicate, pastel-colored pictures of great visual density in both the Bali life and religious styles. Both are full of lush decorative elements drawn from the natural environment. In Batuan, less talented artists, or those who produce for the art market centered in Denpasar, Kuta, or Sanur, the major locations of tourist hotels in Bali, tend to paint formula pictures of dancing women, often against a white background, with decorative elements restricted to the details of costume. Such pictures contrast to the density of much Balinese art, including intricate carvings, complex dances, and multirhythmic percussive music. These pictures are a recent innovation, stimulated directly by the market, and are totally out of keeping with the dominant approach to art in Balinese culture and particularly the culture of Batuan.

The Balinese Data

Drawings by 43 children were collected in Batuan and 41 children were filmed. These ranged in age from approximately 2.6 to 8.0 years. Seventeen fell into the youngest group, between 2.6 and 5 years.

Twenty-eight were boys and 13 were girls; 4 had some school experience, but 2 of these had begun only one month before the sample pictures were collected.

In Bali it was impossible to isolate each of the subjects during the drawing sessions. Cases in which children saw one another's work are noted below, and analyses are presented that reflect both the entire sample and the sample corrected for this factor. The latter was accomplished by grouping each set of children who saw one another's work. Although such children did tend to repeat themes drawn by subjects who preceded them, interesting differences appear in these pictures, and it would be a waste to exclude them totally from the analysis.

Most young Balinese children are shy, and many of the younger ones to whom I had access refused to draw. Most who finally agreed began slowly but soon became immersed in their work. The average time spent on a picture was 13.30 minutes (12.46 minutes for girls and 14.64 minutes for boys); 18 children worked 15 minutes or more while 16 worked 5 minutes or less. The overall time range was from less than 1 minute for a child who decided not to complete his picture to 54 minutes. Of the 6 children in the sample who were 4 years or younger, the average time was 17.5 minutes and ranged from 2 to 45 minutes.

The Finished Pictures

The most characteristic feature of the Balinese children's pictures I collected is overall density. This is produced by packing the page from edge to edge, usually with a large number of small to medium, independent (nontouching) marks or, rarely, simple units such as circles in a wide range of colors.

Thirty-two of 43 Balinese pictures (74%) consist of a page covered

Table 1
The Balinese Sample

	Sex	School	Age	Time (minutes)
B 1	f	yes	6.0	30
B 2	m	1 week	5.9	18
B 3	f	no	5.11	32
B 4	f	no	4.11	4
B 5	f	no	4.11	9
B 6	m	no	6.5	19
B 7	m	no	3.5	3
B 8	m	no	6.0	15
B 9	m	no	5.2	17
B 10	m	no	3.0	2
B 11	f	1 month	7.0	2
B 12	f	1 month	7.0	1
B 13	m	no	7.0	1
B 14	m	1 month	7.0	5
B 15	m	yes	6.9	2
B 16	f	no	5.0	2
B 17	m	no	4.1	51
B 18	f	no	6.11	3
B 19	f	no	5.0	1
B 20	m	no	5.6	7
B 21	m	yes	8.0	11
B 22	m	no	5.0	15
B 23	f	no	4.9	2
B 24	f	no	4.6	25
B 25	m	no	3.3	30
B 26	m	no	2.5	18
B 27	m	no	5.6	5
B 27a	m	yes	8.0	not filmed or timed
B 28	m	no	5.0	1 (not completed)
B 29	m	no	5.6	5
B 30	m	no	5.0	13
B 31	m	no	5.0	less than one minute (stopped self)
B 32	m	no	5.1	6
B 33	m	no	4.0	7
B 34	m	no	6.0	6
B 35	f	no	5.7	6
B 36	m	no	5.3	8
B 37	f	no	4.8	45 (stopped by me)
B 38	m	no	6.6	15
B 39	m	no	5.0	16
B 40	m	no	4.5	54
B 40a	m	yes	8.0	3 (not filmed)
B 41	m	1 week	6.6	17

The following children are grouped as one unit in the analysis because children following the initial number in each case saw the first child of the series draw.

B 4, B 5	B 24, B 25, B 26, B 27
B 14, B 15, B 16	B 32, B 33
B 18, B 19, B 20	B 35, B 36
B 21, B 22	

with multiple marks or units that run from edge to edge in all di-
rections. When the sample is corrected for children who saw the
work of others (counting each such group as a single subject) the
percentage falls somewhat to 24 of 35 pictures (or 69%). Counting
both representational and nonrepresentational *units* as the means
for filling the page, the Balinese sample yields 13 pictures of this
type out of 43 (30%). The corrected sample leaves 9 of 35 pictures
(or 26%).

The use of circles as a major theme occurs frequently in the Bali-
nese sample. Since the circle pattern is thought to be quite common
in the art of young children, Bali is not an exception to these expec-
tations: 9 of 43 children (21%) used circles and the corrected sample
yields 7 of 35 (or 20%).

While it is clear that Balinese children display a "fear of the void,"
only a few of them produced pictures in which marks or units over-
lap or touch each other. Of 43 children only 5 (12%) who packed
the page produced designs of this type, and, of these, two pictures
are near-scribbles, displaying motor activity rather than formal de-
sign properties. If attention is turned to all pictures in which any
overlapping occurs, including those in which page packing is *not* a
feature, we find 7 out of 43 or 16 percent, not a very high figure. In
addition, pictures consisting of single connected wholes are ex-
tremely rare in the Balinese sample. Only 2 of 43 children (.05%)
produced pictures of this type. The tendency to keep marks or units
discrete is also reflected by the fact that none of the 43 Balinese
filled an outlined figure or shape with a color different from the
color used in making the outline. On the other hand, a small amount
of both filling and building did occur. Two children filled in out-
lined units, using the outlining color, and two built thick units with
single colors. This does not mean, however, that Balinese do not
put details into figures. The inclusion of such details (eye, nose, or
mouth in a face, for example) was not rare. It occurred in the pic-
tures drawn by 14 out of 43 children (33%). Such detailing tends to
appear in realistic rather than abstract designs.

Unambiguous representation (i.e. in which the analyst can judge
with certainty that a picture has realistic elements) is not at all un-
common in Bali. Such representation can be found (as at least part

of a picture) in the work of 25 of 43 subjects (58%). In the corrected sample this figure falls only slightly to 19 of 35 pictures, or 54 percent. While the typical page packing was generally accomplished by filling space with small, repetitive, abstract marks, representational figures were also used as devices for filling the page. Counting only those pictures in which the page was covered edge to edge with representational figures as a major theme, the sample yields 13 of 43, or 30 percent, which, when corrected, falls to 10 of 35, or 29 percent. One of the pictures in question consists of three large human figures. The open space around the figures is filled in with circles.

Children can produce abstract, representational, or mixed (abstract and representational) drawings. These pictures may contain many unrelated subjects or the subjects can be related to each other in a coherent composition. Coherent compositions can be made of abstract and/or real elements. If we call all such coherent designs, including those that contain complex repetitive units, compositions, then 18 of 43 Balinese children (42%) produced such pictures. The corrected sample, in this case, increases the percentage somewhat to 43 percent, or 15 of 35 children.

Simple repetitive marks such as small lines or dots are not included in this tabulation because what look like coherent designs may be produced by a more or less random attempt to fill space by working with marks of decreasing size as a picture progresses toward completion. An analysis of the film material reveals that many of the Balinese children drew in just this manner. Thus, an apparently coherent composition may turn out to be nothing more than an artifact of a process involving the compulsion to fill space and a progressive decrease in the space available as marks are added to the page.

Although many Balinese children did produce compositions, some of which contained realistic elements, none drew what might be called story pictures. When discussing their work after the picture-making session was completed, none of the Balinese children told a story to go with their pictures. This contrasts with Balinese dance, most of which is plot oriented, and painting of both the Bali-life and religious varieties. Adult Balinese art is, in most cases, strongly

connected to the narrative tradition, and shadow puppets, which are art objects even to the Balinese, are used directly to animate stories. It should also be noted that examples of children's art collected by Jane Belo in 1938 (Belo 1970) do contain what appear to be story pictures, since they frequently depict shadow-puppet characters in action. Belo does not tell us, however, what the children said about the pictures she pubilshed. In any case, the realistic subjects that can be picked out of our sample contain the following: mammals (cows? pigs?), fish, crabs, unspecified plants, palm trees, other species of tree, flowers, humans (7 of 43, or 16 percent of the sample), automobiles, birds, houses, helicopters (drawn by one schoolboy of eight), mountains, airplanes (one schoolboy of eight), the sun, stars, letters and numbers (inspired by our film codes placed near the drawing paper), sacrificial offerings, betel, eggs, and various types of fruit. By far the most common realistic forms were birds, flowers, humans and, perhaps because circles come easily and can be easily named, eggs or round fruit.

Balinese children of all ages are taken with color and this is clearly reflected both in their culture and in their pictures. Only 9 of 43 children (22%) produced monochromatic pictures. Of these, two were produced by children who stopped drawing almost immediately after beginning and who simply did not wish to participate in the exercise. When these two cases are eliminated we are left with 7 of 41 children, or only 17 percent of the sample. When the sample is corrected for those children who saw the work of others the total falls further to 5 of 33 or 15 percent. In any case, fully 80 percent of all the Balinese children tested used multiple colors.

The Youngest Children

As already noted, Balinese children are extremely shy with strangers, and the younger they are the shier they are. It was, therefore, impossible for me to get a reasonable sample of very young children. It must also be noted that in both Bali and Ponape the ages indicated are only rough estimations based on parents reports

and my own observations. Bearing these problems in mind, if an estimated 4 years of age is taken as the cutoff for the group of youngest children, the sample yields only 6 boys, ranging from about 2.6 to 4 years of age. This small a sample cannot reveal very much about the youngest age group in Bali, but as the project developed I came to realize that experience is a major element in artistic development. Although it is certainly the case that a kinetic scribbling stage will persist for some time no matter how much experience a very young child has with drawing materials, older children who draw for the first time will produce nonscribbles that compare with the work of younger, but more experienced children. It seems fair then, to count children up to and including 5 years of age, providing these children have had little or no experience with drawing. If this reasoning is allowed, my Balinese sample of young children increases to 17. In order to extract as much information as possible from limited data, each of the pictures produced by these children will be discussed individually.

The analysis of the film material shows clearly how Balinese children produce their pictures through a process of page filling in which larger marks generally precede smaller marks. This process yields pictures that conform to the density and separate element requirement that is so characteristic of adult Balinese art.

B 26 (male, age 2.6, 18 minutes)

B 26 (who saw the work of B 25 discussed below) drew an abstract but obviously not kinetic picture, which is therefore, not classified as a scribble. It is typically Balinese in that it fills the page with medium to small polychromatic marks. It is untypical in that there is some overlapping and building, although this occurs in an overall context of discrete marking. Blue predominates in the center, which consists of up-and-down as well as diagonal lines and some built forms. Green marks, more delicate than the blue, occupy the portion of the page just above the blue and to the left. The very top of the picture has similar marks in red and these continue partly

B 26

down the right side. The right border is finished in green. There are also some yellow traces in the middle of the bottom border.

The film record reveals that this picture began with a blue zigzag on the lower right of the page. The child then moved left across the page, building some forms as he went. He moved back to the right of the page and worked leftward again. The right quadrant was then filled with blue (except the extreme top and side of the page). The child returned to the left bottom and then, shifting to green, he changed to the upper left quadrant. This type of pattern was continued throughout the picture-making process. Towards the middle of the period spent on the picture, this child appeared to gain confidence, as his strokes became bolder and larger. After marks had been made on every part of the page, he began to fill in the remaining open spaces. This was done with yellow at the bottom and red on the top of the page. The child was generally careful not to touch

lines and builds of different colors, and managed to fit different colored marks into the increasingly smaller remaining spaces.

B 10 (male, age 3, 2 minutes)

This picture, produced in only two minutes, is not densely packed, but the design does fill the page. It consists of circles and ovoids. A group of medium-sized ovoids divides the page down the middle and moves off to the left. This group is balanced by two larger, touching circles on the right and the left. The latter are drawn in brown.

The picture was begun at the bottom just to the right of center. The first mark was a complete circle. This was followed by another circle just above it, but not touching the initial mark. The child then worked up the center of the page. Next he moved to the left bottom and drew a series of connected circles, moving rightward to join the central group. Large brown circles were then drawn in the open space remaining on the left side. Finally the child shifted to the right and drew two large circles.

It is clear that this child was experimenting with circular forms repeating the motif as he filled the page. What makes this picture typically Balinese is the filled page, accomplished in this case by the simple repetition of circular forms, which, because of their size and relatively small number, leave a good deal of open space within and between units.

B 25 (male, age 3.3, 30 minutes)

This picture, done by a very young child, is nonetheless typically Balinese. It covers the entire page, is polychromatic, and is very dense. It is drawn with a vast number of short lines, dots, and squiggles (small threads) that fill most of the available space without much touching or overlapping of marks. Red and blue predominate, but green, brown, and yellow are also used.

The picture was begun at the bottom right with a dot, immedi-

B 25

ately extended into a squiggle thread that moved left and then up and back towards the right, thus producing a closed loop. The child worked upward to the left across the page on the diagonal. When he reached the left side he switched to the top right of the page. He then moved back into the upperleft quadrant and began to fill space in that area with fast, definite strokes. As the page became filled the child's performance was dictated by the remaining available space. Large spaces were filled before small ones as he moved back and forth over the surface of the page. Filling space rather than any particular directionality appeared to guide his movements.

B 7 (male, age 3.6, 3 minutes)

This picture is very much like a kinetic scribble and is the only one of its type in the Balinese sample. While the page is filled, as in many other Balinese pictures, the marking consists of large red

B 7

loops and zigzags on the center right side of the page and blue vertical zigzags on the left side. While there is some overlapping of colors, it is apparent that an effort was made to keep the two colors discrete. It is this aspect that makes this picture something a bit more than a simple kinetic scribble.

This picture began with a series of red zigzag threads in the lower right corner. These spiraled outward to the left and then upward. The marks then arched downward and became smoother. At this point in the drawing the child began to circle on the right two-thirds of the page (this activity looks very kinetic). After completing the red area the child changed to a blue pen and began to mark within the red area at its left limit on the page. He then moved outside the red zone to the left and then back toward the right. Finally he marked on the lower left of the page (where there was still empty space available), zigzagged there and ended the drawing by moving up to the top of the page and then down to the bottom.

B 27

B 27 (male, age 3.5, 45 minutes)

B 27 saw B 24, B 25, and B 26 work before he produced his own picture. While his design is similar to that of B 25 it is not similar to that drawn by either B 24 or B 26, even though B 26's was drawn just before his own. B 27 used the same colors as B 25, plus brown (black was the only color he did not use). In B 25's picture blue predominates. In B 27's picture green predominates along with red. Although this picture is dense and covers the page it is slightly more open than that of B 25 and is more delicate than that produced by B 26. Rather than being kinetic it is carefully constructed.

This picture began on the lower right center of the page. The first mark was an uneven green thread moving to the right. The next mark was above and to the right of the first. The child then began to work leftward across the page and, as the space became filled, alternated between left and right, increasing the density of the picture. As he filled the page the marks became increasingly smaller.

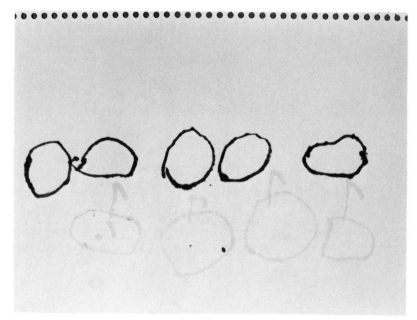

B 33

Threads gave way to small circles and dots as the child searched for empty space to fill. Colors were alternated very rapidly.

B 33 (male, age 4, 7 minutes) B 32 (male, age 5.1, 6 minutes)

B 33's picture is patterned after that drawn by his 5-year old brother. It is a realistic design based on a circle pattern integrated into an overall composition with a single linear orientation. B 32, whose picture served as a model for B 33, drew four circles in blue across the middle of the page from right to left. Each of these circles was drawn in a counterclockwise direction. A fifth circle was added between the first and the second to close the space between them. Stems were then added from right to left across the page. Four green circles were drawn next, from right to left and below the first group. Dots were then placed above these circles. These were also drawn from right to left except for the last dot, which (in order to conform to the overall pattern) was placed over the first circle on the far right.

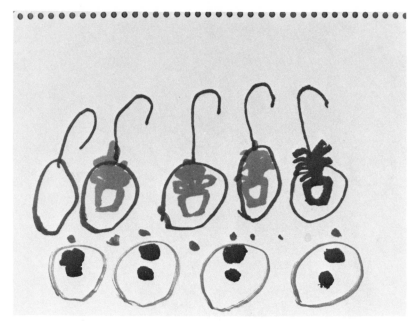

B 32

The child then moved back to the upper circles and placed red "fruit" (the picture was later described as a group of mangosteens, a common Balinese fruit) inside three of the five circles, beginning with the second on the right and moving leftward. Maintaining the consistent right-to-left pattern, brown dots were added to the lower circles.

Although this picture is based on a simple, repetitive motif and consists of few units, it does cover most of the page and in that sense conforms to the general Balinese pattern. This child, unlike many of the Balinese children who produced dense abstract designs, worked consistently from right to left across the page. When a set of units was finished on the left he returned to the right side to begin a new set of units. This consistency contributed to the single linear orientation of the finished picture and helped the child to structure his work.

As already noted, B 33's picture was a "simplified" and less well-organized version of the picture drawn by B 32. A series of blue

circles was drawn across the page, but this time the right-to-left order was not maintained. The first circle was made just to the left of dead center. The second was placed to the left of the first, and the third was drawn to the right of the first. The last circle was added to the far left side. The second row of circles was then constructed below the first row by moving across the page from left to right (the opposite pattern from B 32). Stems were then placed on the circles across the lower row (B 32 had placed his stems on the circles of the upper row), again from left to right rather than from right to left. This drawing covers less of the page than the drawing of B 32. A large open space appears on the upper portion of the page comprising almost one half of the available area. While B 32 filled his page by placing his stems on the upper row of fruit (and thereby marking the available upper space), B 33 placed his stems on the lower row.

B 17 (male, 4.1, 51 minutes)

B 17 produced a typically dense, polychromatic design, which covered the page. Although he made a clear effort to keep his marks discrete, there is some touching and overlapping, as well as some building in this picture. The building appears in the lower half of the page and gives the picture a solid appearance. Green is the predominant color although red and blue stand out in the lower half.

This picture began with a wavy red threat moving right from about the middle of the left edge. A similar mark was added below the first. A third and similar mark was added to the lower left corner. A fourth was then drawn above and to the right, etc. The child then changed to a blue pen and began to work in the center on the right side of the page. Blue marks were expanded by building thick shapes. After building several units with blue the child changed to a green pen. The use of green began as a build above the initial red marks in the center of the page. Some green ovoids were then drawn and filled to match the previously built figures. The child then began to work upward, toward the top left of the page, drawing a series of green threads. As he worked, his marks became less tentative and he filled open spaces with increasing rapidity. As the

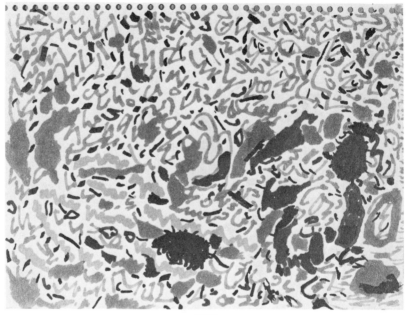

B 17

density of the picture increased he began to search for open space
to fill. While doing this he switched colors (to brown and then yel-
low). He added a few small spots with the brown pen and then
worked between spaces on the vertical with a yellow pen. The pic-
ture was finished with a series of brown spots drawn quickly over
the page in the remaining spaces.

This picture was produced by drawing outward from a single area
and then, as the space became filled, by searching out, more or less
at random, remaining white areas. Marks decreased in size with the
scarcity of available space.

B 4 (female, age 4.1, 4 minutes)

B 4 drew a dense, polychromatic picture that filled the page. Her
major design element was the circle, although she began her picture
with two wavy brown threads drawn downward from the center of
the page. The circles, which were initially drawn in brown, began

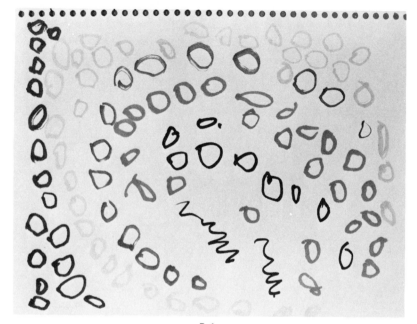

B 4

in the bottom right and moved upward to the left in an arc. When the arc was completed the child followed it back to the right and then changed direction to the left below. She then switched to a red pen and continued to make circles. While circling she changed colors, first to green, and then yellow. As she filled the page, her circles became smaller and tighter. The last color used was blue. The blue pen was used to fill remaining space all over the page with small circles.

B 40 (male, age 4.6, 54 minutes)

B 40's picture is in some ways the most untypical of the Balinese sample. It consists of a combination of partially kinetic polychromatic scribbles made up of long loops that cross one another to fill the page and three human figures. One of the latter is upside down and the larger of the other two is centered on the page in an upright orientation. The third figure is also drawn in an upright position to

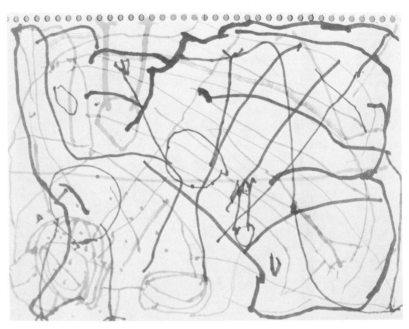

B 40

the right of the second and is much smaller than the latter. Figures 1 and 3 have no arms but do have legs, while figure 2 has arms and legs. In addition, the first upright figure divides the page exactly in half, and runs from the extreme bottom of the page to the very top. The head is placed in the center of the page and the upward movement is completed by the two arms held up over the head.

This picture began with a "half-moon" drawn at the bottom left corner of the page. This was then overstroked several times. Dots were added to this section, increasing its overall density. The child then turned his attention to the bottom center of the page, drawing large ovals and wavy threads. As he worked, his lines became longer and more kinetic. He then appeared to shift gears. The kinetic activity was replaced by the drawing of crude but recognizable human figures. The first human figure is the largest and was placed right in the middle of the page. It consists of a three-quarter-unclosed circle with lines sloping downward to form "trunklegs." Arms were added to this figure by drawing two sloping lines upward from

the head to the top of the page. A small series of red threads was then added to the picture. The other two figures, one in blue and the other in red, and both upside down, were added at the end of the drawing. Both are crude and consist only of round heads and attached legs that drop in parallel lines from the heads. Three stick toes are attached to the bottom of each leg.

B 24 (female, age 4.6, 25 minutes)

This girl was the first of a series of children who saw one another's work. She was the only one of the series to produce an overall composition made up of realistic and "abstract" forms oriented in one direction. Her picture is a dense polychromatic design that fills the page. The major element is a series of what she said were sacrificial offerings (they were actually recognizable as such) made of small red squares filled with green wavy lines, and small, blue, triangular kite-like figures with "tails.") These were also filled with

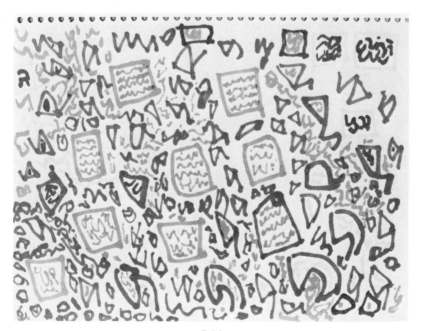

B 24

wavy lines, this time in red. Other shapes appear on the page. Among these are closed and open arclike units. Space is filled with a large number of small threads and dots.

This picture began on the center-left of the page with a square produced with two strokes. Other squares were then added in both red and blue to the left and to the right as well as above and below the original figure. The child then moved down to the lower right of the page and drew a series of closed arc-like shapes, one below the other, and then on the left. Afterwards she switched to the top right corner, where she drew her first triangle, to which a tail was then added. Another triangle was drawn diagonally down to the right. This was immediately followed by a series of such figures placed on the right edge of the page from the top to the bottom. Triangles without tails were drawn next on a diagonal, moving upward and to the left of the page. After this the child began to fill space around the major units with small triangles and M-shaped marks. During this stage the child was careful to keep her marks discrete and there is practically no touching evident, even when they are very close together. As she worked, her marks became reduced in size and her movements over the page became more random as she sought out open space to fill.

B 23 (*female, age 4.9, 2 minutes*)

B 23's picture is a simple design that fills the page with a combination of medium-sized circles in red and yellow and a set of wavy threads in yellow. There is a mass of yellow circles in the center of the page. Four groups of red circles appear at the edges of the page. There is also a group of two red circles within the design to the left of the middle in the center of the page.

This picture was begun with a yellow pen. The child drew her first circle on the lower right of the page. She then moved further right, drawing another circle. Still another circle was added to the left. This series was continued upward and to the left on the page. Yellow wavy threads followed above the group of yellow circles. New yellow circles were then added over the wavy threads across the top. The child then changed to a red pen and drew two red

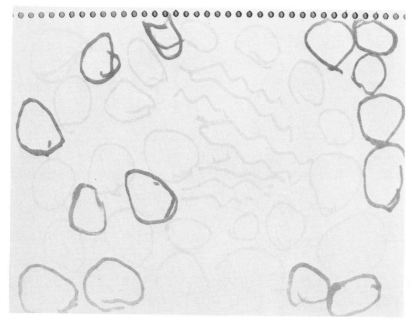

B 23

circles in the lower right corner. Four red circles were added, moving up along the right edge to the top of the page. The pattern was then repeated in the lower left section of the page. The picture was completed on the top left except for the final circle, which was placed to the right of the previous group of two.

As is so common in Bali, this child did not follow a particular direction in her work. Instead, her attention appeared to be drawn first to one zone and then to another as the page became filled.

B 22 (male, age 5, 15 minutes)

B 22 observed the work of B 21 and produced a clumsy version of his 8-year-old brother's picture of helicopters, palm trees, and birds. While his brother used blue and yellow, B 22 used red, green, and brown. He is also the only Balinese child to place one color directly over another (red over green and brown over red). These color overlays followed previously drawn lines. B 22's picture appears not

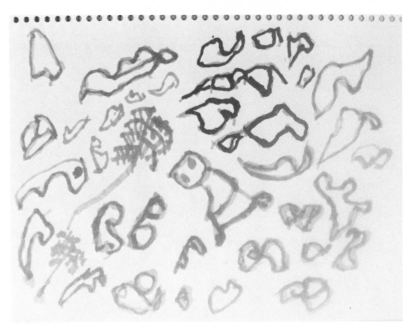

B 22

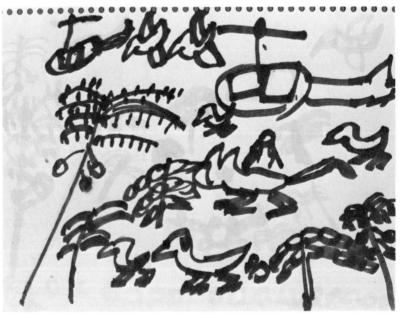

B 21

to have a single orientation on the page. The two palm trees slant upward from the left bottom toward the right, and the human figure, which is larger than the trees, slants in the other direction. On the other hand, the entire picture appears to have a left-to-right diagonal structure. In addition to the clearly realistic elements, it has a series of indefinite closed shapes that serve to fill space so that the entire composition presents the typical page filling seen in the majority of Balinese pictures.

B 22 began his picture by drawing two palm trees in the lower left corner of the page. The human figure (to be discussed in detail below) was then added in the center. These realistic elements were then followed by a series of indefinite forms distributed all over the page.

B 19 (female, age 5, 1 minute)

B 19 observed the work of B 18 and her picture is similar to that of B 18. There are also, however, significant differences between the

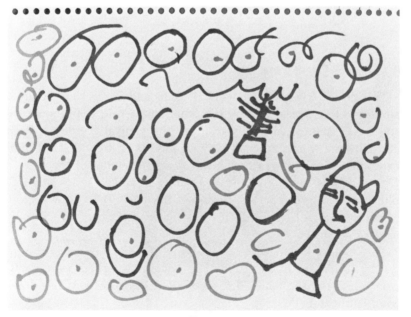

B 19

two pictures. B 18 (an almost-7-year-old girl) produced a series of overlapping and carelessly drawn circles in yellow, red, and green. B 19's picture is made up of discrete blue and red circles most of which have a single dot in their center. This drawing also contains a human figure and a potted plant. Such potted plants are common in Bali. In addition to the circles, dots, and the two representational elements, there are a few half-circles and two threads in the upper right portion of the picture.

The first mark in this picture was a blue circle near the middle of the lower right quadrant. Several more circles were added to the same area. Facial features were drawn in one of these. A closed trunk was then added, followed by the legs and feet. A blue thread was drawn along the center-top and this was followed by drawing the plant. Circles were then placed above and to the right of the plant along with a second thread. The child then filled the upper right with circles that are somewhat smaller than the initial ones. At this point she changed to a red pen and began to fill space on the left side, moving across the page to the right. Finally she drew red circles up the left side in the remaining space. Red dots were then placed in most of the circles.

B 16 (female, age 5, 1 minute)

This child observed the work of B 14 and B 15. Her picture is similar to those produced by the other children in both theme and style. All three pictures depart from the general Balinese pattern and all three were produced very rapidly. B 14 drew a set of monochromatic red birds in two rows across the center of the page. B 17, an almost seven-year-old girl, drew a similar series of birds, plus circles in green across the top of her page. B 16 drew a group of poorly drawn birds and bird-like figures in two rows across the top of the page.

This picture began with the drawing of a small ovoid in the upper left quadrant of the page. The remaining figures were drawn from left to right in a line. The second line of figures was also drawn from left to right.

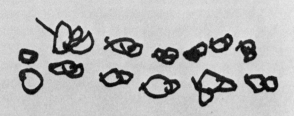

B 16

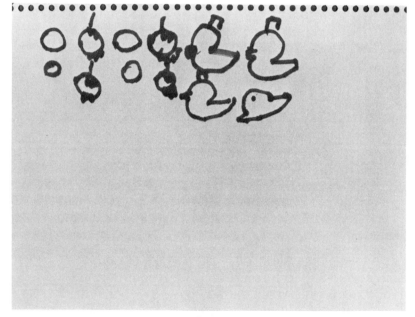

B 15

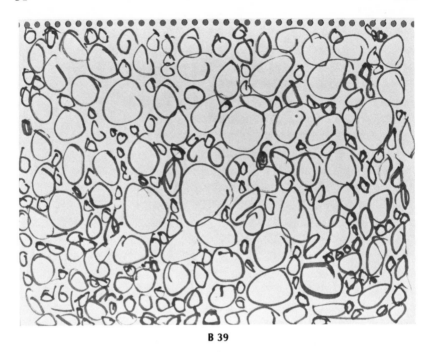

B 39

B 39 (male, age 5, 16 minutes)

B 39's picture is unusual for Bali in that it is monochromatic, but typical in that it fills the page and is quite dense. It consists of a series of blue circles that became smaller as the picture-making process progressed. The first of these circles was drawn in the lower right of the page. The child then moved leftward across the bottom, making circles as he went. After this he moved up and around the outside in an arc. Finally he turned his attention to the inside space, filling it rapidly with circles of diminishing size.

B 5 (female, age 5, 9 minutes)

B 5 observed the work of B 4 and her picture bears some resemblance to it. B 5's picture consists of a series of circles in red, green, yellow, and brown. Wavy threads appear between rows of circles. The picture is framed by a series of red circles, except on the left

B 5

side, where the pattern is continued in yellow. The center of the
page is filled almost exclusively with green circles, plus the threads
that run horizontally across the middle of the page in four rows.
The latter are brown and green.

This picture began with red circles on the lower left of the page
running to the right. When she reached the right edge the child
moved up the right side with the same pattern and at the top to the
left. After moving partway down the left side of the page she
changed to green and drew a single wavy line near the bottom of
the open space. She then began to make green circles in this space,
working from the right and moving leftward across the page. Cir-
cles were interrupted with wavy threads and then taken up again.
Space was filled in this way with yellow, brown, and, finally, blue
circles that were squeezed in along the extreme right side, to the
outside of the previous set of red circles. This picture was drawn
very rapidly and many of the circles touch one another. The overall

impression given by this picture, however, is one of discrete elements.

B 30 *(male, age 5, 13 minutes)*

B 30 was clearly inspired by the film code. His picture is made up of large letter *B*s, numeral *3*s, and kite-like figures with crosses in their interiors. Although there is a good deal of open space in this picture it is polychromatic and covers the entire page. In the latter two respects, therefore, it is typically Balinese.

The first mark in this picture was a red line drawn downward to the left of the center of the page. This line was followed by *3* to the right and a lower case *b* to the left. The child changed to a green pen at this point and drew a circle at the bottom on the right. A dot was immediately placed in this circle. Upper case *B*s and the crossed triangles were added in available space. The center of the page is occupied by a crossed circle with a stem that projects downward from the cross. This figure is similar to the kite figures except that it is round rather than diamond shaped.

B 28 *(male, age 5, 1 minute)*

B 28 was a shy child who appeared to be interested in drawing but was too overwhelmed to produce much of a picture. His is untypical and consists only of a red square slightly to the left of the midline, a brown circle to the right and downward on the diagonal of the previous element, and two yellow strokes that make an upside-down *L* below the circle to the right.

B 31 *(male, age 5, less than 1 minute)*

B 31's picture is a slight attempt by a child who did not wish to draw and who was attracted by our reward. It consists of a single black zigzag running left to right, beginning in the lower left quadrant and passing into the lower right quadrant of the page.

Drawing the Human Figure in Bali

Although no children in this study were asked to draw humans, a small number of Balinese children included such figures in their compositions. Human figures appear clearly in 7 out of 43 pictures (16%), and a single, ambiguous case raises the possible percentage to 19 percent. The youngest child to produce a human figure was 4 years, 6 months old (B 40), while the oldest (B 13) was 7. All depictions of the human figure are crude and compare unfavorably with the sample collected by Belo in 1938.

Three humans appear in the work of B 40 (male, age 4.6). These are all tadpole figures, two without arms, and one with arms projecting in straight lines diagonally from the head. The latter is the largest figure and divides the page in half along the vertical axis. The other two, drawn with the page turned over (they are upside down in relation to figure 2) are smaller. One is drawn on the very

B 13

bottom edge of the page (the top when the picture is oriented in its beginning position), and is to the left of the central figure. The other, the smallest of the three, is on the right side of the central figure. The three humans do not appear to have any compositional relation to each other. There are no facial features drawn in on any of the heads.

A single human appears in the composition of B 19 (female, age 5). This figure appears in the lower right corner of a picture that consists primarily of circles with dots in their centers. This human is a typical closed-trunk type without arms. The head is sur-mounted by a hat, and the face has a well-drawn nose, as well as eyes. There is a hint of a mouth below the nose. Marks above the eyes suggest eyebrows. The legs end in stick feet and there is a red dot in the middle of the body (the rest of the figure is outlined in blue). While the red dot could represent a navel, this is an ambig-uous proposition since all of the circles in the picture also have red dots in their centers. This suggests a common design theme rather than attention to an anatomical detail.

A single anthropomorphic figure appears in the center of the pic-ture drawn by B 22 (male, age 5). It is segmented, with fences be-tween the round head, upper trunk, lower trunk, and the small round feet that project outward from the corners of the lower trunk section. There are no apparent legs, although the lower trunk seg-ment may represent a sarong, which would hide the feet. There are two green eye-dots in the face, but no other features. There are no arms. The figure was outlined in green and later overlayed in red.

Two humans appear in the picture made by B 9 (male, age 5.2). These figures are separate parts of a noncompositional picture that includes two automobiles or trucks and assorted geometrical fig-ures. The humans are oriented with their legs on the horizontal plane, although one is higher than the other. The vehicles are ori-ented on vertical plane, and the geometric figures have an ambigu-ous orientation. Both humans are of the mandala type, with arms and legs projecting from the head. Each of the heads have eye spots, but there are no other facial features. The feet in each case are of the "chicken" type, with short spokes projecting at angles from the bottoms of the legs. Fingers (hands) are drawn the same way.

A single human was drawn by B 34 (male, age 6). It is blue and stands on the very bottom of the page. An animal is drawn in the same orientation just to the right of the human. It is yellow. The rest of the picture consists of banana-like units that cover the page and which appear to follow the general horizontal orientation of the picture. The human is drawn with a round head with two eye spots and a rather thick (built) mouth. The trunk, which is a cutoff triangle, is attached to the head, with the head circle acting as a fence between the head and the body. The left leg is a slightly bowed single line ending in a loop foot. The right leg is two dimensional and ends in a two dimensional L-form foot. The latter is not fenced off from the leg. The bottom of the trunk acts as a fence between the legs and the body. There are no arms.

Human figures are major elements in the picture drawn by B 6 (male, age 6.5). Three large humans occupy over three-fourths of the page. The rest is filled with small circles. This picture was drawn with the page in the horizontal orientation, and, following this ori-

B 34

entation, each figure appears to be lying down. Unfortunately, we neglected to ask the child if the people in his drawing were lying down. The humans in this picture are primitive, but well drawn. The heads are circles, as are the eys, while the noses are single, straight, bisecting lines drawn down the center of the face. The trunks are drawn in two isolated sections. In one figure, each section has a dot (buttons?) in the middle. Legs (two dimensional) are attached below the lower trunk section. Red loops run under the legs to the sides of the lower trunk section in each of the figures. Each figure has "chicken" feet and hands. The three humans are each drawn in one of three colors—blue, red, or yellow. The blue and red figures appear in a field of green dots, while the yellow figure appears in a field of yellow dots. It is, therefore, not as clear in the picture as the other two. B 6 had a particular way of drawing his figures. Unlike most children in Western cultures, he did not begin with a head circle. Instead a small dot was placed on the lower left of the page. A nose line was then drawn, and then another dot (the second eye). These three marks were then enclosed with a circle, making the head. The left side of the upper trunk was drawn next, then the right side. Finally, the upper trunk was closed. The child proceeded to draw the rest of the body in the same fashion, working his way down the figure and adding the arms last. All the humans were drawn with the same kind of stroke sequence, which appears to have been worked out by this child as his way of drawing "formula" humans.

Two anthropomorphic figures appear in the red monochromatic drawing of B 38 (male, age 6.6). The overall picture consists of circles and letters, particularly Ps and Rs, which may have been inspired by the letter B of the filming code placed at the bottom of the drawing book. Every mark on the page is oriented on the horizontal axis. Two circles are drawn at the very top of the page. One of these has two short lines projecting downward from it. The other has what might be a closed trunk with stick legs attached. No features appear in the heads, if indeed they are heads.

A very small human appears in the work of B 13 (female, age 7). The picture, done in two colors (red and yellow), consists of small red circles arranged in an open ovoid pattern across the middle of

the page in a horizontal orientation. A small human figure is drawn with its legs planted right on the bottom of the page. Its head is a circle in which there are two eye spots and a nose line. A closed trunk is drawn below the head and two legs project below it. There are no arms and no feet.

Summary Analysis of Balinese Children's Pictures

Although it was impossible to obtain a truly adequate sample of younger children's work in Bali, the examples I do have reflect an early enculturation to a particular set of rules including page filling, density of design, use of discrete marks or simple units such as circles which generally do not touch each other, and polychromy. The fact that a large number of young as well as somewhat older Balinese children design their pictures in this way and thus conform, at an early age, to a set of cultural rules is somewhat surprising when one considers the fact that Balinese children do not have much, if any, experience doing visual art. Even though Balinese children are exposed passively to the various arts from birth, and many learn to dance and/or to play an instrument at very early ages, young children do not themselves draw, paint, or carve. Even older children do not engage in these activities unless they are apprenticed to an adult artist and such apprenticeships do not begin until the age of nine or ten.

The relative primitiveness of human-figure drawing in Bali contrasts markedly with the apparent complexity of Balinese children's compositions in general. This suggests that the complexity could be a mere byproduct of a compulsion to fill space with discrete marks of various colors. The films tend to confirm this suggestion. While most finished Balinese pictures look complicated, and are, indeed, made up of as many as 350 separate marks, many are highly repetitive and constructed through a process of semirandom marking with increasingly smaller elements. Such a process leads to an apparently complex and harmonious picture. However, none of the designs produced by young Balinese children are complex in the compositional sense and none of the realistic objects, animals, or humans

are drawn with great detail. The only exceptions to this in my collection occur in the work of two boys, each above the age of 8. These children drew coherent, multielement compositions based on realistic themes. Both children attended school and were familar with Western as well as Balinese pictures, and both had had drawing experience in the school context.

Balinese pictures are interesting and pleasant because they are full, colorful, and loaded with what looks at first glance to be detail. They also appear to be balanced and are often oriented in a single direction on the page. These factors tend to give them (or lead us to attribute to them) a strong compositional coherence.

Jane Belo collected a set of drawings by Balinese children at Kuta in 1938 (Belo 1970:240–259). Her sample covered an age range from under 5 to about 10. As she noted in her published report, these pictures are well-drawn and complex compositions. Usually they consist of realistically portrayed *Wyan Kulit* (shadow puppet) figures in actual shadow-play situations. Belo compared the pictures she collected in Bali to pictures drawn by American children of comparable age and was struck by the skill and compositional complexity of Balinese children's art. Her findings thus bring my data into question.

It is interesting to note that the two older boys in my sample, who themselves did have drawing experience in school, produced pictures comparable in complexity and style to those in Belo's collection even though the subjects differed. These children drew planes and helicopters instead of *Wyan Kulit* figures. It might also be noted that *Wyan Kulit* puppets are two dimensional and therefore, perhaps, easier to depict in drawings than real humans. In any case the humans drawn by Balinese children in my sample do not meet the norms seen in my Japanese and American samples. I believe that this difference is due only to a lack of experience among Balinese children with visual art. It should also be mentioned that, realism aside, both Belo's collection and mine show many stylistic similarities that are consistent across a span of over forty years. The birds and helicopters in my drawings are as dynamic as the *Wyan Kulit* figures in Belo's drawings. This dynamism is accomplished in both cases by the use of continuous lines that must have been made

very rapidly. Both samples show evidence of sure and rapid drawing which is supported in my case by the film record. The birds in my sample look particularly like the puppets in Belo's.

The difference between Belo's sample and mine can, I believe, be attributed to the different methods used in making the two collections. I had each child, working in isolation, produce a single picture. Most had little or no drawing experience before they were filmed. I gave the children rather thick felt-tipped pens, which produce lines easily, but which are difficult to manipulate in delicate work. Belo, on the other hand, set up a studio in her home and invited Balinese children to visit and draw for her. Finished pictures, many of which were done in fine pencil, were hung around her courtyard for the children to see and each child worked for several weeks producing a large number of compositions. Belo provides no record concerning the first work done by these children and, indeed, we do not know how long each child worked or how many pictures were finished before the ones Belo used to illustrate her article were chosen. Since my overall study of children's drawing in six cultures show that the two most important elements in drawing skill among young children are experience and exposure to art, Belo's sample and mine differ in very important respects.

PONAPE

PONAPE is a small volcanic island in the Eastern Carolines of Micronesia. It is about ten miles in diameter and has a total population of about 10,000, some of whom are resettled from other islands. Although Ponape had a flourishing visual art tradition, particularly carving, four successive colonial powers (Spain, Germany, Japan, and the United States) have eliminated all vestiges of it except for flowered headdresses. These are produced and worn on festive occasions. There is some local music (a good deal of it influenced by Spanish themes) and the single high school sponsors a folk festival at the end of the academic year at which students from different islands perform traditional dances. A folklore center is located minutes from the capital at Kolonia, where visitors to the island can see a traditional ceremonial house, drink the slightly intoxicating drink known locally as sakao (kava in Polynesia), and watch examples of Ponapean dancing performed to the accompaniment of indigenous music.

During the research visit there was no television on Ponape. Art was not taught in the elementary school, but there was one elective art class for advanced students at the high school. This course was taught by a Peace Corps worker and was taken by about 15 boys between 17 and 19 years of age. These students received a year of practical training in design, drawing, and painting. I attended one of these classes and examined the work of several students.

Drawing, even as an aspect of non-art-oriented elementary-school classwork, is not at all stressed in Ponape. Children in the villages of Awak and Saladek, where fieldwork was carried out, learned to draw only two stereotyped schemas. These were a particular flower (different in the two villages) and a schoolhouse. In filming school

children I soon became tired of seeing the same patterns emerge over and over again. School books are, of course, illustrated and some children have access to magazines in their households, but aside from these pictures, and the movie house in Kolonia, which few children visit, illustrative and artistic pictures of any kind are rare in the child's environment.

The Ponapean Data

On Ponape 43 children drew for the project and all were filmed. They ranged in age from 2 to 13. Older children were included in Ponape because of the observed poverty in the art work of younger children. Twenty-three members of the sample were preschool children (18 from the village of Awak and 5 from the village of Saladek). Of the remaining 20, 15 were filmed in the Awak school and 5 in the Saladek school. All work was done in isolation. Like the Balinese, the Ponapean preschool children were shy, although fewer of them refused to draw for the project. In Awak most of the preschoolers used in the study were related to one another (as siblings or cousins). This is the result of the settlement pattern, which is tied to kinship. In Saladek two families are represented in the smaller sample from that village. The school children in the sample also come from a limited number of families, but this is less true than among the preschoolers because school children came from a wider area.

The average time spent on a picture in Ponape was 8.26 minutes (10.25 minutes for boys, and 6.27 minutes for girls). Eight children worked for 15 minutes or more and 22 worked for 5 minutes or less. Among the younger children (5 years and below) the average time was 8.13 minutes and ranged from 2.5 to 25 minutes. Children 4 years old and below worked an average of 6.3 minutes, with a range of 2.5 to 15 minutes.

The Finished Pictures

Unlike Balinese pictures, most Ponapean pictures are monochromatic. If we eliminate one child from the sample because her mother

Table 2
The Ponape Sample

	Sex	School	Age	Time (minutes)
P 1	f	no	5.0	8
P 2	m	no	3.0	4
P 3	m	no	6.0	5
P 4	f	no	4.0	12
P 5	m	no	6.0	5
P 6	f	no	3.0	4
P 7	m	no	2.0	2
P 8	f	no	2.0	4–5
P 9	f	no	3.5	6
P 10	f	no	3.0	3
P 11	f	no	3.0	3
P 12	m	no	5.0	9
P 13	m	no	6.0	19
P 14	m	no	4.0	19
P 15	m	no	5.0	17
P 16	m	no	5.0	1.5
P 17	m	no	5.0	14
P 18s	f	no	3.0	3
P 19s	f	no	4.0	2.5
P 20s	f	no	3.4	4.5
P 21s	f	no	5.0	5
P 22s	m	no	4.0	15
P 23	f	yes	5.0	8
P 24	m	yes	7.0	9
P 25	m	yes	8.0	5
P 26	f	yes	8.0	20
P 27	m	yes	5.0	25
P 28	m	yes	6.0	30
P 29	f	yes	8.0	2
P 30	f	yes	6.0	20
P 31	f	yes	5.0	9
P 32	m	yes	9.0	10
P 33	m	yes	10.0	7.5
P 34	f	yes	10.0	2.5
P 35	f	yes	9.0	4
P 36	m	yes	8.0	2.5
P 37	f	yes	9.0	>1
P 38	m	yes	13.0	4
P 39	m	yes	12.0	5
P 40	f	yes	12.0	>1
P 41	m	yes	12.0	11

told her to change colors, we find that 30 of 42 children (71%) used a single color (usually red). Among preschoolers, monochromatic pictures were produced by 18 of 22 children (82%).

Nineteen preschoolers out of 23 drew nonrepresentational pictures, most of which, however, are not kinetic scribbles. Of the exceptions P 9 (female, age 6) produced two flowers in the middle top of the page. A boat and a fish were drawn to the right of these. One flower and the fish or boat are red, while the other flower is blue. (This is the child who was told by her mother to change colors.) P 12 (male, age 5) drew what would be a very unusual picture for his age in any Western culture. It consists of a house (schoolhouse?) with a path running from the front door downward towards the bottom of the page. The roof is green, the side of the house blue, the front of the house yellow, and the path yellow. In addition to the use of colors (rare in Ponape), the house is drawn in semiperspective, showing a front-side view. The work of P 12 is more advanced than most pictures in the sample drawn by children up to the age of 13. It is difficult to explain this picture without further information on this child. It could well be accidental, but, on the other hand, it could be the work of a talented child, surprising in Ponape, where no form of visual art is encouraged by parents or teachers. Another representational picture, drawn by P 21 (female, age 5), is not at all unusual. This child was apparently inspired by the letters and numbers of the film code placed below the drawing book. P 21's picture consists of a repetititive design of small semicircles, circles, numbers, and Ps. P 23 (female, age 6) produced a realistic picture made up of multiple human figures, a rare theme in Ponape.

Like Balinese children, Ponapeans do not often overlap lines or, in the case of the few polychromatic pictures, draw one color over another. Only 5 of 43 (12%) children produced pictures with overlapping of either kind and, of these, 3 were kinetic scribbles. When the latter are eliminated, the percentage falls to 5 percent. On the other hand, at least in Awak, but less so in Saladek, the designs of preschoolers tend to be made of connected wholes with few parts separate. This is in marked contrast to Bali. Of the 23 Ponapean preschoolers 13 (57%) drew rather complex designs of this type. Of the 5 Saladek children, 3 produced connected designs, although 2

of these were polychromatic and consisted of grouped zigzags rather than the carefully constructed shapes seen in the Awak sample. This general touching of line to line and unit to unit, along with the absence of multiple colors, are features that strongly differentiate Balinese and Ponapean children's designs.

Equally striking in the Ponapean sample is the general absence of circles as a design element. It appears only in the work of school-children, particularly those from Awak, as a learned part of their version of the Ponapean flower. Among the preschoolers, only one (P 21, who used the film code as a model for her picture) drew circles.

Unlike the Balinese, and, as we shall see, unlike Taiwanese children, Ponapean children do not draw with compulsion to fill the page. Only 11 of 43 (26%) pictures fall into this category. In count-ing this category I was liberal and included even those pictures that had one open corner. Designs in Ponape are also less dense than they are in Bali.

Like the Balinese, but unlike the Taiwanese, Ponapean children tend neither to fill nor to build in their pictures. Only 10 of 43 chil-dren did at least some filling or building and one of these had an American mother. The latter child produced a highly untypical pic-ture. If he is eliminated from the sample only 21 percent of Pona-pean children filled or built, and of these only 5 or 12 percent did so to any marked extent. The filling of a previously outlined figure with another color is also extremely rare in Ponape. Excepting the child with an American mother, only 2 of 43 children (5%) drew in this way.

Again, like the Balinese, most Ponapean pictures, even those that are representational, do not tell a story. Only one child (P 41, male, age 11) drew a story picture. His drawing was a depiction of a sin-gle human taken from a scene in a Kung-Fu movie he had seen in Kolonia.

Ponapean pictures are also low in the number of objects, people, or animals represented. Only the following appear in the sample: schoolhouse or unspecified house, flag, flowers, human beings, fish, automobile (by child with American mother), letters and numbers, boat, palm tree (by older child), table (by older child). After collect-

ing pictures with the repetitive flowers and schoolhouses, I asked the last three subjects to draw anything but these two motifs. If these three are eliminated from the sample, 16 of 17 school children (94%) used the schoolhouse and flower exclusively or as elements in their pictures. Ten of these (59%) used these elements exclusively. Clearly then, Ponapean school children fall back on one or two stereotypic design elements which they have learned to draw. In the chapter reserved for unusual pictures we shall see how one child in Ponape used these simple and repetitive elements to create a particularly interesting and complex picture.

The Youngest Children

As with the Balinese sample, the detailed analysis of pictures from Ponape will focus on the work of younger children, in this case the entire preschool sample. The pictures are interesting because of their nonconformity with developmental norms found in the study of Western children and non-Western children with school experience.

P 7 (male, age 2, 3 minutes)

This child did produce a typical kinetic scribble, in black, in the lower right quadrant of the page. It could have been done by any two-year-old, anywhere.

P 2 began his drawing with an open loop in the top of the lower left quadrant and then circled back to close. The pen was then lifted from the page and what followed was a series of jerky strokes (less sure and deliberate than P 1). These strokes moved outward and downward from the upper portion of the design towards the bottom of the page. Some of these strokes were drawn detached from previous marks, but when this occurred the new strokes were immediately brought back into contact with the growing design. There was some overstroking to make an area denser, but no filling or building per se.

P 7

P 2

P 6 (female, age 3, 4 minutes)

This picture, done in yellow, looks somewhat like an open version of P 2's. It consists of a large series of short marks, most of them lines jabbed onto the page. While some of these marks are independent, most touch and the overall impression of the picture is one of connectedness. The lower two-thirds of the page are covered from edge to edge, and a set of marks run to the top of the left side.

P 6 began her picture on the lower right edge of the page. She moved rapidly along the bottom of the page, producing a series of similar marks. She then moved to the left top and drew a short line. After this tentative mark she moved to the left bottom and worked upward along the extreme edge, finally connecting her design to the previously isolated mark. Her attention then turned to the middle of the design, where she stroked back and forth in a kinetic manner.

When her first picture was done, I asked P 6 to draw a man for me. She took a black pen and drew a series of light, rather vague connected traces down the lower left edge of the page that trailed off to the right. The finished picture, needless to say, bears no resemblance to a human figure. P 6 was extremely nervous while drawing, but she worked on her first picture for four minutes. Her second picture was finished in only one minute. In both cases she held the pen loosely and most of her marks were produced with a light impression. This was apparently her first experience in drawing, yet she did not produce a kinetic scribble.

P 10 (female, age 3, 3 minutes)

Although this picture could be classed as a kinetic scribble, it shares some features with those Ponapean designs described above. It is all of a piece and although it consists of some large loop-like lines that are kinetic in origin, there are also some short jagged marks that are connected into the overall picture.

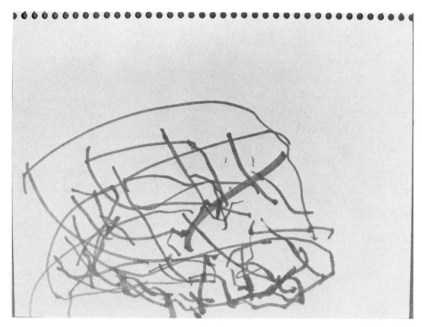

P 10

P 11 (female, age 3, 2.5 minutes)

This picture is a kinetic scribble done in blue. It is particularly dense at the top middle.

P 18 (female, age 3, 3 minutes)

This picture, also in green, consists of small peck-like strokes that develop from a single starting point. It is very dense and occupies about one half of the lower right quadrant of the page.

The first mark in this picture was an ovoid drawn in the lower right of the page. The child moved further right with a series of light, close, crisscross strokes. She worked rightward and a bit upward. She then returned to her first mark and brought it back into what was then the main body of the picture. This led to an obscuring of the first mark by some filling and building beyond the orig-

P 18

inal limits of the ovoid. The density of the picture was increased by moving left and then right over the existing design, adding marks across the previous ones.

P 20 (*female, age 3, 4.5 minutes, village of Saladek*)

The picture is similar to that drawn by P 19. It consists of long zigzags across the page. The colors in this case are yellow, red, green, and brown. It occupies the lower half of the page from edge to edge.

The drawing began with a yellow zigzag in the lower right quadrant. Similar lines were drawn in red on the right and then on the left. A green line was then drawn above from the left side. Blue zigzags were drawn in the lower left-hand corner and the picture was finished with a long brown zigzag thread over the top. This drawing was finished very rapidly with little connection made between elements. Instead the same type of mark was repeated in different colors as if the child were experimenting with color.

P 20

P 22 (male, age 3 or 4, 15 minutes, village of Saladek)

This monochromatic (red) picture displays a mixture of character-istics. It is dense and consists of a large number of small units that cover the entire page. These units are composed of touching marks made of both straight and curved lines. There is also some thread-ing present. Some units are ladder-like in construction and many units touch each other. Ovoids are present in the design but do not predominate. There is also a small amount of filling and building present in the drawing.

P 22 began his picture in the bottom of the lower right quadrant, making two small hill-like marks. Loops were added to the bottom of each mark, closing them. The child then moved leftward and drew another curve. The next mark appeared at the top of the page on the left. He then drew a line down the left side. At this point all the marks touched one another. The child turned his attention to the left once more. This time he drew an independent circle. Next he

P 22

drew inside this circle and, filling space, connected it to previously drawn marks on the page. He then moved to the right side, filling the lower right with a set of marks of indefinite shape. The overall technique used in making this picture was quite similar to that employed at Awak. The child either drew by moving outward from existing marks or, when making independent marks, connected these marks back into the existing design.

P 4 (female, age 4, 12 minutes)

This child began to draw with her left hand and switched back and forth between left and right all through the drawing session. This picture, done entirely in red, is strikingly like P 1's in design and composition although it covers almost the entire surface of the page and is, therefore, more expansive. It is made of a series of rectangular shapes and slightly looping units that are rather open

P 4

on the right side and comparatively dense at the left bottom. Longer lines are used on the top and right side than on the left.

P 4 began her picture with a line drawn to the right in the lower left quadrant of the page near the midline. The next mark was a line downward to the left of the previous mark. For some time the girl worked in the lower left corner of the page, covering it with what was to become the densest part of the picture. She changed her focus next and moved to the top of the established design. There she continued to extend her picture outward to the right with a series of marks. Most of these consisted of units that closed on previously drawn units. As she worked she increased her pace and at the same time her lines became longer and units more open. When she reached the top of the right side she changed from her right to her left hand. After some time on the right of the page, using her right hand, her attention returned to the left and she switched back to her left hand. Later, when she moved back to the right side of

the picture, the pen was again changed to the right hand. In addition, as the page began to fill up, the child tilted it onto the vertical so that the right side became the top.

P 14 (male, age 4, 19 minutes)

This picture was slowly and carefully constructed. It covers most of the right half of the page and was done with a green pen. It is most dense at the right top, somewhat less dense below, and the least dense in the left section. It is constructed of small attached and semiattached strokes in the right portion and longer horizontal and vertical lines in the left portion.

The picture began in the lower right quadrant. The first mark was a thread that changed direction twice. The picture was expanded outward and downward in typical Ponapean fashion. After covering the right portion of the page with rather dense marks the child moved to the left with a large rectangular stroke, beginning at the

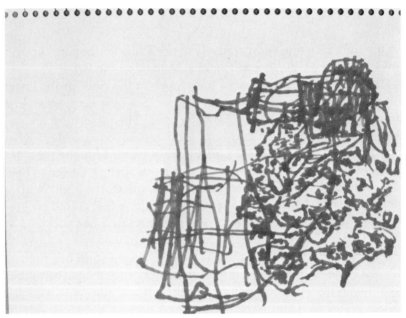

P 14

top and moving leftward. It then was turned down and back into the original design. P 14 then began to work inside the newly de-limited space, continuing with the same type of horizontal strokes.

P 19 (*female, age 4, 2.5 minutes, village of Saladek*)

P 19 produced the first of a small series of drawings by children from the village of Saladek. Her picture differs generally from the Awak series by its polychromy (red, yellow, and green are used), because it covers most of the page, and because it is made up of separate but connected sections each consisting of a single color. This picture was produced more rapidly and is more kinetic than the majority described above. It was drawn by covering large areas with zigzag threads of different colors.

The picture was begun on the right side of the lower left quad-rant. A red zigzag thread was followed by a similar but longer thread above it and to the right. The child moved back and connected her

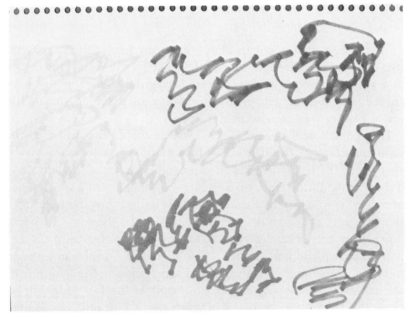

P 19

first mark to the second mark. Changing to a yellow pen, she repeated the pattern above the red, running across to the left side of the page. The entire left side of the picture was completed with a single stroke. After this stroke the child changed to a green pen and drew a new zigzag across the top to the right. The picture was finished with a single similar mark down the right side. The overall effect of this picture, except for the fact that it was done in three colors, is a pattern of connected zigzags. The method of attack was totally different from that seen in Awak and the types of lines and marks produced were also new, but the Ponapean pattern of connecting the parts of a design was followed.

P 8 (female, age 4 or 5, 2 minutes)

This child produced a connected design that is described as a semiscribble. The work was kinetic but not frenetically so.

P 1 (female, age 5, 5 minutes)

This child's picture covers about three-quarters of the page, with two open sides (more space on the left than on the right). It consists of a set of connected rectangular and irregular shapes (many with curved lines, but not circles) that form a vague diamond shape. The entire picture was done with a red pen.

This picture was begun in the extreme top of the center of the right quadrant of the page. The first mark was a line downward slanting to the left. The child then moved back to the top and drew a small curve to the right from the top and then, with a small series of marks, closed her first unit. She then returned to the bottom of the first unit and drew another unit closing on the first. This was down from the bottom right of unit 1 upward. Her third closure was added on the left of unit 1. The picture continued to grow in this way, sometimes on the right and sometimes on the left. In general it developed downward and outward at the two sides. In all cases the technique consisted of contructing one unit on another each closing on the previous unit. At the end of the drawing ses-

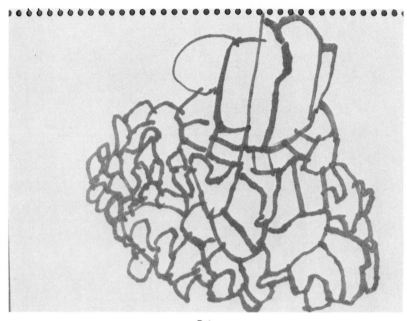

P 1

sion the child's marks became smaller as she made a rather tight series of closed shapes to the left and halfway down the design.

P 12 (male, age 5, 8.5 minutes)

This child drew the picture of a house and a path, described above. It is, as already noted, quite atypical for Ponapean preschoolers in every respect except the chosen subject. It is polychromatic (blue, green, and yellow, which are filled into a brown outline). The most striking thing about this picture is the representation of perspective which it shows.

The picture was begun with the drawing of the roof. The front triangle was drawn first, to be followed by the long ridge line at the top. This line was drawn from left to right. The next mark was drawn downward, forming the back diagonal of the roof. The bottom roof line was then drawn leftward. The front side of the house was drawn next. A single stroke was added, across the bottom of the house,

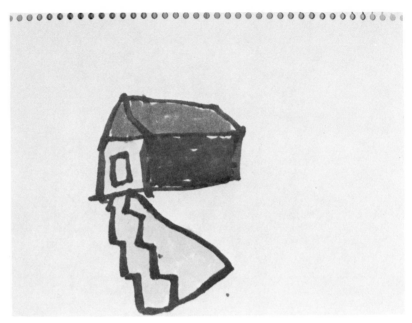

P 12

which turned upward on the right side to finish the outline. The outline of the path was then drawn and after this both the house and the path were filled in color. This began with a green fill on the roof.

P 15 (male, age 5, 17 minutes)

P 15 drew a picture that is in some ways more Balinese than Ponapean. The entire page is covered with dense, rather small units, many of which are independent of each other and do not touch. On the other hand the film record reveals that many of these units were drawn by connecting marks to each other. Thus the picture is constructed of separate units rather than of separate marks. In this sense it is closer to Taiwanese pictures than to those drawn in Bali.

P 15 began this picture in the middle of the page at the bottom. Initially he moved up toward the right and then down along the bottom with small "letter" forms. He then changed to the upper

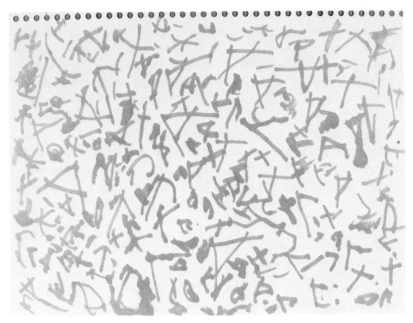

P 15

right center where, working within a small area, he produced a set
of small units. He then changed to the left side and worked across
the top toward the right. At the end of the drawing he added some
small ovoids to a pattern which up to then had consisted of short,
connected straight lines. There was also some building at this point,
but it was restricted to a very small space within and around exist-
ing units. The child finished the drawing by rapidly moving back
and forth on the page, increasing the density of the overall design.

P 16 (male, age 5, 1.5 minutes)

This product seems to be an incomplete drawing by a shy child
who was not happy with the drawing experience. It consists mainly
of a large ovoid, flat on its right side, in the left-middle bottom of
the page. There are also a few small dots just to the right and slightly
above the ovoid.

The picture was begun in the middle of the page at the bottom.

The first mark was a single line up from the bottom. The second mark was a line going left from the top of the first mark. The third mark was a line diagonally right from the previous mark. This was followed by another line that moved diagonally left and upward. The ovoid, not yet apparent, was formed and closed by an arc to the left, which moved down to the right to close. The dots to the right of the ovoid appear to have been made accidentally as the child inadvertently touched the page with his pen. The ovoid in this picture is clearly not a spontaneous and well-formed unit. It emerges in the picture after a series of more or less straight lines is drawn. The fact that the ovoid closes back on itself is a hint of the general Ponapean pattern rather than the result of a desire to draw a ciruclar unit.

P 17 (male, age 5, 14 minutes)

This green picture is similar in construction to that of P 15. It is a dense design that covers the page and thus recalls Balinese pictures. Like P 15, however, P 17 drew a picture in which the page is filled with compound units rather than single marks.

P 21 (female, age 5, 5 minutes, village of Saladek)

This picture is the only example from Ponape that is made up largely of circles and unclosed ovoids. It may represent an attempt at writing and may have been inspired by the film code. Like most Ponapean pictures, it is monochromatic, in this case red. Unlike the typical Ponapean picture, it covers the page from edge to edge and consists exclusively of the independent marks that do not touch. It is, regardless of the single color, most like the Balinese pictures of any work in the Ponapean sample.

P 23 (female, age 5, 8 minutes, village of Saladek)

This child's picture, like the majority of those drawn in Ponape, is done with a single color, in this case brown. It consists entirely

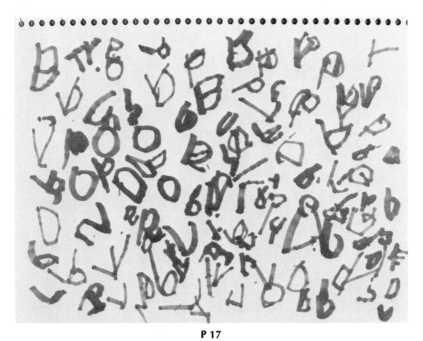

P 17

of human figures drawn more or less in the same orientation on a
vertically placed page. P 23 is the sister of a local school teacher,
who informed us that she had never drawn before. One sees in this
picture and particularly on the film record how a child, in the space
of only a few minutes, can develop some sense of how to draw an
acceptable human figure. This picture will be discussed in depth
below.

P 3 (male, age 6, 5 minutes)

This is an unusual picture (aesthetically pleasing to many Amer-
icans who have seen it), yet it tends to follow the pattern already
seen in the work of P 1 and P 2. It is monochromatic (red). It fills
the center of the page from the top to the bottom, although the
bottom of the design is denser than the top. This is a common fea-
ture of abstract designs from Bali and Ponape. If a design has an

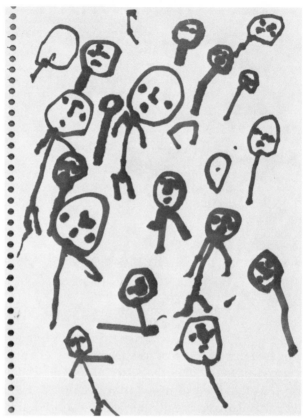

P 23

uneven density, the bottom is usually denser than the top. This produces designs that appear to have a certain aesthetic "stability," at least to Western eyes.

The picture consists of a large, empty, red square with small triangular loops at each corner to which a series of triangular, rectangular, and jagged ovoids are connected. Compositionally, this picture is made of a large open square resting on a foundation of connected jagged marks.

P 3 began his picture by drawing a line down on the left of the page. The second mark went from the top of this line to the right.

P 3

The third mark was a line drawn from the bottom of line 1 to the right. The fourth line closed the figure from the top right to the bottom right. As soon as the rectangular shape was closed, small triangles were added to the lower right corner, the right top corner, the left top corner, and the left bottom in that order. The child's attention then turned to the bottom of the page where a series of detached forms were drawn from right to left across the page, and then on a line below the first such group, and so on. The second row shows a mixture of detached and attached figures and the third line, which was done from left to right, consists (with one exception) of attached marks. The overall impression, as noted above, is of a series of attached marks. The picture was finished when the child moved into a small open space in the middle, directly below the large rectangle, drew a small triangle, and connected the overall pattern to the bottom set of marks.

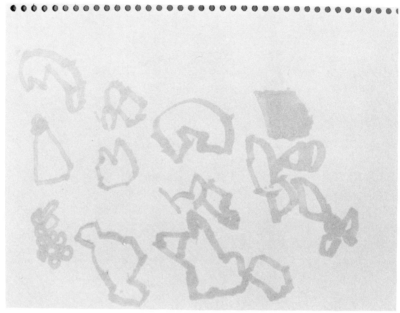

P 5

P 5 (male, age 6, 5 minutes)

This picture, a typical in form, was done exclusively in yellow. It is made up of a series of medium closed blobs of indefinite shape and two or three flower shapes. Most of the blobs are independent of each other and one is filled.

The picture was begun with the drawing of a small flower in the lower left of the page. The flower, typical of Awak school children, began with a circle to which circular petals were added around the center. After the flower was completed the child moved rightward and drew a closed blob. The next move was to the right, but upward on the diagonal. The child continued to mark in this direction with a series of similar blobs. He then drew a rectangle in the upper right quadrant of the page, next to a previously drawn blob. This was filled. A dot was then accidentally made below the filled rectangle and immediately elaborated into a unit. The page was then filled

by moving back and forth on the page, producing a set of similar shapes in a fashion reminiscent of Bali in motion but not in form.

P 9 (female, age 6, 3.5 minutes)

This is the child whose mother suggested that she change colors during the drawing session. Her picture consists of a red and blue flower in the top center of the page and a red "fish-boat" on the right.

P 13 (male, age 6, 19 minutes)

This picture, completed in what was a long time for the young Ponapeans, is unusual in that it consists of a densely filled mass in two colors (green and black).

P 13 began this picture in black with a series of connected semi-

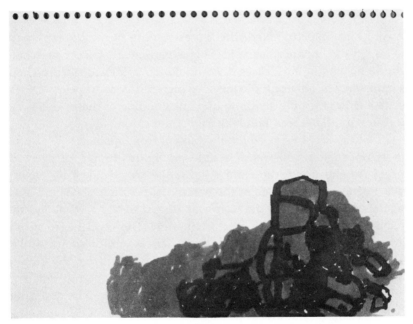

P 13

rectangular boxes near the midline of the right quadrant. The picture then grew outward and downward with "ameboid" movements in both directions. The Ponapean pattern of extending the design by moving outward from an existing portion of the picture or connecting back to previous marks was maintained. Toward the middle of the drawing period the child began to fill some of the rectangles he had previously drawn. At first these fills were done in black, but eventually he changed to green and continued until the end with this color. Eventually the green fills began to flow outside of the original black outlines. This filling and building is not typical of Ponapean picture making. The underlying pattern and the means by which the picture was drawn do, however, conform to the general scheme by which most Ponapean children in the sample made their pictures.

Drawing the Human Figure in Ponape

As I have already noted, the representation of the human figure is rare in the Ponapean sample. This is particularly true of preschool children, who in most cases drew no humans. Indeed the preschool sample shows only one picture in which a human appears. Of the school children, only six drew humans and one of these (P 27) was the son of a Ponapean father and an American mother.

Of all the pictures in which the human form appears P 23's is the most unusual. It consists of a series of figures drawn all over the page. As she drew, the child's technique improved. This picture was begun with the page in the horizontal position. After the completion of two humans the page was turned to the vertical and the picture was finished with this orientation. The child began in the lower right quadrant. She first drew a circle with a single stroke. This was followed by a single line running down from the bottom of the circle. Next she added a right eye spot, a mouth dot, and finally a nose line. After experimenting once more with the same type of schema the child drew another, similar human, but this time added arms just below the head. By the end of the drawing she had added a new set of figures with legs attached to the bottom of the

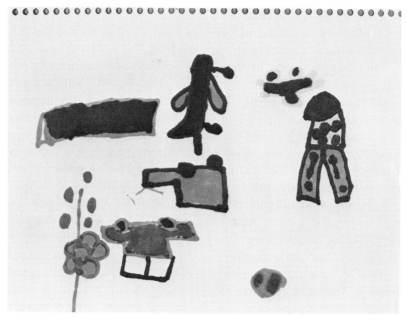

P 27

body line and had thus produced well-formed stick figures. Look-ing at the film one can see that this child began with no clear idea of how to draw a human and that the important parts for her were the head and the trunk. To this basic schema she added arms and later legs. The fully evolved stick figure was drawn in the following order: She began with a head circle (as in her first drawing). Next came the body line. This was followed by the legs (right and then left). The right and then the left arm was added to the trunk. Re-turning to the head she drew in the right and left eye in that order, added the nose line, which was elaborated by drawing another mark from the bottom of the nose to the right, giving the face the ap-pearance of being in profile. The last mark in the face was the mouth, represented as in all her figures by a dot. As the page became crowded the child reverted to her original simple figures con-structed only with a head and a body line. These later figures were fitted into the remaining available space. The latter pattern is con-sistent with data reported by Goodnow (1977), who has shown that

children do not often cross lines over one another. Once space has been filled children tend to leave out elements that they might otherwise put into a picture.

The other Ponapean pictures in which the human figure is represented are in the expected range for children with little drawing experience. It might be noted, however, that the low frequency of drawings of humans in Bali and Ponape suggests that the spontaneous drawing of human figures is not necessarily common in children's art. The fact that many of the experiments with drawing by children have involved the human figure has led to certain biased generalizations about the popularity of such subjects.

P 29, an 8-year-old girl, drew two humans in yellow as part of a monochromatic picture which also contains five separate flowers. All the realistic elements in this picture are oriented on the horizontal plane. The human figures consist of the same basic schemata. The head is a simple circle with eye spots (neither nose nor mouth is used). The trunk is drawn as a triangle projecting below the head. Two-dimensional legs are attached at the bottom of the trunk triangle, and two-dimensional feet are attached to these legs. The placement of the feet indicates that the figures are to be seen at least partially in profile. In both cases the feet project off to the left. Stick arms are drawn projecting from the intersection of the head and the upper trunk. There are no hands.

P 32, a 9-year-old boy, drew a picture consisting of two lines of objects arranged in rows along the horizontal plane. The upper row contains four green figures in outline, two of which are humans. The lower row consists of three figures in red, one of which is human. Each of the three humans is drawn in a different manner, suggesting that this child had no fixed schemata for human-figure drawing. The first human to be drawn is also the most primitive, the second is intermediate, and the last is the most advanced. The first consists of a head circle with two eye spots and a nose spot, a trunk triangle, stick legs, and stick arms. The arms are misplaced and project from the bottom of the trunk triangle to the sides of the legs. The second human is a well-formed closed-trunk figure. Stick arms are correctly placed on the upper section of the trunk, which

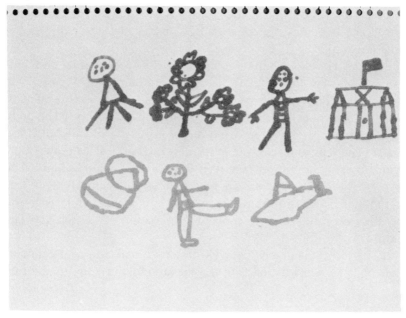

P 32

is itself divided into three sections with horizontal lines. The third human drawn by this child is quite different from the other two and suggests greater confidence as well as a willingness to experiment. It is drawn in full profile and in action. The head appears in full face and has a mouth. The body is drawn as a closed trunk at the bottom of which there is a short fenced-off section that could be the lower trunk separated from the top by a belt. The legs are drawn in two dimensions, are wider at the top than at the bottom, and one of them projects outward from the body in a full kick. The feet are also two dimension and point off to the right of the picture. The stick arms project from the sides of the trunk.

P 35, a 9-year-old girl, drew a circular design composed of separate red flowers surrounding a schoolhouse. Three human figures also appear in the circular pattern. One is on the right of the picture and the other two are on the bottom. One human is a full stick figure, with hair drawn on the head. The second is a similar stick

figure, but without hair. The third has a triangular trunk but no arms. The two stick figures were drawn after the one with the triangular trunk.

P 43, an 11-year-old girl, produced a set of yellow objects including a table, an animal, a fish, a tree, and a girl in a dress. The human is rather well formed. The head has a full complement of features drawn as dots. Hair is drawn on top of the head. The body is realistically presented in two dimensions and is pinched in at the waist. The legs and feet, the latter of which appear to project outward toward the viewer, are well drawn in two dimensions. The arms curve to the sides and are held behind the back. All in all, this is the most successful human drawn by a Ponapean child with the possible exception of the action picture made by P 41, an 11-year-old boy.

P 41's picture is of a single well-drawn human. It is as detailed as that of P 43. Dotted lines are drawn around the arms to indicate

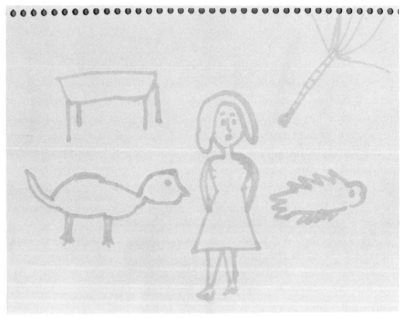

P 43

motion. The picture was inspired by a Kung-Fu movie this boy had seen in Kolonia.

Summary Analysis of Ponapean Children's Pictures

The majority of pictures by preschool children in Ponape are drawn by working outward from an initial mark or set of marks. Sometimes separate marks or units are drawn on different parts of the page, but these are usually soon connected back into the main body of the work. When a picture is made in this way it tends to move outward in an "amoeboid" fashion. If the picture begins on one side of the page, the outward flow will tend to be across the page. When it begins in the center, the picture will develop in all directions from the core design. When the picture, in the beginning stage, contains separate elements that are later connected into a coherent whole, the child tends to work back and forth, looking for open space to fill. This may be one reason why pictures of this second type tend to cover the page in contrast to the first type, which leave a good deal of open space. Since most of the Ponapean children work outward from their initial mark and do not return inside their designs (except to connect already existing elements together) there is little tendency (in contrast to Bali) to make smaller and smaller marks as the picture progresses toward completion.

The general lack of artistic experience among Ponapean children, combined with a lack of passive aesthetic stimulation, apparently leads to a rather impoverished vocabularly of visual forms in their drawings. When they draw they tend to play safe with a few formulae and to build their pictures out of these. Up to about the age of eleven most school children in Ponape find it difficult to draw anything but the simplest schemas, and most of them fall back on the two they have learned at school. These are the almost ubiquitous schoolhouse and flower. In the light of this poverty it is important to note that with the exception of the very youngest children none of the Ponapeans in the sample engaged in kinetic scribbling. After the age of two or three kinetic scribbling gives way to the kind of picture making described here. It is also striking

that circles are rare in the abstract designs of Ponapean children. Although kinetic scribbles are often made in a circular pattern that reflects a common form of muscular activity, and because the first designs grow out of kinetic scribbling, one should expect to see circles in the nonrepresentational pictures drawn by young Ponapeans. Yet in Ponape, once scribbling ends, circling ends as well until it is revived in the school, where children learn to use it in the drawing of flowers.

In Ponape little attempt is made to represent and there is very little in the culture to stimulate representation. Most of the children in this study appeared to enjoy seeing some kind of design flow from the pens. On the surface it might appear curious that many of the preschool children in Ponape produced more complex pictures than their school-aged peers, at least if complexity is measured by the number of marks on the page and the degree of connectedness among marks and units. Such complexity, however, derives in almost all cases from a rather simple repetition of basic patterns that are followed as the picture unfolds on the page. School-aged children in Ponape are limited by the little they know of drawing. They have learned that drawing means the production of two stereotypic patterns. Interestingly, a few of these schoolchildren used their limited artistic vocabulary to produce pleasing designs of rather high complexity and startling beauty. The most striking of these pictures will be discussed in the chapter on unusual pictures.

In the course of the research in Ponape, I filmed one child (P 27) who produced a picture quite unusual by Ponapean norms. This 5-year-old drew a picture with varied subjects, including the expected flower and schoolhouse, but also a green plant, three automobiles, a human, an airplane, and an indefinite figure. The subjects are outlined and filled in different colors and are well drawn. The realistic elements do not appear to have much relation to each other and are, in fact, oriented in different directions on the page. The human figure, the flower, and the schoolhouse are on the horizontal plane. The airplane appears on the vertical plane, and the three automobiles are upside down in relation to the human, flower, and schoolhouse. One automobile is outlined in blue and filled in red, one is outlined in red and blue and filled in green, while the third

is outlined in yellow and filled in blue. The human figure is clothed in a yellow shirt and red pants, both of which are decorated with blue spots. The airplane is drawn in red and filled in red (the wings) and blue (the body and wheels). After this child had finished his picture I was relieved to find that his mother is an American married to a Ponapean and that he draws a good deal at home. He stands in the Ponapean sample as the exception that proves the rule.

TAIWAN

CHINA, of course, has a long heritage of art. When the Nationalist government left the mainland it took with it an impressively large and impressively fine collection of art that is now housed in the Imperial Museum of Taipei. This collection is so vast that, even though about one-third of the museum's exhibits are changed every few months, it will take many years for the cycle to be completed. In addition to the treasures of the Imperial Museum, the National Historic Museum, also in Taipei, has a large collection noted in particular for its Tang Dynasty clay sculptures. Both museums are visited by school groups and are considered important aspects of national pride.

On the level of popular culture, particularly visual stimulation, Taiwan is well served by a host of institutions. Taiwan television is very active and most homes, even the poorest, have a color set. Magazines and newspapers are plentifully illustrated and movie houses are common in the larger cities. On the other hand, folk arts have tended to decrease in importance. Live theater and such performances as puppet shows and festivals have fallen out of fashion. The Taipei version of the Peking Opera is forced to exist on a subsidy from the army. Its performances are attended primarily by old and middle-aged people. Art is not emphasized in the school curriculum. Instead young children are encouraged to learn elementary Chinese characters even before they begin school, and children's intelligence tends to be judged on the basis of how many characters they have learned before entering school. As far as we were able to discern, few if any children are encouraged to draw or paint at home. Several of the preschool children in the Taiwan sample had never done any art work before we had them draw for us. On the other

hand, all had had some experience with writing simple Chinese characters.

Taipei is a colorful city. Its many stores, shops, and restaurants are decorated with modern and traditional Chinese designs and brightly painted signs. Taipei's temples and shrines, as well as those of other cities, are painted in blue, red, green, and gold. They all contain a larger number of painted wooden statues of gods and ancestors. In contrast, the small village just outside of Taipei in which this study was done is quite drab. Small houses cling to narrow streets. There are few flowers and the local stores are rather unobtrusive. Village temples are small and less decorated than those in the city, although they do contain the usual complement of painted statues, some of which are impressive. It is unlikely that the younger children of this village go into the city very often, but they are exposed to television in the home. The homes themselves often are decorated with photographs, and a few Chinese scrolls can be seen hanging on the walls of the living or dining rooms. The house in which my study was done had a large tiger scroll on the wall of the room in which children drew.

The Taiwanese Data

Forty Taiwanese children participated in the project and all were filmed. They ranged in age from 2.4 to 7 years. Twenty-one had no school experience and 19 were in either kindergarden or first grade. The sample was composed of 21 boys and 19 girls. All the children agreed to draw and all completed at least one picture. A very few asked to begin their picture again and were allowed to do so. The average time spent on a picture was 15.43 minutes with almost no difference between girls and boys. Of the 19 schoolchildren, 11 worked 15 minutes or longer and only one worked less than 5 minutes. (This child's picture was completed in 3 minutes.) Among the preschoolers, eight worked 15 minutes or longer and only one worked 5 minutes or less. (This child's picture was completed in 2 minutes.) In general, the Chinese children appeared to be particu-

Table 3
The Taiwanese Sample

	Sex	School	Age	Time (minutes)
C 1	f	yes	6.5	10
C 2	m	yes	6.0	7
C 3	f	yes	5.8	3
C 4	m	no	5.10	16
C 5	f	yes	6.5	21
C 6	f	no	4.7	10
C 7	f	yes	4.7	37
C 8	m	no	4.4	7
C 9	f	no	4.6	11
C 10	f	no	4.8	10
C 11	m	no	5.2	24
C 12	f	yes	6.0	15
C 13	f	yes	6.8	18
C 14	f	yes	6.9	13
C 15	f	yes	6.0	15
C 16	m	no	2.5	15
C 17	m	no	2.4	8
C 18	m	no	5.0	26
C 19	m	no	2.7	10
C 20	f	no	5.2	8
C 21	f	no	3.5	6
C 22	m	no	5.3	35
C 23	m	no	2.7	9
C 24	f	no	5.4	12
C 25	f	no	5.6	2
C 26	m	yes	6.10	6
C 27	m	no	4.7	7
C 28	f	yes	6.9	6
C 29	m	yes	7.0	5
C 30	m	no	4.4	28
C 31	f	yes	6.8	19
C 32	m	yes	5.8	8
C 33	m	yes	5.7	15
C 34	m	yes	5.2	28
C 35	f	no	4.2	27
C 36	f	yes	5.8	30
C 37	m	yes	6.9	10
C 38	m	no	3.9	9
C 39	m	no	4.5	38
C 40	m	yes	6.0	33

larly wrapped up in their work. The time range for all the children in the Taiwan sample is 2 minutes to 28 minutes.

The Finished Pictures

Like those of the Balinese, the Taiwanese pictures are generally polychromatic. Of the entire sample, 31 of 40, (78%) were done in multiple colors. Among the preschool children, 14 of 21 pictures or 67 percent, were polychromatic. Among the schoolchildren the percentage rises; 17 of 19 children used several colors (89%). On the other hand, of the monochromatic pictures, 7 out of 9 (78%) were done by preschoolers. Clearly schooling has an effect on color use.

Again, like the Balinese pictures, those from Taiwan tend to be dense and to fill the page. Examining first all the pictures that filled the page or which had only one open corner, we find pictures by 16 of the 21 preschoolers (76%). Among the school sample the percentage falls considerably. Only 8 of 19 school children (42%) drew pictures of this type. In general, those children who had a year or more of school tended to draw rather stereotypical compositions that were organized according to one or another realistic schema. Because these children had not reached the ground-to-sky filling stage in landscape pictures, their work tends to show a considerable degree of blank space between elements. The degree of open space falls when the picture is not a complete composition but a group of objects or a design based on a single or small group of repeated identical objects.

Returning to those pictures that did fill the page, but eliminating those with considerable unfilled space (in other words, including only *dense* designs that fill the page), we find that 18 of the total sample of 40 or 45 percent fall into the category of dense full pictures. This pattern is much more common among preschoolers than it is among school children; 13 of 21 (62%) preschoolers drew designs of this type while only 5 of 19 (26%) schoolchildren produced equivalent pictures.

When we look at the use of obviously realistic elements we find that 27 of 40 children (68%) chose realistic motifs for at least part of

their pictures. Nine of 21 preschoolers (43%) drew this way, while 18 of 19 schoolchildren chose to use realistic elements. Thus, in the school sample only a single and very young kindergarden child (4 years, 3 months old) drew a totally abstract design. This design, it might be worth noting, filled the page and was very dense.

Schooling also appears to have a strong influence on composition. Forty percent of the total sample produced what can be classified as coherent compositions. Such compositions are defined here as those in which multiple elements are logically and compositionally related to each other. Of all the coherent compositions in the sample only two come from preschool children. These constitute only 10 percent of the preschool sample. In contrast, 14 of 19 schoolchildren or 74 percent produced coherent compositions.

A substantial proportion of Taiwanese children drew humans. Among the school sample, 11 of 19 or 58 percent used the human figure in their compositions. Only 5 out of 21 or 24 percent of the preschoolers did so. If we substract the number of kinetic scribblers from the preschool sample, the percentage of preschool children using human figures in their drawings rises to 38 percent. This stands in marked contrast to both Bali and Ponape.

Those Taiwanese children who used realistic elements in their drawings, whether these were coherent compositions or not, oriented all such elements on the horizontal plane. All figures were drawn proper side up.

In Taiwan the circle *is* a major element in the pictures of a significant but not overwhelming number of children. Leaving kinetic scribbles out (and therefore eliminating five children, all preschoolers) eight children (23%) used circles as a major element in their pictures. Only two of these were schoolchildren. Taking the preschoolers, 6 of 16 (scribblers eliminated) or 37 percent used circles as a major design element. C 18 (male, age 5) constructed his picture entirely of multiple circles. C 10 (female, age 4.8) used circles to construct people, suns with faces, and flowers. C 25 (female, age 5.6) used numbers, squares, and many circles in her mixed composition. C 27 (male, age 4.7) used a number of circles to make humans in a mixed composition containing a few lines and rectangles on his third try at drawing. C 35 (female, age 4.2) used a large

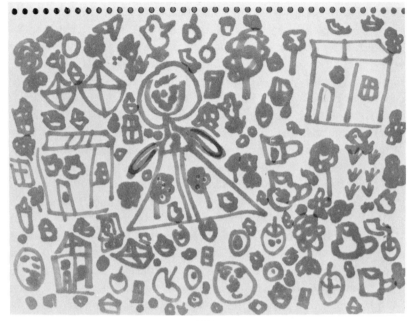

C 31

number of ovoids and banana-shaped figures to produce her design. C 31 (female, age 6.8, schoolchild) used many circles for faces and flowers, but there are many other shapes in her picture as well. C 39 (male, age 4.5) used one circle in his complex picture. This was drawn first, but all the rest of his design elements were built up out of rectangles. The circle is nonetheless the focus of the overall design and remains the strongest single element in the composition. C 32 (male, age 5.8) drew a picture that is a borderline case with respect to the use of circles. A sun and some parts of floral elements are constructed out of circles, but the picture contains many rectangular elements as well.

Overall, the Taiwanese pictures appear to contrast with those from Bali because a fair number of them show touching of marks and units. Of the total sample, 35 percent display this trait. However, if we subtract all kinetic scribbles (9) we get 5 of 31 children or 16 percent, not a particularly high figure, but higher than Bali. Unlike

Bali, filling and building are quite common in the Taiwanese sample. Of the entire group, 23 or 53 percent show one or both of these drawing techniques in at least one part of the picture. Of these, 12 were produced by schoolchildren and 11 by preschoolers.

The Taiwanese sample also shows a tendency to use detail within units or figures. This elaboration varies from drawing facial features to putting marks within abstract closed units that are not filled completely. Twenty-six of 40 pictures or 65 percent show this characteristic. As might be expected such detail is found more often in the work of the schoolchildren. Seventeen of 19 (89%) showed this characteristic. It is, however, also found in the work of 9 out of 21 preschoolers (43%). When scribblers are eliminated from the preschool sample the proportion rises to 9 of 13 (69%). This concentration on detail may be linked to the early learning of Chinese characters, a task that requires the use of small marks with a good deal of attention to details and complex figures.

When the Taiwanese pictures are examined to see how many of them form connected wholes with no separate elements, we find that this only occurs (with one exception) among preschoolers. Ten of 40 children produced pictures of this type. When scribblers are eliminated this proportion falls to 4 of 34 (12%), and 3 of 16 preschoolers (19%), a fairly high figure in comparison with Bali, but low in comparison with Ponape.

Filling a previously drawn outline with a different color is not particularly common in Taiwanese designs, whether they be realistic or abstract. In the total sample only 4 of 40 children used this technique in their pictures. Of these three were schoolchildren and one was a preschooler. Generally, Taiwanese children either leave outlined figures unfilled, fill outlined forms with the same color as the outline, or build figures without any outlining.

The Preschool Sample

Since almost all of the Taiwanese schoolchildren produced formula pictures learned in the school context, and because these pic-

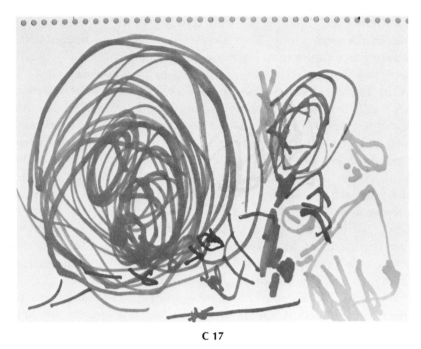

C 17

tures are very similar to the kind of drawing one sees among Western children in the same age groups, attention here will be given to the preschool sample.

C 17 (*male, age 2.4, 8 minutes*)

This child drew in blue, green, red, yellow, black, and brown. His picture is primarily a kinetic scribble with some lining in red. The predominant colors are blue and red, in that order. The picture can be divided into three zones: a large blue kinetic scribble on the left, a rectangular area in the lower right corner done in red, and a blue circle pattern (kinetic scribble) to the right of the large blue area and above the red area. A small green build touches this smaller blue area while black and brown occur in the lower portion of the large blue swirl and just below it. The yellow "connects" the two blue areas.

The child began in red in the lower right corner of the page. Brown

was used next, but was abandoned after only a few strokes. The child then switched to yellow and drew rapidly in the space above and to the left of the red. He then returned to the brown pen and, with a small set of tiny slow strokes, moved leftward. Switching to a blue pen he then began to scribble in typical fashion. As he scribbled, his loops became faster and wider. At the end of the drawing the child changed to a green pen. His loops became tighter and whereas the blue scribble had been drawn in a clockwise direction, the green pen moved counterclockwise and then up and down to form irregular lines. Thus most of this drawing was kinetic, but some experiments with form and color also appear to have occupied the child.

C 16 (male, age 2.5, 15 minutes)

This picture looks like a kinetic scribble. It is dense from the top center down toward the middle of the page. Colors include blue, green, yellow, and brown. The page is not filled and the marks both touch and overlap.

The child began with a yellow line in the lower right quadrant. Two marks were then made with a red pen. Dissatisfied, the child then began a new picture. This time he began with a brown pen, drawing on ovoid with a flat bottom in the lower right quadrant. He marked the page in the center and with the same stroke moved out and above and then back and down the page. As the center began to fill he switched to open spaces, green on the left, yellow to the right. Brown was added below the yellow. The picture was ended with smaller marks in brown on the left.

C 23 (male, age 2.7, 9 minutes)

This child's picture demands special attention because it provides an interesting insight into the difference between what a child thinks he or she can do pictorially and the result based on achieved skill. In this sense this picture acts as a corrective lesson for those who believe that all children are satisfied with "symbolic" or "schematic" attempts to represent rather than imitate nature.

C 23b

C 23 was an active, outspoken little boy, who although he had
never drawn before, was sure that he could exactly reproduce a ti-
ger scroll that hung on the wall of the drawing room. After a few
seconds of scribbling on the pad he became frustrated and "scared."
At first he refused to continue without his mother's help. Neither
did he want to quit, however. Finally he rejected the pad, but, con-
tinuing to ask for his mother's help, he began to draw on a piece of
computer paper available in the room. (This is the only picture in
the sample that is not drawn on the standard paper.) The result of
his nine minutes of work is a typical kinetic scribble (but the only
monochromatic one in the Chinese sample). It was done with a
rather heavy touch in tight circles, with some lining and a few dots
in the middle of the page. At the end of the drawing period the
child was clearly angry with himself as well as surprised that he
could not produce the expected tiger. "Romancing" about what he
finally did draw on the computer paper, he said that it was a flying
saucer. His use of a single color probably reflects his fixation on the
representation of form.

C 19 (male, age 2.7, 10 minutes)

This child produced a kinetic scribble that covers about 80 percent of the page in wide sweeping lines and dense fills in red, blue, and green. While there is some ovoid looping, most of the lines and builds are jagged and zigzagging.

C 21 (female, age 3.5, 6 minutes)

This is another kinetic scribble. It consists of a tight overlay of colors: brown, black, green, yellow, and red (the latter only one small dot to the side). The entire picture occupies a spot in the upper middle of the page about two inches in diameter.

C 38 (male, age 3.9, 9 minutes)

C 38's picture is a polychromatic kinetic scribble made up largely of broad, sweeping ovoids that cover about 90 percent of the page. There are some heavy green builds in the upper left. The impression that this picture was done aggressively is confirmed on the film, which, in contrast to the kinetic scribbling of other children (even C 19, cited above) shows very rapid, heavy marking throughout the drawing process. Several of the adults present in the house during the drawing session referred to this child as spoiled and aggressive. One mother went so far as to point out that he was not "your typical well-brought-up Chinese child.")

C 35 (female, age 4.2, 27 minutes)

With this child's picture we leave the realm of kinetic scribbling in the Taiwanese sample. This picture is a dense and well-organized design. It covers the entire page and contains few empty spaces. The overall design is made up of a set of blue ovoids, many of which have one rather flat edge. A few of the largest of these ovoids contain smaller ovoids in red, brown, or green. The largest ovoid is in the middle of the bottom of the page (slightly to the left of the midline). Smaller ovoids occur in three lines above and some of them are completely filled in blue.

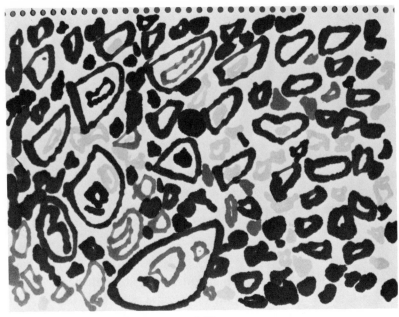

C 35

This picture began with the drawing of the largest ovoid at the
bottom of the page. This was done in a single stroke. The child then
added a series of similar forms to the right and to the left, mostly
above the first ovoid, rapidly filling the page with these marks. Un-
like Balinese children, this girl did not go systematically from large
to small marks as the page became filled. Instead, she made marks
of different sizes according to the remaining available space in dif-
ferent zones of the page until a good deal of the space was filled.
At that point she changed to green and repeated her original pro-
cess. This time the space was limited and she made a series of more-
or-less equal-sized marks, except in the lower left of the page where
more space was available. She then changed back to blue and added
more small marks, most of which had no open centers. Even smaller
yellow spots were added between existing figures. It was at this
point that she decided to work inside the ovoids. Space filling had
clearly become the imperative by this point.

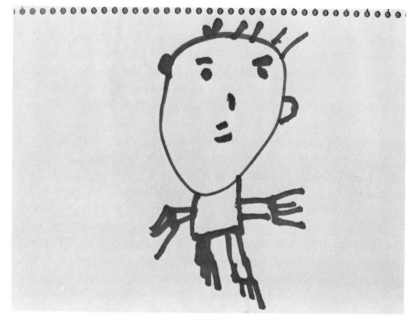

C 8a

C 8 (male, age 4.4, 7 minutes)

This is a large, monochromatic, (blue) human figure drawn in the center of the page extending from the very top to the very bottom of the page. This picture will be discussed below in the section on human figures. After finishing this picture, C 8 asked if he could do another. This time he worked in blue, green, brown, and yellow, covering the page with a series of different-sized Chinese characters.

C 30 (male, age 4.4, 28 minutes)

C 30 drew a very dense picture in red, brown, and blue. There are also touches of green and yellow, but these colors are minor. The picture consists primarily of separate traces (generally lines and threads) in blue and brown in the upper right portion of the page,

C 30

running down to the bottom on the right. Red marks of a similar type occupy the bottom middle, while red builds continue on the left. In general, the picture is denser on the bottom than on the top. It is most open in the upper left corner, which contains a small number of green lines and threads. It is scribble-like, but is not drawn in circular, kinetic strokes.

C 39 (male, age 4.5, 33 minutes)

This child's picture, which is one of the most unusual in the entire collection from six cultures, will be discussed again in the Chapter on Unusual Pictures. It is a polychromatic (every color but black is used) abstract design that completely fills the page. There is no empty space at all. It consists of a series of three circles, (brown, green, brown) one inside the other, surrounded by a series of rectangles of different colors and sizes. Some of the rectangles are outlined in one color and filled in another while some are filled with

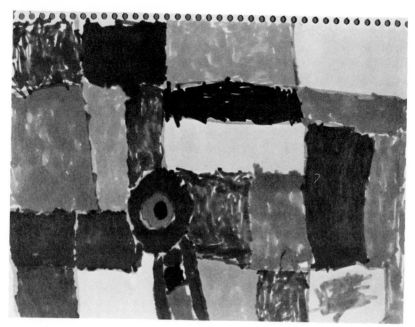

C 39

the same color as the outline. A yellow rectangle in the lower left is partially filled in green. We were struck, while filming this child and again while viewing the film of his work, by the way in which this particular picture developed. Although there is no way to be sure that it was planned, the way the child worked suggests that each step gave birth to the next in a rather conscious way. It was certainly not constructed by a process of random filling.

C 39 began his picture by outlining (later obscured) a circle in red in the lower left quadrant but very near the center of the page. Another red circle (also obscured later) was then drawn around the first. A brown dot was placed in the center of the inner circle. Green was then used to fill the inner circle. Very slowly and carefully, the child then filled the outer circle in brown. Next he drew a line down from the bottom of the outer circle to the bottom of the page. He then drew a second line down in the same direction and parallel to the first. This was followed by a horizontal line dividing the space between the two previous lines. The upper part of this newly cre-

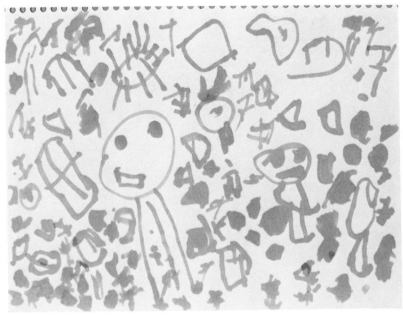

C 9

ated space was filled in blue. This part touches the red outline of the brown circle. After this the child began to divide the rest of the space on the page into rectangles of different sizes and to fill these with different colors until the entire surface of the picture was full of color.

C 9 (female, age 4.6, 11 minutes)

This picture, in green and red, is quite dense and fills the page. It contains some building and filling, and consists of three human figures as well as a set of ovoids, some Chinese characters, and a few indefinite shapes. There is a single orientation for all elements, there is little touching and no overlapping, and there is no overall composition.

This picture was begun by drawing a human with a green pen. Another was then added in red. After drawing a third human the child changed over to a series of Chinese characters, indefinite fig-

ures, and ovoids. The general movement was back and forth on the page to fill available space.

C 6 (*female, age 4.7, 10 minutes*)

This child produced a dense abstract picture that covers the page in brown and green. It consists largely of short, jerky lines done with a rather heavy pen. The brown marks are at the top of the page the green at the bottom.

The child began with a brown pen in the center of the page, making a diagonal mark down to the right. The second mark went off to the right, the third was a loop down, and the fourth was a continuation of mark number 3 and looped downward. The fifth mark was a short stroke inside the previous almost-closed loop. The sixth was a short diagonal that cut through mark number 3. Her seventh mark was parallel and below the second. At this point she moved

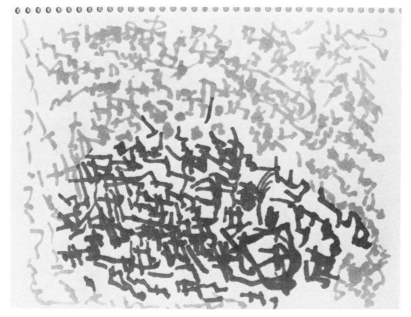

C 6

off slightly to the left of her previous marks and drew a short diag-
onal down to the left. This was followed by a cross stroke down to
the right and across mark 8. The tenth mark was a large stroke which
began across mark 9, passed through the loop, and turned at a sharp
angle to the diagonal left, ending after it had crossed the top of the
loop. After this the child's attention turned to the left of the page,
where she made a new set of marks that were connected back into
the first set. She then moved to the right, following the same strat-
egy. This was to be the pattern for the rest of the drawing. Towards
the end of the period her strokes became markedly shorter.

C 27 (male, age 4.7, 7 minutes)

This child produced two aborted pictures before he finished the
one described here. It depicts a series of objects in blue that are
drawn in four separare rows. Three of these cross most of the page.
The last is made of two human figures that are crowded onto the
bottom of the page on the right. From left to right the upper row

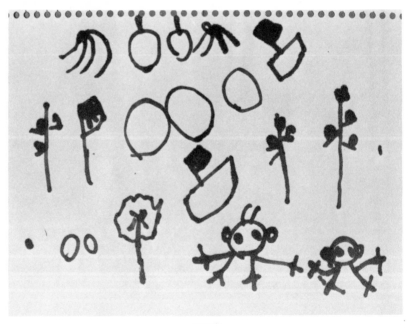

C 27b

contains: a dot with four curved lines radiating downward, a circle with a line above it running up to the top of the page, a repeat of this figure, and a boat with a flag. The second row has six figures: a flagpole or ship's mast, a flag on a pole, three circles in a row, and a boat with a flag. The next row has a blue dot on the extreme left edge, two circles in a row, a boat with a flag, and the two mast-like objects also drawn on the right of the previous row. Two human figures are drawn in the available space on the left bottom of the page. The head of the first has hair (two marks), eyes, and ears. It is a tadpole figure with the legs coming directly out of the head, but with the arms attached to the legs. The arms and legs each have three short spokes at their ends. These represent digits. The second human is identical to the first except that it lacks hair.

C 10 (*female, age 4.8, 10 minutes*)

This child drew a picture in red, green, and brown. It consists of human figures of different sizes, with some overlapping, a flower,

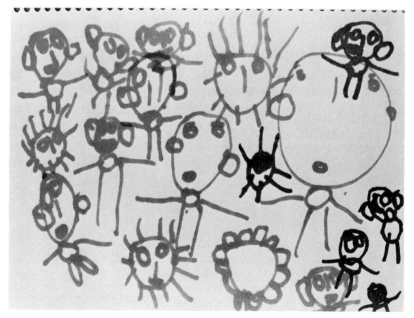

C 10

C 18

and a sun with a face. It will be discussed in the section on the drawing of humans by Taiwanese children.

C 18 (male, age 5, 26 minutes)

This child drew an overall design consisting entirely of red circles lined in yellow. Except for the top corners and the extreme right side, the circles are small and tightly packed. They are practically all of the same size.

The child began by drawing a red circle in the center of the page. The next circle was added on the right and the next below the second. The child then moved down to the right and drew three circles in succession. Next he moved downward to the left on the diagonal. For the rest of the picture his attention shifted over the page as it became filled with the emerging pattern. The corners and the right edge were filled last. When all the circles had been drawn the child began slowly and deliberately to draw yellow circles on the inside

C 20

border of every red circle on the page. This was done from right to left across the picture.

C 20 (female, age 5.2, 8 minutes)

This child drew a picture of two television characters (two anthropomorphic bees) as well as a house with red smoke coming out of its chimney. The figures are oriented on the horizontal plane and the house, which is much smaller than the figures, appears on its side. The chimney, which is set on the peak of the roof, is straight. The picture is colored in blue, green, brown, and red. The bees were drawn before the house.

C 11 (male, age 5.2, 24 minutes)

This picture was drawn in all the available colors. It covers the page and is a coherent composition. There is no overlapping, but

C 11

there is considerable filling. Details are added to the insides of en-
closed spaces. This is also one of the few pictures in the entire col-
lection that tells a story. Although "romancing" about a finished
picture is a common practice among children who are asked what
their pictures represent, the way in which this picture was drawn
suggests that about halfway through the work the child was re-
minded of an incident and combined already present forms with
new forms to illustrate it.

The upper half of the page is divided into a series of boxes each
of which, except one on the extreme left, contains a single, sche-
matic, flying bird. The upper left box has two such birds, and, un-
like the others, which are unfilled, is filled in yellow. There is a red
sun made up of rays projecting from an empty center on the right
side of the page. To the right of the sun are three shapes. The first
is a square with a scalloped flower in its center. This square is

filled in yellow. The second shape is a rectangle filled in blue and transected by a series of horizontal parallel lines. The third shape is an ovoid, filled in red, containing a human figure. This human figure is the subject of the child's story. The drawing represents a man who kept birds in cages and who was burned to death by the sun. The burned man appears in the red ovoid. There are other details in the picture, apparently not connected with the story. To the left of the man is a square, partially filled in green, with red dots. This was described by the child as a swimming pool with fish in it. There is also another human in the picture. Said to be a boy with balloons, this figure is next to the rectangle divided with horizontal lines. A moon shape is drawn just to the left and above the sun. On the bottom left of the page is a large black rectangle described as a house. A yellow sun is drawn just to the left of this "house." One also sees an inverted bird (drawn like the others, but upside down) to the right of the house. This bird was described as dead. Finally there is a set of diagonal zigzags in black across the top of the page that were described as the sky.

C 22 (male, age 5.3, 35 minutes)

This is a very dense blue picture. The page is covered with small, independent closed units, some of which are clearly realistic objects. While many of these touch, the child tried clumsily to keep them separate. The touching results from a contradiction between an attempt to squeeze as many elements as possible into the picture and the thickness of the pen. The objects in this picture all follow the horizontal plane, but they bear no relationship to one another. They were drawn by moving across the page from left to right. This pattern changed only at the end of the drawing period, when the child added objects down both sides. The work was very slow and deliberate. Among the items that are clearly identifiable are the following: a house, a sun, a window (isolated), a knife, a spider with "a lot of feet," various toys, a television set, candy, a lamp, a tree, and a dog. Some of these objects are easy to distinguish while oth-

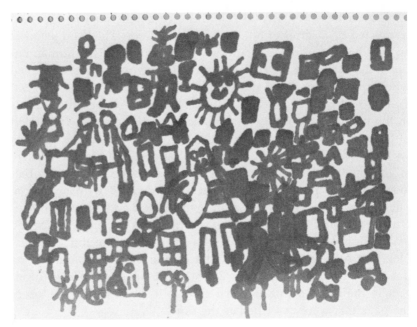

C 22

ers are not clearly drawn, but it is quite apparent that the child was not "romancing" in his descriptions of them.

C 24 (female, age 5.4, second picture—12 minutes)

C 24 was a shy child. She began her first drawing by rubbing a single spot with the pen and not looking at the paper. My assistant talked to her gently and she began a new drawing. The second picture is a bit more expansive than the first but is very similar in style. The picture, in blue, is essentially a scribble done by a child who was afraid to draw. She is one of the very few Taiwanese children who did not open up during the session and draw freely.

C 25 (female, age 5.6, 2 minutes)

C 25 drew a red picture that covers the page with separate (mostly closed) marks. The majority of these were circles and squares al-

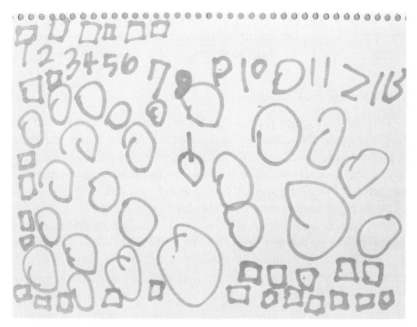

C 25

though the child also drew numbers on the top of the page. The overall appearance of the picture is of bunched squares and circles. The latter occupy the center and the right side of the page while the squares form a border that runs across the bottom (interrupted by one large circle), up the left side, and part-way across the extreme top from the left rightward to about the middle of the page. One of the circles (in the middle) has a "stem" protruding from its top. This was later called an apple and was the only object named by the child.

The picture was begun as the child drew a circle in the left center of the page. This became the apple when a stem was added. She then drew a larger circle to the right of the first and another in the lower left of the page. This was followed by a whole series of circles drawn back and forth on the page. Numbers were added from left to right across the top. New circles were drawn after the numbers. These were followed by the series of squares, which began on the bottom of the page and moved rightward. A new row of squares

was added below the first, again moving rightward across the page.
The left side was filled with squares from the bottom upward and
finally the row to the right at the top of the page was added.

C 4 (male, age 5.10, 16 minutes)

This child's picture is drawn in green, red, blue, brown, and yel-
low, but green predominates. It consists of a female figure just above
a ground line. A set of small "busy" elements is arranged in a row
below the ground line. The page above the line is covered with a
scattering of small figures. A tree in green and red is drawn on the
extreme right. It is about twice the size of the human.

This picture was begun with a green rectangle in the lower left
quadrant (above the area in which the ground line was later drawn).
A yellow sun was added in the upper left of the page. Next the
child drew a series of green circles that were immediately filled with
the same color. Then the ground line was added, to be followed

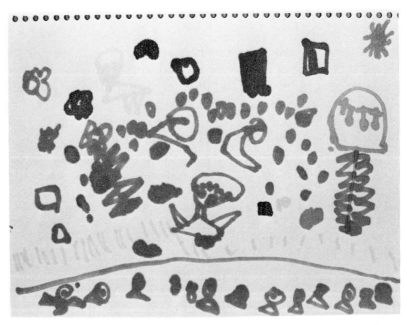

C 4

immediately by the series of green marks below. It was at this point that the human figure was added to the picture. The trunk (triangular in shape) was drawn before the head. Marks were added above the figure, and a green sun was drawn in the right upper corner of the page. A red pen was then used to make a large ovoid in the right, near the top but below the sun. A tree trunk outlined in red was drawn below the ovoid and "apples were added above." A green zigzag was drawn down the length of the trunk and later described as foliage. The rest of the drawing consisted of filling space with a series of small marks.

Drawing the Human Figure in Taiwan: Preschool Children

Eight preschool children drew humans, ranging from a tadpole figure to the closed-trunk type. The youngest child to draw a human was C 8 (age, 4.4). This child's drawing is a single figure that runs from the very top to the very bottom of the page (with the page in the horizontal position). It is placed centrally and appears to be a male. It is drawn boldly. The head is an ovoid and is topped by six hair strands that stick straight up from the top of the head (resembling the crewcuts that Taiwanese schoolchildren wear). The face is complete with two eye spots and short, straight eyebrows, a line nose, and two short mouth lines of unequal length. There are two ears, the left one smaller and higher on the head. The trunk is drawn as a single rectangle. The arms are stiff, two-dimensional rectangles that project outward at ninety degrees from the body. The hands are indicated by stick-like fingers. The legs project stiffly down from the two outer sides of the trunk and are also drawn in two dimensions. The left leg is filled in blue and is shorter than the right. Feet are drawn as three stick-like toes. They project downward and are completely straight.

C 9 (female, age 4.6) drew three human figures. The first began with a large green circle in the middle of the page. Eyes and then a mouth were added. The figure was finished by drawing two stick legs directly down from the head. Stick feet were added to each leg. Her second figure was similar to the first, but was converted into a

sun (?) by adding spokes after the original two legs had been drawn. The final figure had a body composed of a triangular upper segment (with the top apex cut off at the head) and a rectangular lower segment. There are no feet below the latter part and the head has eyes and a mouth but no nose as in figure one.

C 27 (male, age 4.7) drew two identical tadpole figures with the arms projecting from the legs. C 10 (female, age 4.8) drew a page packed with human forms plus a sun figure with a human face. The humans have heads with circle eyes, nose lines, and ovoid mouths. Ovoid ears appear at the sides of the heads. The bodies are all constructed of circles that are smaller than the heads. Stick arms and legs project outward from these bodies. One figure, drawn against the right side of the page, has no arms. One figure on the bottom left has two-dimensional legs. It is the only one in which limbs are more than sticks. C 11 (male, age, 5.2) drew two human figures. Both figures have round heads and rectangular bodies with stick limbs. One has thick, two-dimensional arms. The facial features of the other (the second drawn) are indicated by a cross in the center of the circle. This was probably an innovation the child made during the drawing session, since the face of his first human is filled with usual eye dots, nose line, and mouth dot. These are blended together because the face is small and the pen thick. C 20 (female, age 5.2) is the young girl who drew two anthropomorphic insect figures modeled on television characters. These appear in full face. The faces include well-formed eyes and eyebrows. One has a nose dot, and the other has no nose. The mouths, in both cases, are formed of red "smile-shaped" lines. The bodies are closed trunks with multiple segments (appropriate for insects). Arms and legs on one are sticks with rounded hands and feet at the ends while the other has four wings and no arms. Both figures have rounded wings attached to the trunk. The figure with arms and wings is unusual in that the arms, which drop from the shoulders, cover the previously drawn wings. This successfully gives the impression that the wings are placed behind the arms. Such representation violates the representational rule often followed by young children that forbids the intersection or overlapping of body parts. This manner of drawing in such a young child indicates a good sense of observation and

is quite advanced. The fact that the picture's subject is derived from television viewing raises the question of whether the child had learned to represent in this advanced way through the observation of schematic cartoon figures. This suggests that we need to know more about how children get their drawing models and how schematic models affect drawing skill.

C 22 (male, age 5.3) drew a variety of objects, which have already been discussed above. Among these is a sun with a human face. C 4 (male, age 5.0) drew a rather crude female figure consisting of a head surmounted by a "half-moon" of hair, eye spots in the face, a small rectangle for a neck, a triangle for a body, and two short stumps projecting below the body (skirt) as legs or feet.

The human figures drawn by schoolchildren in Taiwan are not unusual when compared to the drawings collected among Western children. In most cases they appear as well-integrated parts of total compositions. Some figures are done with greater skill than others, but in each case the sophistication correlates with the skill shown in the drawing of other objects in the same pictures. Thus, for example, C 32 (female, age 5.8) drew a very crude human consisting of a poorly drawn circle with two large eye spots in the face and a few straight strokes on the top of the head for hair. The body consisted of two triangular ovoids without arms or legs. The rest of this picture, with one curious exception, is also quite primitive by the standards for this child's age and culture. It is monochromatic, everything is drawn in outline, and the other shapes are either poorly drawn or are stereotypic and very simple. The exception to this overall primitiveness is puzzling. The child made two attempts to depict houses. The first attempt consists of a rectangle surmounted by a triangle and is not unusual. The other house is drawn with what appears to be considerable skill. It appears in three-fourths view with no separation between the side wall and the roof peak on the near side, nor is the roof separated from the wall on the long side. This lack of fencing (an advanced trait in human figure drawing, at least) gives the appearance of three-dimensionality, which is so rare in pictures drawn by children at this age. The omission of certain lines in such a crudely drawn picture suggests that the startling result is due to poor drawing skills rather than

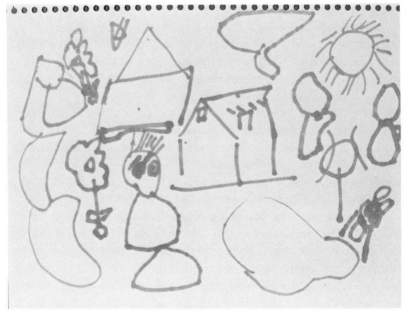

C 32

compositional insight. What is troubling about this explanation is the fact that the chimney mounted on the long side of the roof of the house in question projects straight upward as it would in a true prespective view. In addition, it is drawn correctly in the middle of the roof rather than at the extreme top, where many children would place it. All of this may be the result of a "happy accident" but such accidents may become the means by which observant children come to improve their representation of objects in the environment.

Putting Pictures Together in Taiwan

Preschool children in Taiwan tend to follow the same basic strategies as children elsewhere. That is, they experiment with a few simple forms and elaborate these rather than produce a wide variety of forms at the same time in the same drawing. Scribbling in the Taiwanese sample occurs in the expected age group and then gives

way to simple abstract designs. As in Bali the rule is "fill the page densely with a large number of separate elements," but in this case the elements are often units made up of marks rather than separate marks. Furthermore, this tendency was observed even among several of the school children in the Taiwanese sample (7 out of 19 or 37%). Taiwanese children do not generally build their pictures by working outward, as they do in Ponape, from a set of core marks or a core design. Even when connecting does occur it usually occurs after one or several independent sections have been created on the page.

It seems to me that the emphasis on learning the complex written characters of Chinese, a practice that requires attention to detail, contributes to the Chinese children's drawing style. It might even be that, for these children, writing and drawing are closely linked and even seen by the youngest and least artistically experienced as more or less the same task. I suggest, therefore, that Taiwanese children's picture making is influenced by relationship between pictorial representation and writing. This would be magnified by the fact that drawing, in contrast to writing, is not a cultural imperative for young children in Taiwan. This would explain why elements generally do not touch one another in the drawing of Taiwanese children and why these children tend to draw units rather than use simple single marks to fill the page, as Balinese children do.

JAPAN

APAN is well known for its highly refined traditional culture, with a complicated yet delicate aesthetic, and for its economic success with industrial capitalism. Arriving in Tokyo, one is immediately impressed by the modernity of the city and its apparently Western ambiance. After only a few days in residence, one begins to suspect that under the surface even urban Japan has managed to remain very Japanese. Traditional social patterns run very deep and are reinforced by key elements in Japanese symbolism. These elements are learned in the home and at school.

Modern and traditional Japanese culture are both highly visual. Colorful signs using borrowed Chinese characters combined with Japanese script abound. Writing is often used as an element of decoration in stores, restaurants, and other places of business. Most families have television sets and the many movie houses are well attended. Illustrated newspapers and magazines of all types are sold in newsstands. While most middle-class urban Japanese wear Western clothes, watch movies and television based on modern themes, and decorate their houses in the Western style, they also celebrate the past on major holidays by visiting local temples, wearing traditional kimonos, and making traditional offerings. Many Japanese women practice flower arrangement; educational television features a program on the Tea Ceremony. In addition, the artistic side of commerce still persists in elaborate wrappings and the fabrication of traditional objects, even if many of these have been relegated to the realm of bric-a-brac.

Not all Japanese children go to kindergarten even though public kindergartens exist. Space is limited, however, and parents must apply for their children's admission. Middle-class parents are more

likely to try than those of the lower class. Children who do go find their kindergartens well equipped and do much artwork. Children learn very early, by the end of their third year of age, to manipulate paper and to construct complicated origami figures. Clay, paints, crayons, and felt-tipped pens, as well as paper, are in good supply. Children are free to use whichever media suit them. The school day is divided into free activities, when children can do what pleases them, and group activities, including games, story telling, and music. Many of the children in the two kindergartens visited for this study spent a good deal of their free time doing various kinds of artwork. None of the children in our Japanese sample were strangers to any of the available artistic materials. Japanese schools are known for their rigor and their competitive atmosphere. This is not the case in the kindergartens. We found these to be highly permissive and friendly places in which all the children appeared to be enjoying themselves. We were struck by the calm that reigns between teachers and children and the creative atmosphere encouraged by patient teachers and administrators.

The Japanese Data

All my work here was done in the kindergarten context. However because Japanese begin kindergarten very early in life, I had access to rather young children. Three children in the Japanese sample were between 3 years, 10 months of age and 3 years, 11 months. Twenty-four of the children were in their fourth year and ranged from 4 years to 4 years, 11 months. Thirteen children were between 5 and 6 and one child was 6 years, 3 months old at the time of the study.

Forty children drew for me and all were filmed. Of these, 18 were boys and 22 were girls. The boys drew for a mean time of 8.11 minutes and the girls for 5.68 minutes. Eight children drew for 15 minutes or longer (the longest drawing period was 33 minutes) and 24 drew for 5 minutes or less. The shortest period was less than 1 minute and this occurred in two instances. Looking at the mean times, we can see that Japanese children drew for much shorter times than children in Bali, Taiwan, and even Ponape. This is reflected in

Table 4
The Japanese Sample

	Sex	School	Age	Time (minutes)
J 1	m	yes	5.5	33
J 2	m	yes	4.10	2
J 3	m	yes	5.3	3
J 4	f	yes	5.9	2
J 5	f	yes	5.1	>1
J 6	f	yes	5.0	8
J 7	f	yes	5.1	2
J 8	m	yes	5.9	>1
J 9	m	yes	4.10	5
J 10	m	yes	4.11	19
J 11	m	yes	4.11	7
J 12	f	yes	4.11	23
J 13	f	yes	4.11	17
J 14	f	yes	4.11	>1
J 15	f	yes	4.11	8
J 16	m	yes	6.3	5
J 17	m	yes	5.6	27
J 18	m	yes	5.3	8
J 19	f	yes	5.8	2
J 20	m	yes	5.9	10
J 21	f	yes	5.9	5
J 22	f	yes	3.11	5
J 23	m	yes	4.1	5
J 24	m	yes	4.0	2
J 25	f	yes	4.5	2
J 26	f	yes	4.9	1
J 27	m	yes	4.3	24
J 28	f	yes	3.11	10
J 29	f	yes	3.10	14
J 30	f	yes	4.8	1
J 31	f	yes	4.0	3
J 32	m	yes	4.5	3
J 33	f	yes	4.6	1
J 34	m	yes	4.5	16
J 35	f	yes	4.2	1
J 36	m	yes	4.10	4
J 37	f	yes	4.10	3
J 38	f	yes	5.0	13
J 39	f	yes	4.10	3
J 40	m	yes	4.11	26

J 11

the compositions produced by Japanese children and by the sure-
ness with which they drew. Most children produced simple pic-
tures with coherent themes. Many pictures show formula elements.
In addition, with few exceptions, Japanese children, although shy,
were confident about drawing and did not appear to find the task
strange.

Japanese children enjoy using color. Only 5 of 40 children (13%)
drew monochromatic designs. Unlike Bali, Ponape, and Taiwan, very
few pictures in the Japanese sample fill the page. Counting the few
kinetic scribbles (I collected two), only six of forty children filled the
page. Of these, only one did so with multiple marks or units (in
this case small marks were used) and these differed in many re-
spects from the dense designs seen in Bali and Taiwan.

About a quarter of the Japanese sample, 11 of 40, drew pictures
consisting of a single object (one person or one flower, for example)
or a single coherent design. Most of these pictures also show a ten-
dency to center the pictures on the page or at least to center it be-

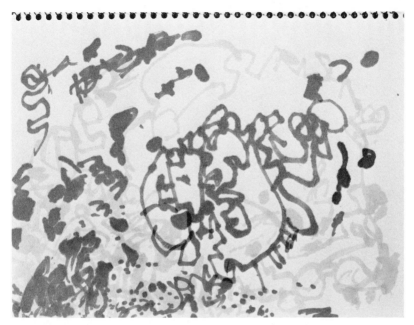

J 27

tween the right and left sides. Seven of 11 are fully centered, one is slightly off center (J 11) and two (J 24, J 27) are centered between the sides but are on the bottom of the page. If this category is expanded to include those pictures in which the general focus of the design is centered, 28 of 40 or 70 percent of the sample, are so constructed.

Humans were the spontaneous choice of subject for a fair number of children. Thirteen of 40 pictures (33%) had at least one human or a part of a human in them. Of these pictures, humans were the exclusive subject in five.

All of the Japanese pictures (not counting kinetic scribbles) have a single up-down orientation and, in contrast to Taiwan and Ponape, the sample includes only one multiple-subject picture in which discrete elements unrelated to each other by the child's verbal description are drawn on the page. Most of the Japanese pictures are, therefore, true and unambiguous compositions showing a variety of interests. Among these are the following: a ghost entering a house

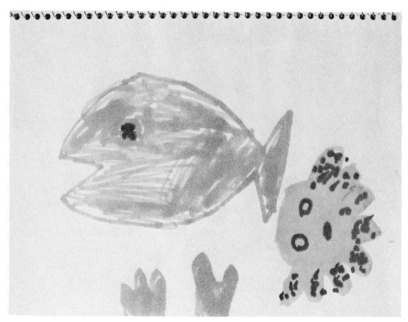

J 16

(J 23); an undersea scene with a fish, an octopus, and seaweed (J 16); and a row of cars on a highway with a mountain in the background (J 17). Two pictures, J 13 and J 12 (the only pictures in the sample in which the page is filled with a dense design constructed out of multiple elements) appear to be collections of discrete units, but in contrast to the above example were explained by the children as coherent compositions. J 13's picture (a girl surrounded by flowers with two windows in the background, a sun in the corner, some butterflies, and cucumber shapes) was described as a girl in a flower shop. J 12's picture (composed of a group of human females and a smaller group of anthropomorphic figures) was described as a panda with a group of girls. Judging from the process by which these pictures were drawn, the children began with only vague ideas but finished with a definite subject in mind.

True circling is rare in the Japanese sample. No abstract designs occur based on a circle pattern, and none are found in which circles are the major design element. The sun, as might be expected, was

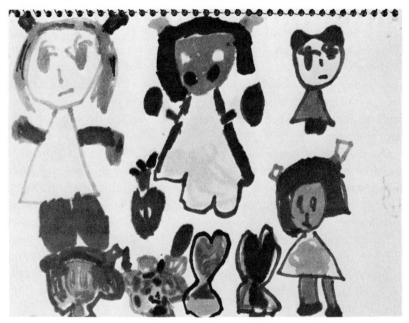

J 12

(in all but one case) drawn as a circle with rays emanating from it. The sun appears in five pictures, and in all but one it is found in an upper corner of the page. In a single picture the sun is cut by the corner of the page and only about one quarter of it is actually drawn. Circles are also used in the representation of balloons, car wheels, and the centers of some flowers. On the other hand, the head (human or animal) is often exempt from the circle formula so commonly used by Western children. One Japanese formula head is heart shaped, and is used particularly to represent animals. The two upper lobes of the heart become ears. Since most Japanese children learn to draw girls with hair in bangs, such drawings often begin with a flattened ovoid for the head to which hair is then added. A true or almost-true circle used to represent humans or anthropomorphs appears in only 6 out of 15 pictures.

After the kinetic-scribbling stage is finished, overlapping lines or colors are rare in Japanese pictures. On the other hand, filling and building are common. These techniques are part of a picture-mak-

ing strategy that involves considerable sophistication and learning. They reflect the amount of experience young Japanese kindergarten children have with art. In my sample, 26 pictures show one or both of these characteristics. An additional element of sophistication is seen in the degree to which Japanese children use detail to increase the specificity of their subjects. Fully 75 percent of the Japanese pictures in the sample use considerable detail in the drawing of realistic elements.

The many subjects included by Japanese children in their pictures are dominated by humans, anthropomorphs, and flowers. Other subjects represented are butterflies, cars, mountains, the sun, trees, a ghost, a garbage dump on fire, balloons, a television robot, game paddles, and fish.

The general coherence of many of the Japanese pictures and their obvious relationships to a set of learned patterns make a discussion of process less important for the Japanese sample. Only a few typical cases in each of the major age categories will be analyzed from the film materials.

J 29 (female, age 3.10, 14 minutes)

J 29 was the youngest child in the Japanese sample. Although two older Japanese children produced kinetic scribbles, this child did not. Her picture, drawn in red, consists of a human figure with a large head and a small body. To the left of the human are a series of objects that look like flowers. A sky is drawn across the top of the page. The area from the middle of the page to the left edge is blank. There is a good deal of filling and building. The head is featureless and along with the body, the hands, and the feet, it is completely filled. The sky is built with a series of lateral strokes.

This child began her picture by drawing a round head. Round eyes and a large mouth circle were added. A body in the form of a rectangle was drawn below the head. This was followed by a left stick leg and then a right stick leg. Feet were added to the legs, first on the left and then on the right. The right arm and hand were drawn, followed by the left arm and hand. Both the hands and feet were made of circles about the same size as the mouth. After she

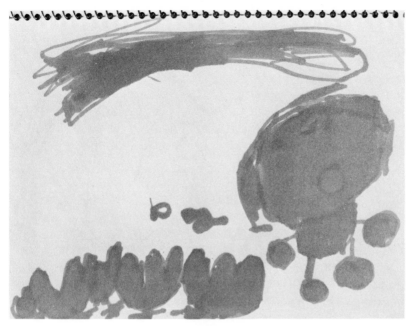

J 29

completed her human, the child moved to the left and drew her first tulip-like flower. This was followed by a sequence of identical flowers until she reached the left edge of the page. The sky was then built across the top first by stroking from right to left and then by reversing these strokes. Afterwards the child returned to the flowers and filled them. Finally she filled the human figure completely, obscuring the eyes and mouth.

J 22 (*female, age 3.11, 5 minutes*)

This child drew a picture in brown, red and blue. It consists of a crudely drawn head that occupies about two-thirds of the page on the right, two indefinite shapes in the lower left, and a built sky in blue above and touching the right edge of the head.

The bottom of the face was drawn in red from the upper left down. This resulted in a large loop that was closed with a brown line running across the top. The right eyebrow was drawn, followed by the

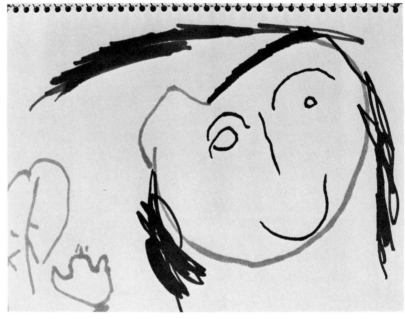

J 22

right eye, the left brow and eye, a nose line running down the center of the face, and an upward-curving mouth. The brown line at the top of the head was then built into hair. Two indefinite shapes were drawn in red on the lower left of the page and, finally, the blue sky was built with a sweeping movement back and forth from left to right.

J 34 (male, age 4.5, 16 minutes)

This child's picture, drawn in black and yellow, consists of a window placed almost dead center on the page, with a black blob below it. Arms enclose or embrace the two sides of the window at the bottom. A yellow mass is attached to the bottom of the black blob and separate yellow spots of indefinite shapes fill the rest of the page.

The child began by drawing the window. The first mark was a line down on the left which then angled right at the bottom. An-

J 34

other vertical line was added halfway across the bottom and then a third vertical at the end. This was followed by a short horizontal drawn halfway up the left side to connect the two verticals. This line was continued to the right edge of the window. The next mark connected the top half of the window to the midline and another mark was used to close the pattern from right to left. The black blob was then built by beginning on the right side of the bottom of the window, moving to the left, repeating the process of building, and then joining the two builds (left and right) by working inward from the two edges. The yellow blob was added below the black. It began as an arc and was built downward at first and then upward towards the window. The independent yellow marks were added last in a general movement back and forth and up and down on the page.

The subject of this picture is quite interesting. It was said by the child to represent a ghost (the black blob) entering a house at night. The focus of the picture is directly on the subject. The house, sug-

gested only by the window, is drawn in the same color as the ghost.
The window itself was drawn by means of a rather ideosyncratic
process. Most children would have begun by constructing a box
and then dividing it with cross marks for windowpanes. A lack of
drawing experience and skill in this young child as well as an initial
uncertainty about the subject matter of the picture may have played
a role in the peculiar way in which the window was drawn.

J 36 (male, age 4.10, 4 minutes)

J 36, although older than the two previously discussed children,
drew what is at least partially a kinetic scribble. (The other kinetic
scribble in the Japanese sample is by a child 4.1 years old at the
time of the study.) This child's picture was drawn in red, brown,
yellow, green, and blue. It consists of an initial red circle with two
sets of parallel lines. The rest is a set of loosely packed and large

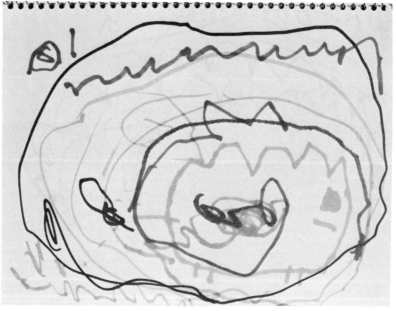

J 36

sweeping ovoids, some of which have zigzag parts. In addition, there are a very few independent, long, wavy threads across the page in the lower right, and a few small marks outside of the circle, including a red spot in the lower right. This picture is largely open and a good deal of the paper shows through the lines.

The child began this picture with a red line in the center of the page running up to the right and then zigzagging down and across to close. What look like four feet were then attached, first on the left and then on the right bottom of the circle. Changing to a green pen, the child drew a large loop outside of the previous red unit. This was done slowly and with deliberation. Yellow was then added in the same manner *outside* the green followed by blue *inside* the green. Brown irregular threads that looped back on themselves were added to the left side of the picture. This looping pattern was continued with different colors until the child finished the picture.

J 37 (female, age 4.10, 3 minutes each for two drawings)

This shy girl drew two pictures for us on request. Both are small, delicate, multicolor designs. Both are in keeping with the subject matter of Japanese children's pictures in our collection, but have a strong individualistic style that reflects this child's diffidence. The first picture consists of a tiny house placed in the middle of the page near the bottom. It is drawn in only two dimensions so that we see only the front with an overhanging roof. The house is outlined in red and the roof is filled in green and red. The wall is filled in yellow and has a small green door that touches the right wall. The second picture by this child is stylistically identical to the first. It consists of two petaled flowers placed on a small built ground drawn in green. This picture also occupies the middle of the page on the bottom. Exactly the same colors are used as in the first picture and the flowers are drawn with the same delicacy as the house. One flower has a green stem while the other stem is red. Both flowers have two green leaves rising at angles from the base of the stem, and both have small green circles in their centers. The flower on the left is red, the one on the right yellow.

J 37a

J 37b

Picture 2 began with a red circle to which petal loops were added immediately. The loops were filled in red and a green center was drawn in the middle. The ground was then built in green below the flower from right to left. A stem was drawn connecting the flower to the ground. Leaves were drawn on the stem. The same procedure was followed as she drew her second flower.

In drawing this picture, this girl followed a somewhat unexpected pattern. Usually the complete flower with stem would have been drawn before the ground line or the ground line would have been drawn first, followed by the stem and flower together. Since she drew both flowers in the same way, the fact that she connected two units (the flower and the ground) with a stem was not accidental (or at least was not so the second time). Her diffidence coupled with the success of her first attempt may have led her to follow the same sequence in drawing both flowers. This processual conservatism is not uncommon in the pictures completed by children in the samples and tends to confirm the overall conservative nature of the drawing process in the making of pictures by children.

J 15 (female, age 4.11, 8 minutes)

J 15 was also a very shy child. Her picture, which consists of two girls playing paddle ball, is one of the few action pictures in the entire collection. Similar human figures are drawn in the center of the page opposite each other on the same plane. They are dressed identically except that the girl on the right has green and brown in her skirt while the girl on the left has a skirt that is only outlined in red. Each girl holds a large red (filled) paddle that is turned inward towards the center.

This picture was begun on the left of the page with the drawing of a head. After the face was finished (eyes and then nose), the hair was added over the head and down the sides of the face to form braids. A small square was then added for the neck and, below this, a green truncated triangle (the body) was immediately filled. The right arm was built out from the body, and then the left in the same manner. The first paddle was outlined in red. The child returned to the head and added blue to the hair before filling the paddle in red.

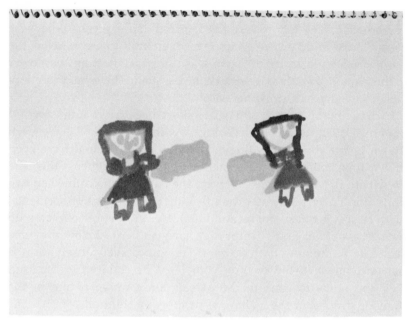

J 15

Rectangular legs (first the right and then the left) were drawn in brown. The second human figure was drawn in exactly the same sequence as the first except that the paddle was drawn after the entire human was finished. The two humans in this picture were drawn from the head down, as one might expect a child to draw them. The fact that they are identical suggests that this child followed a formula for drawing the human form.

Among the twelve children in the Japanese sample between the ages of 4.10 and 4.11, six drew pictures that are rather restrained and four drew expansive compositions. The pictures of the other two children fall into a middle category. If we look at the work of the entire Japanese sample we find a variety of style, manner, and composition that is wider than that found in the Ponapean, Balinese, or Taiwanese samples. This is to be expected if we consider the fact that Japanese children have training and material with which to express their different experiences and personalities in pictorial work.

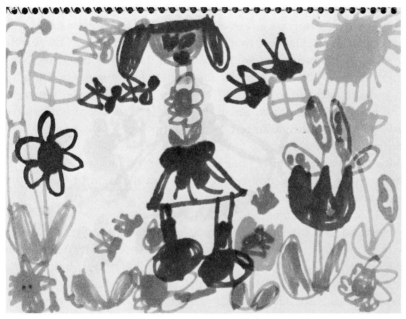

J 13

J 13 (female, age 4.11, 17 minutes)

This picture contrasts markedly with the last two described. While the former are very small and restrained drawings occupying the center of the page, J 13's picture is expansive, contains many elements, and covers the page.

The picture, described as a girl in a flower shop, has a human figure in its center. This large figure is surrounded by a pattern of flowers and other units that fill the remaining available space. The head is standard. It is composed of a half-ovoid, flat at the top, and is covered with hair that flows down the side of the face. The face, which is drawn in green, has two rather large eyes and a mouth shaped exactly like the head. The neck is a small rectangle drawn in red. The trunk is drawn in two sections. The first is a yellow rectangle that appears above a blue truncated triangle (the skirt). The upper torso is decorated with a green flower, and the skirt is decorated with a large blue bow at the waist. The arms, drawn in yellow, drop

at an acute angle almost parallel to the skirt. Straight blue legs drop down from the outside edges of the skirt. The two-dimensional legs end in large circular feet that are partially filled in blue. Large yellow hands, with fingers, are prominent at the end of the arms. Neither the lines nor the colors of this female figure suggest delicacy. A red sun fills the upper right corner of the picture. To the right and left of the girl and at about the same level as her shoulders are two windows outlined in red. A row of flowers is at her feet. These run all the way across the page. The rest of the space is filled with flowers, some indefinite shapes, a few butterflies near each window, and a set of cucumber-like shapes on the right of the picture on a line with the torso of the figure.

J 13 drew the human in the expected manner, from the head downward, but interrupted the process to attend to other detail before returning to finish. The head and torso were drawn first. She then drew a flower (flower, stem, leaves, in that order), before adding the legs and feet to the human. Toes were drawn on both feet before shoes were added in a blue fill that blocked them out in the finished picture. After the human was finished, the child drew a red sun in the upper right corner of the page. At this point the picture had a central element (the strong human figure), another on the left, going up half the page from the bottom (the flower), and the sun, high on the right. Next, a blue tulip was added in the lower right of the page. The child then moved leftward and drew a yellow flower next to the large brown one. This filled the space between the first flower and the girl. The windows were added, first on the left and then on the right. Flowers were put into the composition on the right side, where there was more remaining space. Butterflies came next on the right. She then filled where she could with flowers and the cucumber shapes. At the very end of the drawing, she returned to the human figure and added the flower on the upper torso. She came back to her central figure three times during the drawing session. This girl began her picture in the center (a pattern seen in many of the Japanese pictures) and then went to the outside on both the left and the right. She returned to the center at the end, when most of the space on the page had been filled.

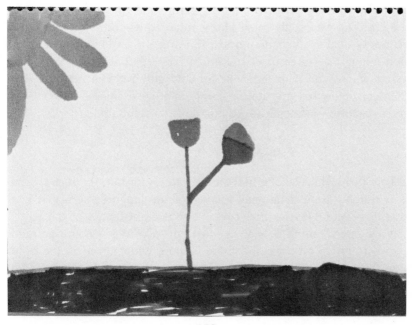

J 38

J 38 (female, age 5, 13 minutes)

This child drew a rather simple picture with great care. Its conceptual unity was enhanced by a comment made by the child at the end of the drawing session. She said, "Someone has planted a flower. It has grown. The sun shines down on it. The pond in the picture is used to water the flower." The picture consists of a brown ground space built on and across the bottom of the page. This is interrupted on the right by a small blue pool set into the "earth." A single large flower grows from the ground line in the middle of the page. The stem divides in two near its top and each branch is capped with a flower. The one on the main stem is red. The other, which tops a stem drawn at an angle to the right, is half red, half green; it could be a bud about to open. Both flowers are tulip shaped. Only one other element appears. It is a sun drawn in the extreme upper left of the page and three-quarters of it are off the page. Large lobe-like rays project from the existing quarter of the

sun. The sureness with which this picture was drawn indicates that the child knew exactly what she wanted to do from the start. The economy of the finished composition and the child's own description suggest a coherent visual and narrative conception that is in many ways typical of Japanese art and culture. The material that follows shows that my sample contains other examples of the same early enculturation in the aesthetic-cultural standards of Japan.

J 1 (male, age 5.5, 33 minutes)

This boy, who was the first child to draw for me, produced what is perhaps the most unusual picture of the Japanese series. It is a single, coherent whole that covers about eight-tenths of the page, leaving only a small border in white on all sides. As the painted area is rounded on the right, there is more white space on the right side than on the left. The units of the picture are drawn inside a

J 1

space demarcated for the most part by black, but with a smaller brown border running across the bottom and curving up the right side. The picture's border is reduced to a thin band at the top and turns partway back to the left at the top. There is a large blue star in the center of the black area, with a red moon slightly below it and to the right. A group of small yellow stars appears on the left bottom and a small green star is drawn on the top left. A fish-like object with a black eye spot begins in the brown fill at the top and finishes to the right in the black fill.

This picture began when the child outlined a large star with a single stroke. This was done quickly and was obviously the result of a practiced pattern. The star was next filled in blue. The moon was drawn below and to the right of the star. This was then filled and built outward from its edges to increase its overall size. A yellow star was added to the left followed by the other yellow stars, and, finally, the green star was drawn to the left on the top. A brown pen was used to make a threaded line across the top of the units and was brought around them as an enclosure. Another brown line was drawn down between the moon and the blue star and immediately thickened through building into a two-dimensional form above the moon. The "fish" was added and the area around the blue star was filled in. This interesting picture was constructed from a series of simple formulae that were integrated by the child into a pleasing composition. Although the final product forms a single connected whole, the film record suggests that it developed step by step during the drawing process and was not planned in advance by the child.

J 17 (male, age 5.6, 27 minutes)

J 17's picture is well drawn. It is a pleasing and integrated composition enhanced by the use of repetitive but slightly varying pictorial elements. The picture shows a line of cars on a highway that passes a mountain. There is a red sun in the upper left corner and three yellow clouds across the top. Indistinct forms bleed off the page on both the right and left edges, giving the picture a sense of

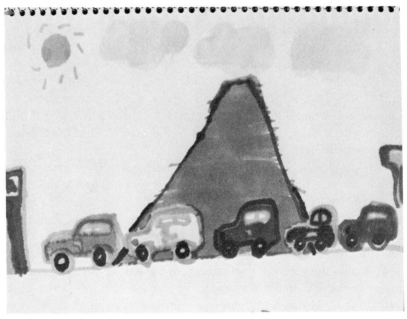

J 17

continuous flow. The form on the left was called the finishing point of a sports car rally and the object on the right was identified as a gas station. This is an "event" picture, one that tells a story.

J 21 (*female, age 5.9, 5 minutes*)

This child produced a pleasing composition typical of the older children in the Japanese sample. It is particularly delicate and harmonious. The combination of repetitive and nonrepetitive elements contributes to its success. Its delicacy is enhanced by the use of negative (i.e., white) space. The overall effect evokes an image of adult oriental art even though it is naïve and childlike.

The main focus of the picture consists of three red tulips with large green leaves. The middle flower is higher than the other two, which are drawn near the bottom of the page. A yellow butterfly with green wing spots is drawn to the right and slightly above the tulips. Another butterfly appears above the highest tulip, near the

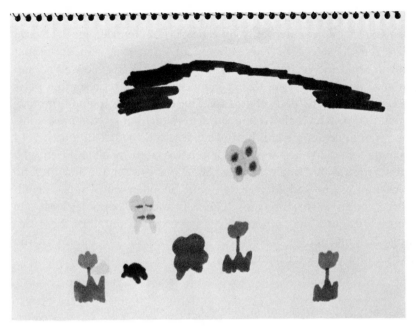

J 21

center. There is a blue spot to the right of the left tulip and a green flower between the two tulips on the left. The sky is suggested by a blue arc drawn across the page on the top. It is thick on both sides and is reduced to a thin line in the middle. The child said that the picture represented a butterfly looking for a flower to sit on. Like the previous drawing, this one contains implicit action although as a composition it reflects stillness and calm.

Drawing the Human Figure in Japan

The Japanese sample suffers from having no children under 3.10 years of age and no children without some experience with art. Human-figure drawing in the sample shows a relative lack of spontaneity that contrasts with similar work among children in the three cultures discussed so far. In most cases Japanese children rely on formulae, probably learned in school, that conform to their skill lev-

els. In the sample itself, no mandala humans appear although two humans *are* represented only by a head (J 22, female, age 3.11, and J 26, female, age 4.9). The drawing of humans is similar to that encountered in Western cultures. The few differences observed can be attributed to what are clearly Japanese ways of representing parts of the body, particularly the head. These formulae include the flattened ovoid, which allows the child to depict bangs (the most common hair style among children in Japan), and the use of a truncated triangle for a skirt or dress. The latter was used by all children who drew specifically female figures. The Japanese sample includes no stick figures, no tadpole figures, and no open-trunk types at all. Three children, all girls (ages 4.11, 5.1, and 5.8), drew at least one figure without arms, although legs were drawn on all of these figures. In only one of these three cases were all the figures in the picture drawn without arms.

Summary of Japanese Children's Pictures

Japanese children learn to manipulate various artistic media early and under the best pedagogical circumstances. Kindergartens are well supplied with art materials and children have time to develop on their own and under the guidance of teachers. The construction of complex origami figures undoubtedly contributes to an understanding of spatial relations as well as a knowledge of "hidden" forms that underlie certain complex shapes. Although Japanese children learn to draw many stereotypic elements based on simple formulae (this is particularly true of humans and flowers), they also are frequently able to combine these into aesthetically interesting compositions that reflect both their culture and their individuality. Viewed against their age mates in the United States and France, Japanese children appear to make more complete, more interesting, and more harmoniously structured pictures.

THE UNITED STATES
AND FRANCE

THE American and French samples are both discussed here not be-
cause the pictures from the two cultures show identical character-
istics but rather because the French sample is smaller than the oth-
ers and does not, itself, warrant a separate chapter. As we shall see,
there are significant differences between the work of American and
French children.

The American Sample

The American sample is peculiar in that it was collected in three
different schools, each of a different type. The younger children were
filmed at two nursery schools: one for underprivileged children; the
other for children of middle-class parents. While both nursery
schools are in the near suburbs of New York City they are located
in separate small towns about six miles apart. The kindergarten
children in the sample attended an elementary school located about
halfway between the two nursery schools. It is attended by children
of a mixed working- and middle-class population. The parents of a
substantial number of the kindergarten children are professionals.

All three schools are well equipped with art supplies, but, while
all of the American children did some artwork in the school setting,
the amount and type of guidance varied from child to child and
from school to school. The kindergarten children drew and painted
less than the nursery school children. There was more artwork in
the middle-class nursery than in the lower-class nursery. I have no

way of knowing how much artwork any of the children in the sample did at home (this is equally true for Japan), but it is likely that middle-class children, particularly those who have professional parents, did more than lower-class children.

The American Data

The American sample consists of 45 children, all of whom were filmed. A 1 through A 20 came from a free nursery school where most of the children had working-class parents. Several of these subjects were the children of Haitian parents, but all spoke English on the level of their American born peers. A 21 through A 30 came from a private nursery school where most of the children had middle-class parents. A 31 through A 45 came from a public-school kindergarten.

The mean time per child in the American sample was 6.6 minutes (7.75 minutes for boys and 5.8 minutes for girls). If one child, who was the son of a professional artist and who drew for 44 minutes, is excluded from the male mean, it drops to 5.84 minutes. The children in the free nursery worked for a mean of 8.15 minutes and those from the paying nursery for 8.3 minutes. When the son of the artist is excluded from the first group, the mean time drops to 6.26 minutes. The most surprising statistic in the American sample is the mean time for kindergartners, only 3.6 minutes. This short average time is reflected clearly in their pictures, which are among the most impoverished in the total sample from six cultures. These results may well be an artifact of the testing situation. The American children all left their classes to draw in front of two strange adults in an empty room. Japanese subjects were also taken out of their classrooms, but they worked in the presence of one of their own teachers, who acted as interpreter. Out of 15 kindergartners 7 worked for only one minute and only 3 for more than five minutes.

For the total American sample, the longest drawing time was 44 minutes (the artist's son) and the shortest time was about one minute. Only 5 children worked for 15 minutes or longer; 29 worked for 5 minutes or less. In general, the American children spent less

Table 5
The American Sample

	Sex	School	Age	Time (minutes)
A 1	m	1	3.9	16
A 2	f	1	3.8	13
A 3	f	1	3.7	2
A 4	f	1	3.9	12
A 5	m	1	3.0	6
A 6	f	1	3.0	12
A 7	f	1	3.7	3
A 8	f	1	3.6	2
A 9	m	1	4.8	44
A 10	f	1	4.5	2
A 11	m	1	4.9	5
A 12	f	1	4.4	4
A 13	f	1	4.7	12
A 14	m	1	4.6	6
A 15	m	1	3.11	2
A 16	m	1	4.2	1
A 17	m	1	4.3	15
A 18	f	1	4.2	3
A 19	f	1	4.4	2
A 20	f	1	4.3	1
A 21	f	2	4.10	2
A 22	m	2	5.0	12
A 23	f	2	4.2	5
A 24	m	2	4.3	9
A 25	m	2	4.4	1
A 26	m	2	4.10	15
A 27	m	2	3.2	1
A 28	f	2	3.9	7
A 29	f	2	4.4	26
A 30	f	2	3.8	5
A 31	f	3	5.8	3
A 32	f	3	5.10	4
A 33	m	3	6.0	3
A 34	m	3	5.8	7
A 35	f	3	5.2	5
A 36	f	3	5.11	5
A 37	m	3	5.9	1
A 38	f	3	6.1	1
A 39	m	3	5.11	1
A 40	f	3	5.11	13
A 41	m	3	5.11	1
A 42	f	3	5.7	>1
A 43	m	3	5.7	1
A 44	f	3	5.8	>1
A 45	m	3	5.7	7

time on their pictures than the children from any other culture in the sample.

Nineteen out of 45 pictures were monochromatic. Eight of these came from the free nursery school (henceforth school #1), 4 from the paying nursery school (henceforth school #2), and 7 from the kindergarten (henceforth school #3). Within each subpopulation then, approximately the same percentage of children produced monochromatic drawings (40% in schools #1 and #2, and 47% in school #3). The high degree of monochromy might be related to an association in the minds of the children between the felt-tipped pens used in this study and writing instruments. This interpretation seems unlikely, however, because one should expect the same kind of association among Japanese children and because the children in school #1 of the American sample had little or no experience with writing.

A small number of the American children covered the page with their drawings. Looking first at those pictures that covered the page but were not dense designs, we find 7 of 45 (or 16%). Subtracting kinetic scribbles, the figure is reduced to 5 of 43 (or 12%). All the children who produced pictures of this type, except A 40, are in the nursery-school samples. Grouping those pictures that cover the page and *are* dense compositions with little white space showing, we find 6 of 45 (or 13%). When we eliminate scribbles, this figure falls to 3 of 42 (or 7%). Combining all pictures that fill the page, whether dense or not, we find 13 of 45 (or 29%), but when scribbles are eliminated this percentage falls to 8 out of 40 pictures (or 20%).

A large number of the American pictures can be classed as kinetic scribbles or semiscribbles: 12 of 45 (27%) can be so classified; 4 of these are semiscribbles (a part of the drawing is clearly kinetic). If we examine the subsample of nursery-school children, the percentage of kinetic scribbles rises considerably. As one might expect, none of the kindergarten children (all over 5 years of age) scribbled. Twelve out of 30 nursery-school children produced scribbles (40%). (In the middle-class nursery 3 of 10 children scribbled.) Even when semiscribbles are removed from the count, the figure remains high, at 27 percent of the nursery-school sample. A considerable number of these scribbled pictures were done by children older than 3.6,

but most in this category come from school #1. It is likely that these are also the children in the sample who had the least experience with artistic materials both in school and at home.

Balinese and Ponapean children had as little or less experience with art materials as the American children in this sample, yet children in Bali and Ponape produced pictures that were more organized than American children. The difference between Bali and the United States might be attributed to the considerable exposure Balinese children have to the arts in general, but this does not explain the contrast between Americans and Ponapeans. It might be that the high frequency of kinetic scribbles found in the American sample is caused by an affective element, namely aggression and the need for physical activity that it entails. During the filming we were struck by the degree of aggression displayed by the children, particularly toward the materials used in making the drawings and, in a few cases, towards us. Many of the American children (particularly in school #1) literally attacked the page. Marks were made with great pressure; the page was either dug into or struck with force. Movement was rapid and continuous. Since we lack psychological data on the children concerned, the suggested relationship between scribbling of this particularly violent type and aggressive feelings must remain a hypothesis.

Like Japanese children, the American children in the sample centered their compositions on the page and left a good deal of white space on either side and, less often, above and below: 18 out of 45 (40%) of the American pictures were of this type. In school #1 the overall percentage was 14 percent (3 out of 21). This low figure is to be expected in a group where scribbling all over the page was quite common. In school #2, 4 of 10 pictures (40%) fit this category, and in school #3, 11 of 15 (or 73%) were of this type.

In spite of the rather large number of scribbles, many of the American pictures show coherent organization. Only one American child (A 43, male, age 5.7) oriented different objects in his picture in various directions. Twenty-two of 45 pictures (49%) show a single coherent subject or design (including single or multiple units). These range from a human head or complete human or animal figure to whole compositions made up of discrete elements. The abil-

ity to compose in this manner increases with age and, I assume, with experience. In school #1, 5 of 20 (25%) children drew in this way. In school #2, the figure rises to 6 of 10 (or 60%), and in school #3, fully 12 out of 15 children (80%) composed this way. This result, however, should not obscure the fact that American pictures were simple in comparison to Japanese pictures. Very few drawings in the American sample were realistic compositions, properly oriented, with multiple elements (house, sky, grass, trees, for example). In fact, only three pictures fell into this category. One of these is from the artist's son and two are from the kindergarten sample. Nor were the American pictures complex abstract designs or simple designs composed of a large number of single marks or units.

Circles were not particularly apparent as a major design element in the American pictures. Including scribblers, 6 of 45 children used circles as an important part of their pictures. Circles were, however (unsurprisingly), used as a basic form in the construction of certain realistic elements, such as human heads: 15 children used circles in this way. Of these, 11 pictures involved the use of circles in depicting the human form.

Filling and/or building are quite common in the American pictures, unlike those from Bali, Ponape, and Taiwan. Twenty-one display one or both of these characteristics and there is little difference among the three schools in the sample: 8 of 20 in school #1; 5 of 10 in school #2; and 8 of 15 in school #3.

Overlapping lines or colors appear frequently in the American pictures: 11 of 45 (24%) show this feature. But when scribblers are removed, this statistic is shown to derive from the scribbling process. Only two American nonscribblers used overlapping lines or colors. Both were young nursery-schoolers.

Seventeen of 45 (38%) of the American pictures are drawn with details placed inside a figure or a unit. If we eliminate the scribblers from the sample, the proportion increases to 17 out of 33, (or 52%), a considerable amount. Most of the details in these pictures, however, are limited to elaborations on the human figure, particularly the use of facial features in the head, a common feature of children's art everywhere when humans are drawn. Twelve out of 17 elabora-

tions of this type consisted merely of putting facial features in a head.

The Picture-Making Process in the American Sample

Only selected drawings from the American sample will be examined here. Most scribbles need not be analyzed for my purposes and formula pictures, even by nursery-school children, tend to follow expected patterns.

A 9 (male, age 4.9, 44 minutes)

This child is the son of a professional artist. His picture is a complex, dense, polychromatic composition. The entire page is bisected by a ground line about two inches below the middle of the paper. A smoking locomotive is drawn to the right side of the page along this line. It faces to the right and pulls two cars and a caboose. To the right of the locomotive is a green mountain with a black tunnel mouth. There is a flag on the top of the mountain that is smaller than the train and looks as if it is far away. Another ground line with filling below it is drawn at the bottom of the page and a blue airplane rests on it in the lower right corner of the page. Above and in the left far corner is a green airplane. A series of letters begins just to the right of the green airplane. These letters end with the name Harry, which appears over the blue plane. The rest of this area is filled with small dots of various colors. Above the locomotive and the first car (in the middle of the page) is a house with three side walls (faulty perspective). A smoking chimney is drawn in the middle of the roof line at the top. A sun with a human face appears above and to the left of the house. Its rays are drawn in black and its body is filled in green. Two airplanes, outlined in black and filled in green and red, are drawn to the left of the sun. A green cloud appears just above and to the right of the locomotive's smoke. Some letters are drawn to the left of this cloud and the rest of the picture is filled with birds and dots of various colors.

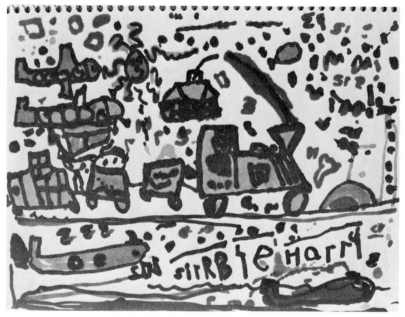

A 9

A 9 began his picture with an outline of the train in black. The first stroke was a line slanting down to the right in the upper right quadrant of the page. This was to become the left side of the loco-motive's smokestack. The next stroke was a horizontal line across to the right from the top of the first mark. The third mark closed this triangular unit. The child then went on to draw the body of the locomotive. The first mark moved left from the bottom of the stack. This was followed by a diagonal down in front of the body to form a cow-catcher. The next line was on the left side at the end of the engine. This vertical was the beginning of the cab. The next mark was a complex line that completed the entire outline of the engine, including its cab. The left and then the right wheels were added to the bottom. These were followed by details, including smoke, bells, and the slanted lines of the cow-catcher. The next three cars were swiftly added to the train by drawing the body of each in a single

stroke and adding the wheels. The caboose was then decorated. The child returned to the other cars and added details to them, moving from left to right. The round sun was drawn above and to the left of the train. Rays were added around the sun, followed by facial features placed inside it. The child then made an attempt (the pen tip was too thick) to draw an engineer inside the cab of the locomotive. Dots were added to the cab below the engineer. The child then moved to below the train and began to draw letters. Before writing his name he recentered his attention on the engineer, retouching the eyes. A cloud was then drawn to the right above the locomotive smoke. Next he drew a series of birds in the air near the cloud. The caboose received further elaboration. At this point the track, running from left to right, was added below the train. A ground line was added below the letters. The highest airplane on the left was drawn in a single stroke (clearly a formula) and the house was drawn to its right. Next the plane on the lower left below the train was drawn, then the second plane above the train, and finally the plane on the right bottom of the page. Inside details were worked into each plane in succession. Dots were drawn into the remaining spaces on the page. The child ended his picture by adding small details to previously drawn objects on the page.

A 9 showed a considerable amount of skill and confidence as he worked, and is evidenced in the signature he drew on the picture. It is large and boldly drawn by a preschool child who had not yet learned to write. Part of his picture consists of a coherent composition and part is made up of semirelated objects (such as the planes) and space-filling dots. It is difficult to say if the two ground lines present define two separate pictures or if they are both part of a single picture with some attempt to represent perspective. The latter possibility is strengthened by the size of the tunnel with respect to the train. The drawing progression in this picture suggests that some of it either flowed logically from previous steps or from some plan the child had in advance. Certainly the idea of drawing a train was in his mind when he began. The landscape elements may have been added on a spontaneous basis as he worked. The rest of the picture probably developed out of a desire to fill space and balance

A 45

the composition on the page. In this respect it bears some resemblance to Balinese pictures.

A 45 (male, age 5.7, 5 minutes)

This child's picture is interesting for its attempt to capture the peculiar orientation of his own house, situated in a village built on a steep hill. The picture is drawn with the page in the horizontal position and occupies the center of the page from the bottom almost to the top. It is drawn in outline with partial filling in green, red, and black and consists of four figures, three of which are arranged one on top of the other up the page from the bottom. The last figure is to the right side of the lowest unit. The bottom figure of the group of three is a human, drawn in green with a black mark in the middle of the body. The human is almost as tall as the two-story house drawn to its right in red outline with a blue fill on the roof. The house is tall and narrow. Its curious shape is accentuated by

the size of the human and by the door and first-story window, both of which crowd the side walls of the house, accentuating it linearity.

Another house is drawn just above the head of the human. It is similar in structure to the first except that the black inside details are made up of an irregular build. There is also green filling around this black build. The uppermost structure contrasts with the other buildings because it is wider than it is tall. The child said that this was the garage of his kindergarten teacher, who lives above him on the hill. A car is drawn sideways inside this garage, which suggests that there is no wall or that the picture is an "X-ray" drawing.

A 45 began this picture with the garage on the middle top of the page, in the center. The car was then placed inside the drawn space. A house was drawn just below the garage, to be followed by the human figure at the bottom. The red house on the right was added last. This drawing sequence suggests that the child began his picture with the vertical orientation in mind.

A 43 (male, age 5.7, 1 minute)

Considering that this child's picture was drawn in only one minute, it is strikingly complex. He accomplished this by applying a small number of stock forms. The composition consists of a house with a fence to its side. A semicircular path curves away from the house on the left and passes under it to the right. Smoke is drawn coming directly out of the top of the roof; there is no apparent chimney. The final element in the picture is a car drawn to the right of the house on an angle to the bottom of the page and parallel to the diagonal formed by the slant of the roof. The front of the car is lower than the back.

The child began this picture with the slanting lines of the roof. A window, the door, and the smoke were added in that order after the outline of the house had been drawn. The path was drawn next. Returning to the house, the child retouched the smoke and then filled in a section of the path. This section was later referred to as a "pool." The car was begun after the child had made a few rather indefinite zigzags above and to the right of the house. This small

A 43

build apparently inspired the child and he drew a slanting line par-
allel to the roof of the house. This became the top of the car. The
rest of the car body was added, then the wheels. After he completed
the car the child added the fence to the right of the house.

Although the car appears to have a peculiar orientation, the fact
that the child lives in the same hilly village as A 45 suggest an at-
tempt to depict an unusual environment.

A 36 (female, age 5.11, 5 minutes)

This picture, in brown and yellow, occupies the center of the page
and consists of a single large animal drawn in profile. Its head is
yellow and points to the right. The body, which is filled in brown,
is constructed out of a semitriangular blob drawn more or less hor-
izontally. The legs are four straight lines that project downward from
the body, ending in small circular feet.

A 36 began her picture by drawing the head of her animal. This

A 36

was a circle. Eyes and a mouth were then crowded into this space. Next she drew a long line off to the left from the head. This became the top of the body. The line was continued (as a separate stroke) to form the first leg, on the left. After some hesitation the child finished the body and added the other legs. One of these was placed in the middle of the body, one to the right, and one was drawn on the left side. The ears were the last features drawn. When the outline of the animal was complete she filled the head in yellow and the body in brown.

This picture is rather primitive in form. The child had considerable difficulty drawing the body and legs. Observation of the film suggests that she lacked the schema with which to make a "formula" animal. If this is correct, the picture is at least intellectually creative, if rather crude. This picture and the two discussed previously, A 45 and A 43, suggest that these children were all willing to grapple with a particular problem and managed to solve it with some success. In this sense these three pictures may demonstrate more

A 40

creativity and initiative than many of the "better-formed" pictures from Japanese and Taiwanese schoolchildren.

A 40 (female, age 5.11, 13 minutes)

A 40 worked longer than any of the other kindergarten children and her picture is congruent with that effort. It is a complex, coherent composition that looks very much like some of the work done by Japanese and Taiwanese schoolchildren. On the other hand, it is rather crudely executed and consists of a series of figures that are probably based on learned formulae.

A large female human appears in the middle of the page on the bottom. She stands on a narrow strip of grass built across the bottom border of the page. Large yellow and brown flowers rise to her right and left. Also on her right are three flowers of unequal size. The one closest to her comes to the top of her legs and the other two are almost as high as her shoulders. The sun is drawn on the

left side jut above the flower and the top of the page is filled by a strip of blue sky broken by "negative" clouds, consisting of white spaces left open in the blue fill. The latter technique suggests some sophistication, but the rest of the picture is quite ordinary. Although this picture is more complex than A 36's animal, it is also very much within the range of expected children's pictures in this age category, especially among children who have drawn in school and have learned to deal with certain basic problems concerned with representation.

Drawing the Human Figure in the United States

With a few exceptions, the drawings of humans by the American children in our sample are typical when compared with previously published material. This fact suggests that the sample is a fair representation of that group of American children who have participated in previous studies.

Fourteen of the children in the American sample of 45 (31%) drew the human figure. Four of these (20%) were in school #1; 2 (20%) were in school #2; and 8 (53%) were in school #3. (Percentage figures here represent the subsamples in each case.) The human figure was the exclusive subject in all but five of these pictures and an additional picture had humans plus four colored circles drawn in a row between them. In three cases humans were drawn as parts of complex scenes (A 40, girl with flowers; A 9 train scene; A 45, human with stacked houses). One picture has a human figure drawn under a series of numbers and letters. Four of the 9 pictures that are exclusively of humans depict only the head.

Summary Analysis of American Children's Pictures

The American sample departs from expectations only by the large number of kinetic scribbles done by nursery-school children and the general rapidity with which the majority of the children worked. The latter factor relates directly to the rather simple pictures pro-

duced by most of the American children. If my data are correct, the kinetic element in picture making persists longer among American children than among children in the other five cultures in this study. The simplest pictures done in the shortest time period come from the kindergarten subsample. As I have already noted, this result may be an artifact of testing conditions. Whatever is responsible for the simplicity of these pictures, a certain degree of caution might be advisable before such judgments are taken at full value and extended to statements about the relative aesthetic merit of children's drawings from different cultures. It would be premature to suggest that, because they are more complex, more colorful, and consist of a larger number of marks, Balinese pictures are in some sense more aesthetically interesting than American pictures. Such a judgment, made on the basis of subject matter and complexity of the overall design, might appear to be objective, but what makes *interesting* art for any particular individual has a high degree of subjective loading. The reaction one might have to finished Balinese, Ponapean, and Taiwanese pictures is certainly colored by experience with the art of one's own culture's adult world.

The French Sample

For reasons already discussed, the French sample is less than half the size of the others. The children in the French sample are quite young and most have had little experience doing or seeing art. They do not go to museums and, except for three children, there are no art books in their homes. Visual stimulation is not lacking, however. The Midi of France is noted for its bright light, abundant flora, and variegated landscape. One child in the French sample used some of these elements in his picture. In addition, all the children in the French sample have television in their homes and spend at least part of each evening watching it. Their parents all read magazines and newspapers in the home.

Because French children begin nursery school at a very young age (as soon as they are toilet trained in many instances), they begin to draw and paint very early. The French sample was collected in a

Table 6
The French Sample

	Sex	School	Age	Time (minutes)
F 1	m	yes	4.9	35
F 2	f	yes	4.3	41
F 3	f	yes	4.6	20
F 4	f	yes	4.9	40
F 5	m	yes	2.1	12
F 6	m	yes	3.1	15
F 7	f	yes	4.3	18
F 8	m	yes	5.5	35
F 9	f	yes	2.9	13
F 10	f	yes	2.11	8
F 11	f	no	3.8	4
F 12	m	no	3.11	7
F 13	m	yes	3.6	29
F 14	m	yes	4.0	33
F 15	f	no	3.3	6

village where the nursery school is equipped with paints, crayons, and felt-tipped pens. While the children get no formal (or even informal) art training, they do get a chance to use these materials freely. The French sample consists of 15 children between the ages of 2.1 and 5.5. All but 3 were filmed at the school. Two of the 3 were filmed at a farm near the village. One of these lives on the farm and the other was visiting with her family. In both cases these children are the offspring of professional people. The third child, whose parents are also professionals, was filmed at my house in the village.

The French children worked for an average of 23.14 minutes (25.6 minutes for boys and 18 minutes for girls). Seven worked for 20 minutes or longer and only 3 worked for 8 minutes or less. The shortest time was 4 minutes, the time spent by a 3.8 month old girl.

In general, the French pictures are polychromatic. Once a decision was made to use more than one color, at least three were used, and most children drew with all the colors except black. Among the monochromatic pictures, two are kinetic scribbles, by children ages 2.9 and 3.1. The other monochromatic picture is a realistic composition with a good deal of filling.

The French pictures tend to be quite dense and the page is frequently covered. Three of 15 pictures (20%) cover the page but show considerable white space between marks. Eight (53%) are dense designs with little white space anywhere on the page. The impression of denseness is enhanced by the high degree of filling and building in the pictures as well as a good deal of overlapping of marks and colors. Seven (47%) show such overlapping, but if kinetic scribbles are eliminated, the figure falls to 3 out of 11 (or 27%). Filling or building is found in 11 pictures (73%) and one or both of these are strong elements in 9 (60%).

Unlike the American and Japanese pictures, none in the French sample has a subject centered on the page with white space on all sides. This is the case even though 3 of the 15 pictures do have realistic subjects. These three contained a large number of elements spread over the page, but of course these three cases are too few to demonstrate a trend.

The human subject is rare in the French pictures. It appears three times if we count one abstract design that was "romanced" by the child and described as a human. The small number of humans, however, is explicable by the low number of realistic designs in general. Most of the children in the French sample drew abstract designs. Given their young ages this is not surprising. What is surprising is that few of these children, in comparison to American children in the same age range, produced kinetic scribbles.

Circles are also rare in the French pictures. Even the kinetic scribbles are not particularly circular in pattern, although looping does occur. One child (F 11, age 3.8), produced a semiscribble with a flower in the middle of the page. The flower is constructed from a schema that includes a well-drawn square! This square is surrounded by petals made of loops. None of the French pictures contains circles as the major design element.

Process in the French Pictures

I shall exclude scribbles from the detailed discussion of the French pictures, since they are no different from scribbles in the other cul-

tures in this study. What is interesting about the small French sample is the number of nonkinetic abstract pictures produced by very young children.

F 15 (*female, age 3.3, 6 minutes*)

F 15 is an unusual child. Her father is a professor of philosophy in a high school and her mother, who does not work, is trained to teach mentally retarded children. Her mother is also a talented artist. At the time of the study, this child spent her summers in the vilage that is also the summer home of her mother and her mother's parents. Her father comes from the north of France, while her mother and her mother's family are from the Midi. Since this study was completed, I have followed her progress in art and her drawing skills have progressed rapidly under the encouragement of her parents. The picture she drew for this study consists of a series of exploratory threads in red, green, blue, brown, and yellow. They were done slowly and do not appear to be kinetic in nature. Some of the threads are zigzags, while others are composed of loops. Both types of line are long and cover from one-fourth to one-half of the page in length. Most run across the page on the horizontal plane. A few red builds occur on the left side of the picture and a few marks are touching.

The picture was done with relative care. The pace was slow and the child's eyes remained constantly on the page.

F 13 (*male, age 3.6, 29 minutes*)

Although this picture has sections that resemble kinetic scribbles, much of it was done slowly and with care. I have actually counted it among the scribbles in the sample but describe it here because of the process by which it was drawn. The picture is dense on the top and on the right side. Both areas are dominated by large builds in black that cover smaller and more delicate red and green units. The left side is dominated by green meandering threads that overlie yellow threads and builds. Nearly the entire page is covered and little white space shows through.

The child began this picture with a red line in the center that moved from left to right. He then looped it down and then up to

F 13

close. Rays were added at the top of the closed unit. This was then attached with a yellow fill that was finally overlayed with black. Black areas were built up on the lower left and then on the upper right. A green pen was used to make a loop beginning on the right and moving leftward. This was followed by a series of kinetic loops within loops. The child then returned to the black pen and built upward over the red rays. The green pen was used to mark the lower left corner and was then brought upward into the other green marks. This was followed by a series of rapid color changes (yellow, red, yellow, black, brown, blue) as a great deal of overlaying was done.

F 11 (female, age 3.8, 5.5 minutes)

This girl drew a green flower centered on the page. It is unique in that the flower's center is a square. The square is surrounded by

F 11

a ring of nine looping petals. A stem line drops from the bottom of the lower petal and runs down toward the right, almost to the bottom of the page. The rest of the picture consists of rather large loops and ovoids on both sides of and below the flower. These are made in brown, red, and green.

This picture was drawn with considerable speed. It was begun with the central square. The first mark was a line moving from left to right and then down. The second was a line down the left side and then across to the right to close the square unit. The petal loops were added first to the top of the square, then down the left side and across the bottom. The right side was completed and the child drew a stem line running downward from a bottom loop. A red pen was used to make two ovoids, one to the left and one the right of the stem. A brown unit was added above the red on the right. The last (and longest) tightly packed loops were made with a black pen on the left, in the remaining open space.

F 12

F 12 (male, age 3.11, 7 minutes)

F 12 is the son of professional actors who now live and farm on a plateau near the study village. This child did not attend nursery school and spent a good deal of his time alone or in the company of adults. He did, however, have drawing materials of his own and used them frequently. The most unusual feature of his drawing concerns the description he gave it rather than the picture itself, which consists of two separate groups of loops and ovoids drawn in many colors. A brown ovoid at the top was described as a head. A blue circle at the bottom right was called a turtle. A red spot inside a brown loop below the "head" was called a frog. Three small spots between the head and the frog were "eyes." Yellow lines on the top of another unit to the left were called "a railroad station." A set of green marks inside a green loop on the left side was also referred to as a railroad station. A series of yellow threads connecting the two figures was called a "train." Brown threads were "hair"

and brown fill in the midst of these threads was "a spider caught in the hair." Blue marks on the bottom that touch the turtle made up "the turtle's house." No other French child provided such a detailed and imaginative description of a completed picture and, although the child was clearly romancing, he apparently felt the need to associate visual images with things and ideas. This appears to be an early reflection of the intellectual concerns of his parents, both of whom are artistic and highly articulate.

F 14 (male, age 4, 33 minutes)

F 14 drew a dense design that fills the page with a series of large builds and fills separated by white space. A few of them touch at tangential points. The use of color, particularly the yellow and red filling of a large, brown enclosed unit, plus the careful distribution of colored forms gives this picture (at least to me) a sense of organization and aesthetic impact.

F 14

F 7 (female, age 4.3, 18 minutes, but interrupted before finished)

This child's picture consists of several rows of colored dots that run from left to right across the page. Each color was chosen in order from the row of pens on the table next to the child. When the entire series had been used, the child ran through the colors again, always in the same order. If she accidentally picked up the wrong pen she immediately put it down and picked up the correct one. This child, described by her teacher as mentally retarded, said that her picture was of many beach umbrellas. If she had had time to continue to the end she would have undoubtedly filled the entire page with the pattern of dots. When forced to end the picture because lunch time had arrived, she had already covered over half the page with the same marks.

F 2 (female, age 4.3, 41 minutes)

This child drew a polychromatic abstract design consisting of a series of builds and fills that covers the page. Although reminiscent of F 14's picture, this one is made up of smaller units that are distributed more evenly on the page, although they appear in greater density on the left side. A good many of these units are separated by white spaces but, of these, some are connected by a series of multicolored threads that appear to wind through the design. The overall effect is, once again, rather pleasing.

The child began her picture with a black line down the middle of the left side of the page. This was expanded into a closed rectangular shape. Her attention then turned to the right side, where she drew a green curve that was immediately built up into a blob. Staying on the right but changing to blue, she outlined and then built up a blue blob. Working very slowly, she changed to black and built a unit in the center of the right side. This shape consisted of three lobes that were unfilled in their centers. These were then filled with yellow. Working on the left side just below the first brown figure, she built in red. The picture progressed in this way for some time. Towards the end of the drawing process she added the thin connecting threads that look to me as if they provide unity to the composition.

F 3 (female, age 4.6, 20 minutes)

F 3 drew a monochromatic picture in green. It consists of a house centrally located on the page surrounded by a series of flowers and indefinite shapes. There are two anthropomorphic figures in the picture, one on the roof and one leaning rightward on the right side of the house.

F 4 (female, age 4.9, 40 minutes)

This picture, drawn in many colors, consists of a house and a church outlined in green. Both structures appear at the top of the page. Different-colored flowers, some of which are filled and some

F 4

of which are outlined only, cover the foreground at the bottom. Another house and church occupy the middle of the page. These are drawn in approximately the same scale as the green buildings.

F 1 (male, age 4.9, 35 minutes)

This child drew a dense, semiorganized picture in several colors. It consists of two houses, one of which is filled in several colors. A series of animal, human, and bird figures occupies the space to the left of the houses and the sky appears as a blue fill on the top of the page.

This child began his picture slightly to the right of the middle of the page. The first unit drawn was a triangle that became the roof peak of a house. This was followed by the body of the house, the single door on one side, and the chimney drawn at the apex of the roof triangle. The house was filled in brown and blue the roof in red. The first animal to be drawn was placed on the left of the house. This figure was begun with the head, which was constructed of a circle. The right and then the left ear was added. The head was completed with a mouth line. After this it was filled in blue. The body, tail, and legs were added to the figure in that order. Another circle was drawn to the left. This began a second "cat," drawn in the same manner as the first. Then the child shifted to the lower right of the page and began another, larger house with a rather unbalanced triangular roof. No attempt was made this time to represent the house in three dimensions, with the result that it appears to be more primitive than the first, rather well-drawn, house. This sense of primitiveness may be due to placement. The front crowds the right edge of the page. The child may simply not have had room to put the side in as he had with the first house. The house was finished with a large door complete with a doorknob, and a few brown marks drawn onto the roof. The child's attention then turned to the top right of the page, over the first house, where he drew a boat. The hull was done first and then a sail was added above. Water was then built below the boat. Afterwards, the child drew a bird *below* and to the left of the house. This was drawn from the right side moving leftward to complete the figure. Moving to the lower left corner, the boy drew a circle and added eye spots, a nose spot,

F 1

and hair, in that order. A neck, rectangular torso, and legs with feet were then drawn to complete a human being without arms. Moving next to the top of the page, but still on the left, the child added a brown tree trunk and green leaves. A yellow sun followed on the top right *below* the water line. Blue sky was filled in at the top of the page. After adding chimney smoke that curves to the right and down around the roof, the child filled the boat in green and red. This was followed by a good deal of filling and retouching of various previously drawn figures. At this point there was still a good deal of open space left and the child ended his picture by adding new figures, primarily birds and trees, where he found open space.

This picture was drawn with a great deal of relish. As he worked, this child kept up a running commentary. He asked if he could fill in white space. As he did so new ideas occurred to him and he added new elements to the page. When he was finished he said that there were three little pigs in the house and that a wolf wanted to burn it down. The house on the right was described as a chateau.

The picture-making process in this case suggests that the child

did not have a total picture in mind when he began to draw. This lack of overall organization is evident in the finished product, but the addition of animal figures and the sky does tend to give the picture some coherence as a composition.

F 8 (male, age 4.7, 35 minutes)

This is the most highly organized and, for me, most aesthetically and conceptually successful picture in the French sample. It is drawn by a child who does art work at home as well as in school and whose mother is a teacher. The picture consists of several houses drawn in two lines, one line clinging to the bottom of the page and one crossing it in the middle. A house in the lower left corner is drawn in the same size as four houses in the second row, but the other two on the bottom are much larger than the ones above, giving the picture some sense of perspective. There is a yellow ground line at the extreme bottom. A sky, outlined in blue, crosses the top

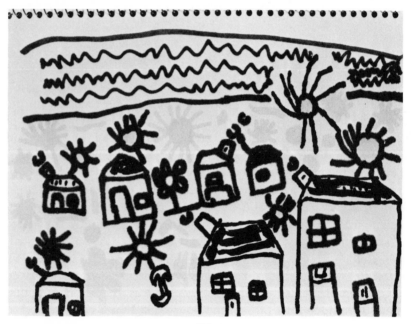

F 8

of the page. It is filled with three zigzags in blue but the lower line is broken by a sun outlined in brown, with large curving rays projecting from a yellow center. There are several other suns on the page, outlined in blue, brown, or yellow.

The first thing drawn in this picture was a mushroom-like shape on the bottom of the page near the middle. This was described as an umbrella. The child then began to draw his houses. The first of the series was placed in the lower left corner, drawn from left to right. Houses numbers 2 and 3 followed on a line from left to right. Suns were added over the houses. A flower was drawn above and to the left of house number 2 and the sky was added on top of the page. Afterwards, the child began to draw a second line of houses. More suns and details of these houses were drawn alternately until the page was quite full and the child declared that he had finished.

F 8's mother remarked after seeing her son's picture that she was building a house in the village and that her child was preoccupied by the construction. The fact that the village is in the Midi of France, a region of bright summer light, adds to the picture's significance *if* the many suns were used by the child as a device for showing this. The presence of multiple suns in the picture, however, may be nothing more than a filling device used by the child to complete his composition.

Summary Analysis of French Children's Pictures

In general, the French pictures in my sample are more like the Taiwanese and Balinese pictures than they are like those produced by American children. Like the Chinese and Balinese children, French children drew for a long time and produced complex designs. These differ from the Balinese pictures in that only two of the French children constructed pictures out of discrete marks (and one of these was said to be a retarded child). Furthermore, the French pictures are unlike the pictures from other cultures because they are frequently composed of large units filled with color. This is particularly the case for the nonkinetic abstract designs described above.

Although the French children in my sample have little guidance

in art, they have long attention spans and produce complex pictures. French children engage in a good deal of kinetic play during school periods and at home, but they also learn to sit quietly for long periods in the presence of adults, particularly during mealtimes. They learn early to control their energy and can, apparently, direct it into artistic activity that is not as kinetic as that of some of their American counterparts. The French children, unlike Americans and Japanese, who appear to be rather subject oriented when they leave scribbling behind, fill the page with abstract designs. Unlike Balinese, Ponapeans, and Taiwanese, the French use filling and building frequently. Units in a picture may be connected or separate (there seems to be no cultural rule about this), but separate units tend to be large and to cover a significant portion of the page. However, a considerable amount of white space may be left between such units. Thus the density in these pictures comes more from the size of the filled and built units than from the number of individual marks made on the page. In addition, unlike Ponapean pictures, French pictures are not drawn outward from any particular beginning point on the page. Since they do not follow a left-to-right or right-to-left progression, children work at random all over the page and what space filling does occur follows the Balinese and Taiwanese pattern.

UNUSUAL PICTURES

THE ABILITY to make successful pictures, to make art, derives from a series of skills that develop progressively but not necessarily at the same time.[1] Indeed, different types of visual art (representational versus abstract versus expressionistic) may require different visual, motor, and intellectual skills in different combinations. In contemporary American society, representational facility (through a culturally appropriate set of transformational techniques) is a goal that may be operative in art education even for those bound eventually to work in some form of abstraction (abstract art, conceptual art, etc.). Yet a child who draws unusual and aesthetically pleasing pictures, even profound pictures, need not have mastered representation. Conversely, those who have mastered representation may not be able to provide their pictures with those characteristics of design that are considered aesthetically successful. Representational and design skill *may* occur or develop in the same individual and both qualities must ultimately rest on experience. Except for unusual cases (limited, as far as we know, to autistic children), it is likely that the ability to represent, particularly among the very young, is *more* the product of learning than is the ability to produce

1. Nelson Goodman has said the following in relation to aesthetically successful pictures. "Three symptoms of the aesthetic may be syntactic density, semantic density, and syntactic repleteness. . . . syntactic density is characteristic of nonlinguistic systems, and is one feature distinguishing sketches from scores and scripts; semantic density is characteristic of representation, description, and expression in the arts, and is one feature differentiating sketches and scripts from scores; and relative syntactic repleteness distinguishes the more representational among semantically dense systems from the more diagrammatic, the less from the more 'schematic'. All three features call for maximum sensitivity of discrimination" (Goodman 1976:252). My data suggest that these three symptoms of the aesthetic can appear either separately or in combination in successful works by children.

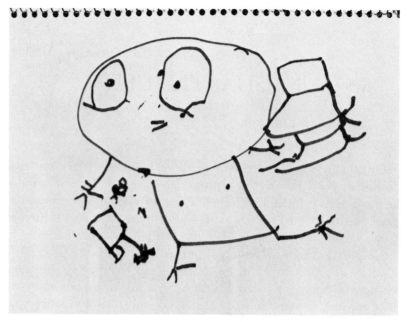

Batak. Age 2.5.

interesting designs. Experience in representation most likely involves some formal rule learning from exogenous sources. Experience in the making of abstract designs apparently develops from both exogenous *and* endogenous sources. Purely formal design skills appear to develop as children experiment with what they can do using their imaginations and their own work, as a source of self correction. Free play with form, which I believe is an essential element in children's artistic development, provides an important degree of reinforcement for successful designs. In young children, free play in art is not automatically connected to representation. It has been my experience that young children will not attempt to represent unless that task is set by adults. The data show that in Ponape, where children had the least passive and active experience with visual art, no child under 5 attempted to represent. In those cases from Bali and Taiwan where representation did occur in the work of younger children it may have been inspired by some notion of proper art already derived from adults.

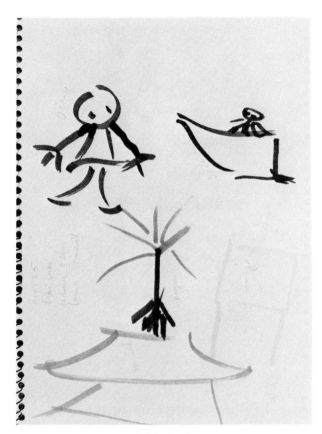

Batak. Age 3.

I do have one peculiar case that might contradict this idea. While among the Batak of Sumatra, where he did his doctoral field research, Larry Hirschfeld collected thirty-eight children's drawings for me. I am not exactly sure what kind of instructions the Batak children were given, since the pictures were made on request for teachers in the local school (although the sample contains both school and preschool children). In asking children to draw anything they want, for example, they might decide to draw some *thing*. Whatever the instructions given to the Batak, every child drew a series of objects. All Batak children, even those just over 2 years of age, did this and they did it surprisingly well. In fact, the Batak representa-

Batak. Age 4.

tional skill is one unexpected finding of this study. On the other hand, none of the Batak children combined their objects into pictures. In each case a series of compositionally unrelated things was drawn over the page. Batak children apparently understood the task as one of representation, but not necessarily as one of play with visual elements. In *this sense* they did not draw pictures. This material will be discussed again in the next chapter.

I do not mean to suggest that there is a deep dichotomy between representation and abstraction. Good pictures are well designed as well as properly executed according to cultural norms. The satisfaction that comes from playing with form and using learned rules

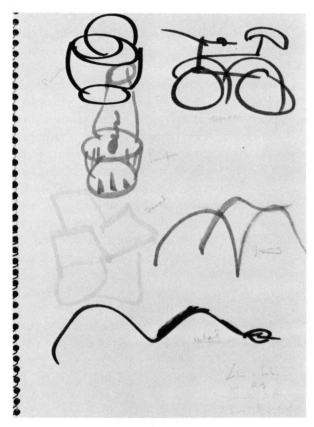

Batak. Age 5.

must both enter into the production of aesthetically acceptable art-
work. In the chapter on Bali, I used the relatively primitive depic-
tion of the human form as an index against which to judge the skill
by which Balinese children produced *apparently* complex as well as
aesthetically successful pictures. I do not wish to argue that the pic-
tures drawn by these children are not aesthetically successful, only
that they are not particularly complex. Balinese children learn early
to conform to one imperative of the Balinese aesthetic, the use of
discrete elements in an overall dense design. It takes them a long
time to master the other aspects of Balinese art and to produce suc-
cessful examples of it.

During the course of this research, I accumulated a small number of unusual pictures.[2] The goals and methods of this study make it impossible to make definitive statements about the status of these pictures, but they appear to me to be the products of talented children. I am aware that my judgment of these pictures is based at least partially on subjective criteria and that if others had been requested to make a choice of this type the selection might be different. I am also aware that my familiarity with and appreciation of modern art colors my judgment. The pleasing nature of some of the drawings may be the result of a rather primitive set of skills that leads accidentally to pictures similar to those produced by accomplished artists in our own culture. The similarity is formal but the routes to success may be totally different. The film record, revealing as it does how each of the pictures in my sample was done, however, allows me to discriminate various drawing processes. I believe that this material permits one to make some objective, if guarded, statements about the work of a very few children whom I regard as talented. A larger sample of the work of each child plus some knowledge of development within the context of each culture would be necessary to confirm what are essentially guesses.

In order to help objectify what I mean by talent I offer the following set of four design capabilities. It is not required that each of these occurs for talent to be present, but at least one of them must be seen in the work of any child to whom I would attribute talent. The first trait is the ability to represent, a skill I believe is not necessarily "inborn" in children who possess it. Representational ability involves the discovery through experimentation and/or education of transformative rules and the application of these rules so that realistic elements taken from the environment can be drawn in a culturally acceptable fashion. No art is realistic in an absolute sense and all art must, therefore, involve transformations that reduce physical reality to a pictorial analogue. The tricky thing about this is that successful representations may be of two types: (a) standard

2. All of these pictures are unusual by two criteria. (1) They stand out as different *and* (for me) aesthetically pleasing in the context of the culture from which they come. (2) I judge them as generally aesthetically successful according to my own evaluations. I realize that the second criterion is totally subjective on my part and I leave it to the reader to judge with what success I have chosen.

representations based on existing cultural convention, and (b) innovative representations based on new ways of transforming, that are then accepted as successful innovations by viewers.

The second capability is the ability to design pictures that work within a cultural frame (and sometimes across cultures) as overall abstract compositions whether or not they actually are "realistic" or "abstract" or a combination of these.

The third capability involves a degree of intellectual cleverness that is translated into the visual mode through drawing. This is the ability to use creative ideas in visual presentation. When a child uses multiple suns as an iconographic tool in order to communicate the idea of bright sunlight, as one French child may have done in his picture, this is intellectual cleverness in visual art.

The fourth capability involves the ability to use stock elements borrowed from the standard visual symbols of a culture to produce new and aesthetically successful realistic pictures. This ability, it should be obvious, is difficult to separate from the ability to design pictures that work as overall compositions, since any designs using stock symbols must work as compositions.

In the course of this study I have come upon eleven pictures by different children that suggest the presence of considerable artistic potential. Two of these are from Taiwan, two from Bali, two from Ponape, two from France, and one from the United States. While all are pleasing to the eye from the point of view of this American's aesthetic, some are unusual, particularly when the cultural context in which they were produced is taken into consideration. This is especially true of the two Ponapean pictures. Ponape was the one place studied where there is very little present in the contemporary culture to stimulate artistic creativity in children. Children in Ponape have little or no chance to experiment with visual art and even in school the learned and standardized symbols are small in number and reduced to visual cliches.

The pictures I am about to discuss were chosen for their visual and, in at least one case, their intellectual qualities. With one exception, skill at representation was not a criterion. These pictures were made by very young children whose representational skills had not yet developed, if indeed they were to develop at some later time.

Some of the pictures chosen may be the result of a single happy accident, but looking at them, as well as the film record of their production, I am convinced that they indicate more than average artistic skill. Each of these pictures must be judged against its cultural background and the age of the child who drew it.

I have not included any representations of the human figure here although some pictures of this type were quite tempting. These have been eliminated because young children often produce effective representations (or at times what appear to be caricatures) of human beings by accident rather than by design. These are often judged extraordinary by adults through complicity and willingness to accept distortion in certain contexts. An understanding of the relation between individual and cultural variables in the creative drawing of the human figure will have to await additional developmental studies of children's art.

The one picture that stands out clearly in the American sample is by the son of an artist, age 4.8. It is both the most complex and fully organized of the American sample. The picture, described in the previous chapter, is dominated by a well-drawn train that crosses the page from left to right. Elements of landscape as well as a house and airplanes appear in the picture. Red dominates the center of the page (train, house, and central parts of the two airplanes). Green is used on the bottom and on the two sides of the page, and blue is scattered in small spots throughout. The variety of objects and skill with which they are portrayed, the harmonious use of space, and the distribution of colors all contribute to making this a successful picture. Considering the child's age, these means for constructing pictures are used with considerable skill. Judging from the speed with which the child drew as well as the order in which specific figures were constructed, he must have had a good deal of practice in drawing. While these figures have "childlike" forms (they represent the use of a set of learned formulae), their treatment is rather advanced, particularly the train and the tunnel. The house is also drawn with considerable skill and appears to be three dimensional. By placing the chimney on the roof ridge, the child avoids the common mistake made by children of his age and older of drawing it at a right angle to the diagonal roof edge. Although it

may not be significant, the use of green to color the sun appears to be a deliberate compositional choice, since it fits in with the use of this color as an important peripheral element in the overall color scheme. It is also notable that even though this picture as a totality was probably not planned in advance, it was finished in the rough before the addition of smaller details and fills in color. The film record suggests that it was finished only when the child was satisfied with the use of space and the overal composition. The depiction of large airplanes in the foreground indicates some sense of perspective by size. This drawing conforms to capability 4, the use of stock elements to produce new aesthetically successful realistic pictures. It is likely that this child's early exposure to his father's artwork has had a strong influence on his own artistic development.

Two pictures stand out in the Japanese sample, one for its subtle, realistic delicacy, the other for its unique and coherent composition. J 21, a girl, age 5.9, drew a picture with a set of stereotypic Japanese children's subjects. These were flowers and butterflies under a sky. Her picture, however, is notable because of the way she treated and organized these subjects. The lower part of the page is dominated by three red tulips that stand in their own small patches of green grass or base of green petals. These are well spaced on the page and the middle one is higher than the other two. It is also slightly to the right of center. A fourth, completely green flower (that might have been intended as a butterfly) is drawn close to the middle tulip. Two yellow butterflies, each with four small green spots on its wings, rise above the flowers. One of them is to the left of the flowers, and the higher is above the highest flower. This arrangement provides the picture with a harmonious geometric arrangement that slants down from a central focus on the upper butterfly strongly to the left and with less force to the right. This triangular structure is accentuated and complimented by the child's representation of the sky, which appears as a series of close zigzags that are thick on the two sides but thin (producing the effect of a rising arc) in the middle. Each figure is drawn with a delicacy that adds to the stylistic unity and is pleasing to the eye. The picture provides an excellent example of a personalized use of delicate elements that are common among children in Japanese culture. Again

J 21 produced a drawing that conforms to capability 4, the ability to combine stock elements to produce new aesthetically successful pictures.

The picture drawn by J 1, a boy, age 5.5, is stylistically unique in the Japanese sample. In this picture the child imposes his own spatial conception rather than accomodating to the rectangular page. It consists of a single connected and coherent design that fills the space of an enclosed ovoid. Somewhat reminiscent of a Paul Klee, the picture is dominated by three figures; a yellow fish-like object that faces right, a red crescent moon with its convex surface to the right, and a large blue star on the left of the colored area and to the left of the moon. This star, by accident or design, follows the general movement of the picture, which flows from left to right. It reaches from a little below the highest point of the moon to just below it. Its right point juts out from a side that is drawn to thrust forward. The left side appears as an indent (its two points form a negative space between them for the strong black fill). The left side of the design contains a series of smaller stars that curves upward from the bottom left, off toward the right. These are balanced by the brown border fill that begins on the top left, sweeps right, goes down the right side and finishes all the way to the left on the bottom. The bottom of this brown border is thicker than the top, giving balance to the outside of the design. The fish rests on the brown fill. The outside border of the design is perpendicular to the page, while the right border is convex. This increases the overall sense of movement to the right. The large arc produced by this border on the right repeats the convex thrust of the moon. In contrast to J 21, J 1 drew a picture that conforms to capability 2, the ability to design pictures that work as overall abstract compositions. Even though this picture does employ some stock representational elements (stars and the moon) the overall effect comes from its abstract gestalt rather than from aesthetic pleasure that depends on the way in which realistic elements are presented.

To a naïve observer, the finished Balinese pictures, made up as they are of a myriad of apparently balanced polychromatic marks, are not only aesthetically successful but also highly complex in structure. An examination of the films reveals that these pleasing

pictures are generally the result of a simple compulsion to fill space with a large number of independent marks. Within the context of Balinese culture and Balinese children's art, such pictures are not unusual. Their aesthetic effect is the result of the simple application of what must be culture-specific design rules without the skill of the adult Balinese artist who, just as compulsively, fills the page, but with complex and well-drawn forms ordered into a coherent composition. Only one Balinese child in my sample drew a somewhat original picture, in which she made creative use of the imperatives of Balinese design structure. The fact that this child was one of the younger subjects in the Balinese sample increases the possibility that her picture represents the work of a potentially exceptional artist. B 24, a girl, age 4.6, drew a well-balanced design made up of realistic figures combined into a repetitive pattern. These figures represent sacrificial objects that occur in different shapes, and are made each day by women and girls as offerings to the many demons that threaten the stability of Balinese life. They are composed of small pieces of banana leaf on which a few grains of rice and perhaps a few flower petals are placed. Such ritual objects are left on the ground around the house. In B 24's picture, large square offerings alternate with smaller triangular ones. The larger squares are outlined for the most part in red, though one of them and the smaller triangular forms are outlined in blue. A few curved shapes in the picture are also drawn in blue. The squares are filled with green wavy lines that represent those things that are placed on the leaf surface when preparing an offering. Some of the triangular forms are filled in red. The red outlines of the large squares are balanced by the red fills in the smaller triangles. The overall unity of this picture is achieved through repetition and by the general centering of the large squares that are drawn to form three lines across the middle section of the page. Blue triangles with red fills dominate the right upper corner of the picture and slant downward toward the middle of the right edge. The rest of the picture is filled with the typical small marks so characteristic of Balinese children's drawings.

The interest generated by this picture is enhanced not only by the strategic positioning of the larger elements that focus one's at-

tention, but also by the unusual (for Bali) use of well-defined shapes that, when repeated, have a special visual strength. In this case the use of representation adds to the purely formal aspect of repetition that is seen so frequently in the abstract designs of young Balinese children. Since not many young Balinese used realistic elements in their pictures, such use may be another indication of possible talent. It is possible that this picture represents a combination of capabilities 2 and 4 in which aesthetic success depends upon both abstract structure and successful compositional realism.

A few older Balinese children asked if they could draw for us. One 8-year-old schoolboy drew a picture which, though by no means unique, might be worth examining, particularly in the context of Jane Belo's 1938 collection of Balinese children's art from the village of Kuta. I have already noted that Belo's methods were different from my own and that the children in her sample saw each other's work for some weeks during the project. Belo was impressed by the drawing skill of the Balinese children, particularly by their sense of composition and their ability to draw the complex beings taken from Balinese mythology. Many of her drawings depict what look like *Wyan Kulit* (shadow puppet) characters in the midst of some action. I have no comparable pictures from children as young as some in Belo's sample, and indeed the only one that is, in composition, similar to Belo's is that of B 21, the 8-year-old boy mentioned here. His picture is typically dense and is composed of three different repetitive figures that cover the page in blue and yellow. These figures are palm trees, birds, and helicopters. The design is balanced in color use, with yellow surrounding the dominant blue. The birds and the helicopters all face to the left of the page. Four lower birds, two on the ground line and two above it, are walking, while two birds drawn on the top left are clearly in flight. This child's style and his quick, sure touch remind one of Belo's pictures, which were collected over thirty years before. The stylistic similarities between this picture and Belo's suggest a strong continuity in Balinese children's art.

Two very different pictures stand out in the Ponapean sample. These are by a boy (P 12, age 5) and a girl (P 26, age 8). Both treat themes popular among Ponapean children in their school drawings,

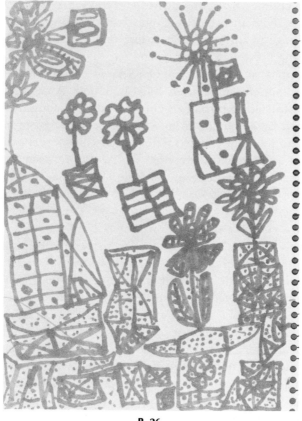

P. 26

although P 12 was a preschool child. His picture, described, is of a house or schoolhouse and stands out because it is drawn in partial perspective and is filled in color. Whether this picture is the result of good memory and/or skill is difficult to say, but the picture contrasts markedly with the rest of the Ponapean sample. It is clear that this picture's success rests upon capability 1, the ability to represent, in this case the ability to represent perspective, unusual in a child of this age in any culture.

P 26's drawing is also quite unusual, and is also one of the most, if not the most aesthetically successful of the Ponapean pictures. It is drawn only in red and uses the two available school themes in

Ponapean children's art, the flower and the schoolhouse with flag, but it uses them in a most complex way. The picture was drawn with the page in the vertical position (one of two with this orientation in the Ponapean sample). The page is densely packed at the bottom with a series of rectangular shapes. These are divided by triangular lines and are densely filled with dots. A large rectangular shape constructed in turn of rectangles is drawn along the left side. It is topped by a triangle from which a flower stem projects. The right side of the page is filled with two box-like structures, each of which has a flower growing from it. Two more such boxes with flowers float in the middle of the page. The flower in the extreme right upper corner has a series of thin, ray-like lines projecting from its loop-petals.

This is a complex composition that is built out of simple elements. The rectangular and triangular shapes of the schoolhouse and the round flowers are combined in a series of variations that add up to an aesthetic whole. It was my impression that this child (in whose house I lived while in Ponape) is quite bright. Her picture suggests that she has the creative power to explore available design elements in her culture and to combine them creatively. This picture is another clear example of capability 2, in which the abstract nature of the design outweighs the use of realistic elements.

The small French sample has many rather unusual pictures that in general are characterized by the juxtaposition of bright colors filled into large abstract shapes. F 2, a girl, age 4.3, drew a picture that is reminiscent of Miro's work. Although I would not suggest that adult level control was used in making this picture its clear color zoning, its balanced distribution of design elements, and the contrasting use of thick islands of color united by delicate threads, contribute to a successful composition. It is impossible to know whether the unity of this picture is an artifact of random drawing or is the result of some conscious or unconscious compositional sense. I can only say that most of the threads were added at the end of the drawing. When filling outlined areas this child took great care not to run one color into another. All this suggests intentionality.

F 8, a boy, age 4.7, drew a realistic composition that is possibly an example of intellectual skill (capability 3) used to transform an

idea into a visual scheme. This is the picture (described above) in which houses and many suns are used as repetitive elements in an integrated composition. The picture is structurally pleasing because of the repetition of realistic elements that vary in size. The way these are distributed on the page accentuates the design gestalt of the picture. The child's actual skill in drawing realistic objects was about or just above average, but his sense of composition appears to be advanced. The fact that he used suns rather than some other element to fill space raises the question of intellectual inspiration. Most children who draw formula pictures (this one uses formulae to draw both houses and suns) put a single sun somewhere near the top of the page.

Two pictures stand out in the Taiwanese sample. One of these involves the use of a single repetitive element that is varied in size, while the other is a truly original abstract picture drawn with great control by a very young child.

C 26, a boy, age 6.10, drew a series of mice in red outline across the entire page. A line of small mice (with round shapes that signify their food) is drawn across the bottom of the page under a ground line. The center of the picture is dominated by a very large mouse whose nose is left of center and whose tail runs diagonally upward to sweep the right side of the page almost to the upper right corner. The nose is just above a dish (?) of food, which is an "X-ray" drawing, since we can see the contents through the sides. This X-ray drawing technique is repeated everywhere in the picture that the child drew food containers, but none of the mice are drawn in this way. These animals, drawn with great speed, are formula patterns in every respect. Each was the product of exactly the same stereotypic kinesthetic and visual program. The only variations used in this picture are the size of the mice, and the fact that one of them faces right instead of left on the page. The one rightward-facing mouse is cruder than the other mice, supporting the notion that the child was following a stock method of drawing. What gives this picture its charm is the repetition of the single theme, the variation in size, and, of course, the reversed mouse. Again this picture displays the use of capability 2, in which design reigns over realistic content.

C 39, a boy, age 4.5, drew what is my favorite picture in the

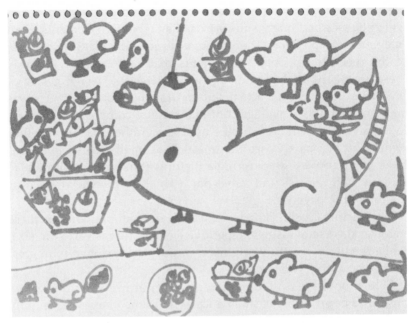

C 26

entire sample from six cultures. I was amazed to watch it unfold as the child carefully divided the space on the page and chose his colors. I am not suggesting that the entire structure of this picture was planned in advance. Rather it tended to follow a Markov chain process, in which each single step influences (or determines) the next step.

This picture was described in chapter 5. It was begun with the drawing of a circle in the left center of the page and grew to cover the rest of the page with a series of colored rectangles. It is a satisfying abstract design that works in both the contrast of the circle (the central focus) to the rectangles, and the way in which color is used to fill the page from edge to edge. Interestingly, this boy was said to be "slow" by his parents. They also said that he did not know any of the basic Chinese characters that children are encouraged to learn before they enter school. It may be that his inability to use characters, for whatever reason, freed him from the typical patterns used by Chinese children when they draw. As I have ob-

served the patterns involve small units, which are kept independent of each other and cover the page, are suggestive of Chinese writing. C 39's picture is the most deviant of all the Chinese pictures and is based on a completely different kind of organizational pattern. C 39's drawing is the purest example of capability 2. It is a purely abstract and totally coherent work of considerable aesthetic impact.

An examination of this small sample of unusual pictures, some or all of which I believe reflect a true creative talent in the children who drew them, reveals two important lessons. Some of these children worked within the confines of a children's version of their own culture's style and, in this sense, produced pictures much like those of other members of their cohorts. But for these children the familiar was exploited in a nonfamiliar way to produce new combinations in aesthetically pleasing compositions. A few other children broke completely with the culturally determined style and struck out on their own to produce pictures based on personally created units and compositions. These are two paths to creativity.

CONCLUSION

THE MOST interesting findings of this study concern design patterns and those processes that appear to direct their making. However, since a great deal of research has been done on children's drawing of the human figure, it seems appropriate to begin the last chapter with this topic.

If we eliminate the drawings of humans or anthropomorphs by children older than 6, we get the following distribution of human and humanoid drawings: 11 from Taiwan, 5 from Ponape (of which one was a requested second picture), 2 from France (in a total sample of 15), 14 from Japan, 6 from Bali, and 13 from the United States. Taking into account that the American sample was the largest (45 children), the only important difference in the numbers of humans drawn is between children with and without school experience. The samples are not large enough to make an informative within-age comparison across cultures.

Claire Golomb (1974) has traced developmental sequences in the representation of the human figure and has shown that, while more-or-less regular stages exist, these cannot be pinned down within narrow age limits. Even with experience, some children lag behind others before they move to a more sophisticated state of representation. Thus, a large sample would have to be collected in each culture and for each age group to provide an adequate set of drawings. Some things can, however, be said about the total sample of humans in my collection and some rough comparisons can be drawn between cultures.

Taken as a whole, the Japanese children's drawings of humans are the most sophisticated in the sample. This is consistent with the amount of art training even Japanese kindergartners are exposed to.

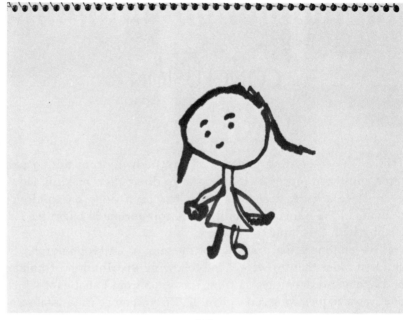

J 35

Although there is individual variation, and although the youngest children tend to draw incomplete figures that emphasize the head, experience after the earliest attempts appears to be the most important factor in the development of human figure drawing. One child, J 28, (age 3.11) drew two anthropomorphic figures with closed trunks and was able to add such details as hats and two different kinds of animal ears. While another child of the same age (J 22) did not match this sophistication (she drew a rather crude head without a body), the next-oldest child (J 35, age 4.2) drew a well-formed female figure in closed-trunk style with long hair and a triangular skirt. J 25 a girl, age 4.5, drew a rather crude large-headed figure with a closed trunk. Details included a hat and well-drawn eyes. J 26, a girl age 4.9, drew a very primitive head, but she and J 22 were the only Japanese children to make such primitive representations of the human figure. The other children who drew humans, including J 13, age 4.11; J 12, J 15, same age; J 5, age 5.1; J 18, age 5.3; J

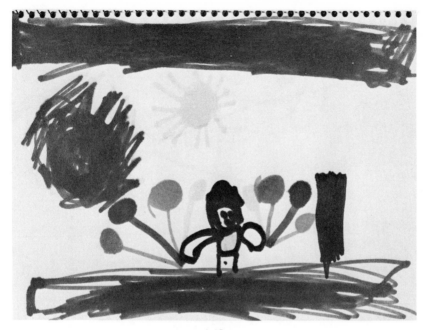

J 18

7, same age; J 19, age 5.8; and J 8, age 5.9, drew a variety of closed-trunk figures, with such details as hair ribbons, filled dresses, etc. Two of these children drew figures without arms (J 7 and J 19) but neither picture was particularly primitive in style.

The children of Ponape and Bali produced the least sophisticated human and anthropomorphic figures. These are the children with the least drawing experience. Human figures in general were extremely rare in Ponape, even among schoolchildren. When I asked a 3-year-old Ponapean girl to draw a man for me as her second picture, she drew a series of threads winding down the left side of the page and trailing off to the right along the bottom. One 5-year-old (P 23) described previously began her figures with a simple head circle and a single line down from the head to form the body. After a few minutes and several tries, however, this child did produce well-formed stick figures complete with facial features. The only other young Ponapean who drew a human figure on his own was a

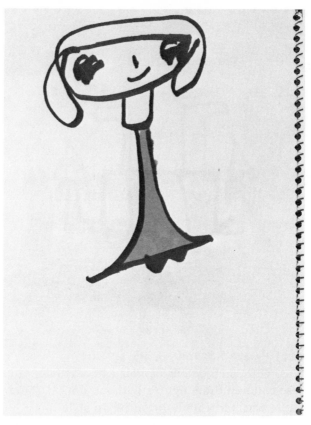

J 7

5-year-old schoolboy whose mother is American. His figure was of the closed-trunk type, and, although it lacked arms, it was well formed and clothed.

I have already used the primitive drawing of the human form in Bali as an index of skill when discussing Balinese abstract designs. Few Balinese drew humans and only one (B 6, a boy, age 6.5) produced a well-formed closed-trunk model. The sample includes two children who drew tadpole figures (B 9, age 5.2, and B 40, age 4.6) and three who drew closed-trunk figures with legs but no arms (B 39, age 6; B 19, age 5; and B 22, age 5 or 6). Only one Balinese drew a complete closed-trunk figure with arms and legs (B 6, age 6.5).

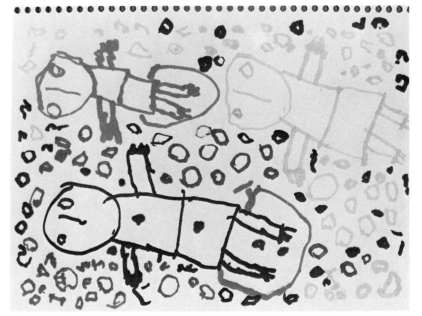

B 6

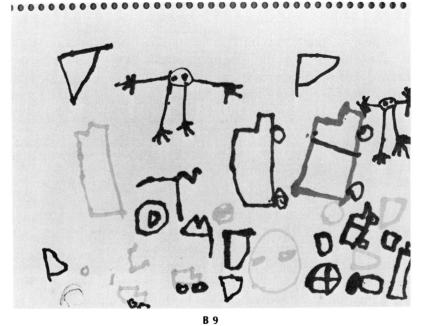

B 9

C 8b

In general, the preschool Chinese children drew human figures on about the level of the Americans in the sample. These ranged from closed-trunk figures by a child as young as age 4.4 (C 8) to very primitive figures without limbs but with eyes complete with eyelashes (C 32, 5.8 years old). C 8, age 4.4, drew a well-formed closed-trunk figure with hands and feet placed at the ends of stiff, rectangular arms and legs. The head in this picture is out of proportion to the body and dominates it. Facial features include hair, eyebrows, ears, and a two-line mouth. C 9, age 4.6, drew a tadpole figure without arms and a closed-trunk figure with the torso divided into two sections. This second figure lacks both arms and legs. A boy, age 4.7, (C 27) drew tadpole figures with eyes, ears, and (in one case) hair strands to indicate hair.

The French children in my sample, who do so well with color and who apparently enjoy playing with form, do not do very well with the human figure. The two pictures with recognizable humans are both quite primitive. A girl age 4.6, (F 3) drew two humans, one of

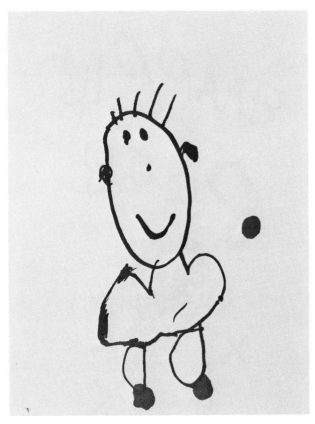

A 30

whom lacks both arms and legs, while the other has no arms. One
(apparently female, judging from the long hair) stands on the top of
a roof and the other leans at a 45° angle away from the house. F 1,
a boy, age 4.9, drew a very awkward closed-trunk figure without
arms.

The American children in this study hold their own with the rest
of the sample except for Japan, where the level of drawing in gen-
eral is more sophisticated than in the other cultures studied. Com-
plete figures range in type from tadpole to closed trunk. Three chil-
dren drew heads only, but I would hesitate to classify these as
mandala figures, since at least two of them look like unfinished hu-

A 34

mans or even portraits. A girl age 3.8, (A 30) drew a closed-trunk figure with a large head and no arms, but a boy age 5.8, (A 34) drew a primitive tadpole figure.

Design Process in Six Cultures

Even a cursory examination of the data shows that a considerable amount of stylistic consistency exists within each of my six subsamples. This is most marked among children without school experience, but it occurs to some extent even among schoolchildren.

Equally striking are strong stylistic differences among the six cultures, but particularly among Ponape, Taiwan, and Bali. These appear early and persist through all age groups. It is quite clear from the data that cultural influences appear early and have a strong effect on the overall style of children's drawing. Leaving aside similarities in the development of human figure drawing (there appear to be real cross-cultural regularities in this domain) generalizations about particular stages of development in children's drawing appear to be false. My data also strongly suggest that development from scribbling toward representation is not an automatic result of maturation, or even of experience with drawing. Children are often content to play with form and need not imbue this form with meaning. In most cases in Ponape, Taiwan, and Bali, when children who had drawn what appeared to me to be abstract designs were asked what their marks were or meant, they did not respond with a "romanced" description of their work. The question did not seem to mean anything to them or to have any importance.

While this study suggests that culture plays an important role in the development of style in children's drawing it does not prove or disprove the hypothesis that universal aesthetic principles exist in humans. There are two reasons for this. First of all, it may be that such principles do not emerge until rather late in the developmental process and that when they do emerge they depend upon both inborn propensities and experience. My observation of a group of teenagers in an art class in the Ponape high school, who had been doing art for about six months prior to my visit, showed a rather spectacular emergence of skill in a short time.[1] While not all the students drew with equal facility, all had learned the fundamentals of picture making and a few showed what might be called "talent." (The latter cases may be the result of greater interest in the art course on the part of these students, or it may be the result of the rapid emergence of certain drawing skills in a minority of them.) Secondly, any universal aesthetic principles that may underlie success-

1. I realize that drawing skills alone are not equivalent to aesthetic rules, but the late, rapid emergence of such skills in older children who have had no previous drawing experience suggests a connection between the ability to represent and at least a part of the overall aesthetic domain and its development.

ful art in different cultures will have to be generative rules rather than absolute determinants of form. The fact that many different languages exist in the world cannot be taken as evidence against the existence of a universal grammar that sets the limits for all specific grammars, and we already know that art styles differ markedly from culture to culture and from one historic period to another. We cannot find universal principles in surface phenomena alone.

Although a good deal more cross-cultural work on the development of drawing as well as the development of artistic "taste" will have to be undertaken before we can even begin to find out whether or not aesthetic universals exist, I shall suggest below that the apparently wide differences in the art work of unschooled children from Bali, Ponape, and Taiwan can be reduced to rather simple generative rules. Thus stylistic differences that appear to be quite profound can be brought about through rather small variations in drawing strategy. As I suggested in the introduction, we need to know if these variations are finite, and what the generative rules behind them are, before we can make any judgments about universal aesthetic principles in the process of making art.

Summary of Drawing Styles Among Nonschool Children in Ponape, Bali, and Taiwan

Ponapean children tend to draw connected abstract designs that work outward from an initial mark. If more than a single aggregate is drawn early in the picture-making process, these are generally connected into what becomes a coherent whole by the time the picture is finished. In the village of Awak, drawings were primarily monochromatic, but for unknown reasons in Saladek a smaller group of children yielded a higher frequency of color use and some stylistic differences as well. Page filling occurs in Ponape, but does not seem to be a major stylistic imperative. Drawing density is also high in some pictures, but, again, is not a consistent trait.

The Balinese pattern includes a high degree of polychromy. Most children use three or more colors and many used all but black. There is a strong tendency in Bali to fill the page with a dense array of

small independent marks or simple units such as circles or ovoids. In the drawing process, the Balinese child usually begins with a relatively open placement of medium-sized marks that wander over the surface of the page. As the drawing continues, these become progressively smaller. When realistic forms are used, the rest of the page is filled in with independent, nonrepresentational marks.

Taiwanese preschool children also tend to fill the page, but this is often done with small simple or compound *units* rather than independent marks. These units may be abstract or representational and generally do not touch each other. Color use among Taiwanese children is not as pronounced as among Balinese children, but is more pronounced than among Ponapeans. Like the Balinese, Taiwanese children tend to begin their pictures with the largest forms and to end with smaller ones. There is a somewhat greater tendency in Taiwan to follow a linear process when filling the page.

The data on preschool children, particularly from Ponape, where the contemporary culture contains almost no visual art of any kind, suggest that representational and/or overtly symbolic art does not automatically arise at some stage in the development of children's drawing. Although some representation occurs in the preschool samples from Bali and Taiwan, it is much less pronounced than in the samples of kindergarten children from Japan and the United States. The French sample is too small and contains too many very young children to allow any firm judgments about the frequency of representation.

The only counterevidence I have for the idea that representation does not occur spontaneously is the sample of 38 pictures by Toba Batak children. Although I cannot say exactly how this set was obtained, I instructed the anthropologist who obtained it, Larry A. Hirschfeld, to follow the same procedures that I used in collecting my data. Hirschfeld informs me that the pictures were drawn in a schoolhouse under the supervision of Batak teachers. Three different individuals collected different parts of the sample and it is apparent that at least some of the children saw the work of others. Given these restrictions, the Batak pictures are amazing for the skill with which Batak as young as 3 years old produced representational drawings. The curious thing about these drawings, aside from the

skill they demonstrate, is the fact that none of them are composi-
tions. Each Batak child drew a series of unconnected objects, ani-
mals, and people on the page. Batak children apparently see the
drawing task as a representational one *but not* as a compositional
one. It should be noted that the Batak are well known for their skill
as artists and that the Toba village studied by Hirschfeld contains
many highly decorated houses and a large array of other art objects.
On the basis of my data I believe that representation and symbol-
ism are things children are consciously or unconsciously taught to
do by adults and other children. This leads to the conclusion that
the only safe definition of children's drawing can be "playing with
visual form." This definition should not be construed in any pejor-
ative sense; it is offered to clarify what it is that happens when
naïve children are allowed to draw freely. It may also serve to dis-
tinguish between what unschooled children do when they draw and
what artists do. Artists have learned to draw with some kind of
plan, a factor that is not inherent in children's drawing. Artists,
even those who consciously adopt a set of special randomizing rules
for picture making, have a preconceived strategy for arriving at some
aesthetic end, while children tend to follow what is, at most, a semi-
Markov chain process in their picture making. The structures that
emerge in children's drawing are built up as each move (each mark
or set of related marks, but also what is already on the page) comes
to influence the next move. Some artists, particularly in our own
(modern) culture, have attempted to adopt this semirandom means
of picture making, but this choice is made more in opposition to
the way art is "normally" made than as an autonomous and spon-
taneous method. It is the result of a culturally determined art his-
tory rather than some natural way of making adult pictures.

The children in my sample who drew for the first time were clearly
constrained by cultural influences. The data thus disconfirm most
of the specific sequential schemas proposed to describe the devel-
opment of art in children, particularly those that entail an orderly
movement from a scribble stage to representation. I have limited
the use of the term *scribble* to drawing heavily influenced by motor
activity in order to distinguish between kinetic drawing and the
production of abstract visual forms through controlled drawing.

Children below a certain age *will* produce kinetic scribbles, but after the kinetic scribbling stage ends one cannot predict what the picture-making pattern will be in any specific culture that does not include some form of Western-style art education. On the other hand, general rules concerning drawing strategies rather than specific forms appear to have some cross-cultural validity. The set of rules offered by Goodnow (cf. chapter 1), for example, confirmed by my finding that a semi-Markov process directs emerging structure, works for drawings by young children in at least three of the cultures I studied. Thus I *can* suggest that certain principles of attack are held in common by children everywhere and that these general principles interact with specific conscious and unconscious culturally based rules to govern what kind of pictures children will make.

Rules for Making Pictures in Bali, Taiwan, and Ponape

The processual rules for Bali are: Begin anywhere; using many colors cover the page with marks, or simple units (circles, for example); do not allow these to touch. As space becomes filled, search for open space and fill with marks of decreasing size.

The processual rules for Taiwan are: Begin anywhere; using many colors cover the page with marks but more usually complex units; do not allow such marks or units to touch. As space becomes filled, search for open space and fill with marks or units of decreasing size. Some Taiwanese children substitute a linear progression across the page for the filling procedure.

The processual rules for Ponape are: Make a mark or simple unit anywhere on the page. Build the picture outward from this starting point, but, as the picture builds outward, close back on it. Some Ponapean pictures begin with more than one focus, but usually by the end of the picture the separate aggregates are connected to each other. There is no strong page-filling imperative in Ponape.

An important question remains. What are the reasons for the observed differences in these three cultures? I can only guess at these, but would like, nevertheless, to make some suggestions. Balinese pictures, all from the village of Batuan, look like children's versions

of what adult artists do in the same village. The Batuan style is characterized by dense and complex polychromatic designs that cover the page. In addition, the Balinese child's use of myriad small and independent marks is reminiscent of Balinese music, which consists of a continuous interplay of rhythm and melody played primarily on percussion instruments (gongs, bells, metalophones, and drums). Balinese dance can also be characterized by complex sets of independent movements made by isolated parts of the body (feet, legs, trunk, neck, head, eyes, arms, and hands) often with stacatto, disconnected changes in movement direction. Overall, Balinese painting, carving, dance, and music are all pointillist in style. This style is also characteristic of Balinese children's drawings. These children lack the representational skill of adult artists, but they successfully imitate the style of adult art.

The Ponapean children who drew for me were very shy. Having no experience with art to fall back on, unlike the Balinese and Taiwanese, they drew abstract designs that I believe reflect their insecurity and indecision in a new and strange situation. The fact that Ponapeans tend to connect their marks and to draw what becomes a single whole may be an unconscious pictorialization of the situation in which they find themselves and a search for security. Ponapean schoolchildren displayed the same shyness when faced with drawing, but they had two ready-made models to fall back on. Their pictures reflect this as well as their general unwillingness to experiment in the face of an unfamiliar situation.

Taiwanese children are somewhat familiar with art, but they do not draw in the home and their parents undervalue artistic behavior. What counts among young children in Taiwan is their ability to draw Chinese characters before they enter school. Like those of Japan, Taiwanese schools are highly competitive, and parental anxieties about their children's futures are communicated to children. The fact that many of the Taiwanese preschoolers drew independent units all over the page suggests that they have assimilated the idea of drawing to the idea of writing. This suggestion is reinforced by the fact that several children actually drew characters in their drawings.

A cross-cultural study of this type has the advantage of providing

a set of fairly well-controlled comparative data. I have attempted to use these data in order to learn about how children put pictures together in six cultures. I believe that the study has uncovered certain regularities that have not previously been noted and disconfirmed others that have been widely accepted. What we need next are in-depth studies of artistic development in cultures where children do not normally draw as well as of cultures with rich artistic traditions.

BIBLIOGRAPHY

Adler, L. L. 1967. "A Note on Cross-Cultural Differences: Fruit-Tree Preferences in Children's Drawings." *The Journal of Psychology* 65:15–22.

Alland, A. Jr. 1977. *The Artistic Animal: An Inquiry Into The Biological Roots of Art.* New York: Doubleday-Anchor.

Anastasi, A. and J. Foley, Jr. 1936. "An Analysis of Spontaneous Drawings by Children in Different Cultures." *Journal of Applied Psychology* 20:689–726.

—— 1938. "A Study of Animal Drawings by Indian Children of the North Pacific Coast." *The Journal of Social Psychology* 9:363–374.

Appia, B. 1939. "La Representation Humaine dans les Dessins D'enfants Noir." *Bulletin de L'Institute Francais d'Afrique Noir* 1:405–411.

Arnheim, R. 1954. *Art and Visual Perception.* Berkeley: University of California Press.

Belo, J. (editor). 1970. *Traditional Balinese Culture.* New York: Columbia University Press.

Child, I. 1965. "Personality Correlates of Esthetic Judgment in College Students." *Journal of Personality* 33:466–511.

Child, I. and L. Siroto. 1965. "Bakwele and American Esthetic Evaluations Compared." *Ethnology* 4:349–369.

Chomsky, N. 1975. *Reflections on Language.* New York: Pantheon.

Ford, C. S., E. T. Prothro, and I. Child. 1966. "Some Transcultural Comparisons of Esthetic Judgment." *Journal of Social Psychology* 68:19–26.

Gardner, H. 1973. *The Arts and Human Development: A Psychological Study of the Aesthetic Process.* New York: Wiley Interscience Publications.

—— 1980. *Artful Scribbles: The Significance of Children's Drawing.* New York: Basic Books.

Golomb, C. 1974. *Young Children's Sculpture and Drawing: A Study in Representational Development.* Cambridge: Harvard University Press.

Goodman, N. 1976. *Languages of Art.* Indianapolis: Hackett.

Goodnow, J. 1977. *Children Drawing.* In J. Bruner, M. Cole, and B. Lloyd, eds., The Developing Child Series, Cambridge: Harvard University Press.

Iwao, I. and I. Child. 1966. "Comparison of Esthetic Judgment by American Experts and by Japanese Potters." *Journal of Social Psychology* 68:27–33.

Kellogg, R. 1959. *What Children Scribble and Why*. Palo Alto: National Press Books.
—— 1969. *Analyzing Children's Art*. Palo Alto: National Press Books.
Kellogg, R., and S. O'Dell. 1967. *The Psychology of Children's Art*. Del Mar, California: CRM Associates for Random House.
Lark-Horovitz, B., H. Lewis, and M. Luca. 1973. *Understanding Children's Art for Better Teaching*. 2d ed. Columbus, Ohio: Charles E. Merrill.
Selfe, L. 1977. *Nadia: A Case of Extraordinary Drawing Ability in an Autistic Child*. New York: Academic Press.

INDEX